Mission Statement : **Graphis** is committed to presenting exceptional work in international Design, Advertising, Illustration & Photography.

Published by Graphis Inc. | CEO & Creative Director: B. Martin Pedersen | Publishers: B. Martin Pedersen, Danielle B. Baker | Editor: Anna N. Carnick
GraphicDesigner: Yon Joo Choi | Support Staff: Rita Jones, Carla Miller | Interns: Joanna A. Guy, Eno Park, Jong Yoon Park, Meaghan E. Tirondola

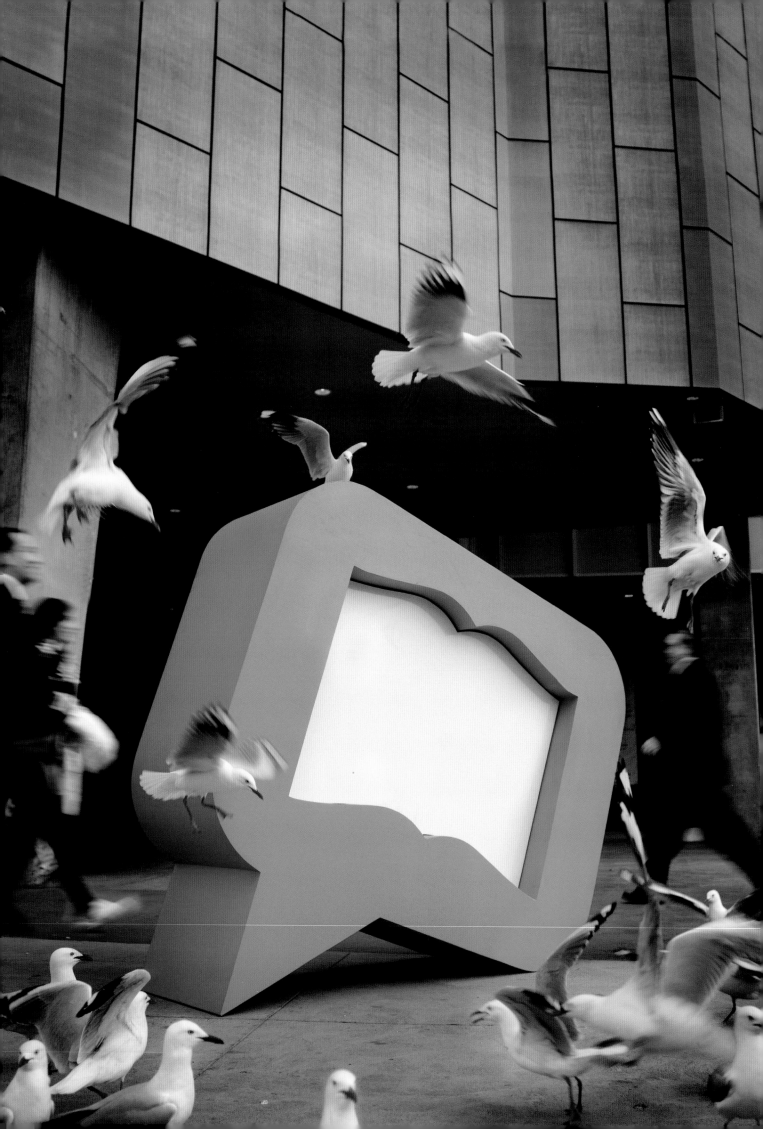

Contents

"Raise the aesthetic standard-the public is more perceptive than you think."
Walter Allner

"Design is not a thing you do. It's a way of life."
Alan Gerard Fletcher

"All that I know I share. I get back much more than I ever give."
Morteza Momayez

Walter Allner1909-2006 Alan Gerard Fletcher.....................1931-2006 Morteza Momayez1935-2005 Sergio Saverese1958-2006

Gustav Ewert Karlsson1918-2004 Ivan Luini ..1960-2006 Warren Platner1919-2006 Tom Suzuki1930-2006

Since 1944, Graphis has been a beacon for outstanding work in the visual arts. With the introduction of the Annuals, each piece selected for inclusion was always considered an award winner. This year, we further recognize any piece included in the Annuals as a Gold Medal winner, and a limited few as Platinum Award winners, with accompanying certificates and awards. We congratulate and thank each and every one of our talented contributors for the amazing work we continue to see every year, and proudly present you with this year's winners.

Rebeca Méndez Communication Design : UC Student Recreation Center Archigraphic Murals

Thom Mayne and his firm Morphosis designed a 353,000 sq. ft. student recreation center on the campus at the University of Cincinnati, which opened in May 2006. Rebeca Méndez was commissioned to create two permanent installations at the recreation center, one in the convenient store (c-store) and another at the food court.

For the c-store, The University imagined market scenes; Méndez had her own solution in mind. Hovering over the giant bags of Doritos and university paraphernalia, she composed 24 extreme panoramic landscapes. Méndez refers to them as "ever sustaining landscapes. All products and nourishment have as their origin the extraction or harvest of the raw materials provided by the earth." Méndez's interest is to give the viewer a glimpse of these raw materials in their integrity and beauty, as well as expose the distribution and processing of these goods before they are conveniently packaged for consumption at the "c-store."

Formally, the horizon lines of the landscapes have become thresholds onto imagining new, non-existent landscapes where glaciers float over puffy clouds and Nordic cows graze on top of tropical waters. Using her own documentary photography from far-flung places like Patagonia and the Sahara desert, Méndez's landscapes tease the viewer to see beyond the horizon, which she views as "the perpetual aim of humanity." Méndez sees this urge as a double-edged sword, and instilled in her murals this sense of ambivalence. Each of the six murals has an overall dominating color – red, orange, yellow, blue, green and white. The first five of those colors correspond to the United States Department of Homeland Security's National Alert Threat Levels, red corresponding to "severe" and green corresponding to "low." Méndez realized that "peace"—the most important ambition of humanity—and its corresponding color, white, were missing from the chart, and it became her sixth panel. Her subtle critique, in her words, "exposes the sadly backward state of affairs of the current United States government."

Placed in each landscape is a short line of text—a sensation, a glimpse of a memory, or a moment of an experience triggered by the landscape, including thoughts with regards to sustainability ("till the last tree" over an image of cows grazing), pointing back at Méndez's interpretation of the core theme of the murals—ever sustaining landscapes—which are being farmed, drilled, eroded and melted, for our "convenience."

The six panels become an impression of the power and beauty of the landscape, and a message to question the cost of convenience.

For the food court, Méndez was commissioned to create murals on four cone-like structures, two of them reaching over 50 feet high and piercing through the roof. The cone structures envelop the kitchens of the food court, and hide all the piping and machinery necessary for such enterprises. What often happens in spaces like these is that the occupants fill them with evergreen ficus trees to liven up the interior, often leading to dreary, dried out dust collectors dying in a lonely corner. Permanent flora printed on the cones, Morphosis imagined, would avoid this tragic fate. Méndez and Mayne discussed D'Arcy Wentworth Thompson's seminal work *On Growth and Form* (1917), which posits that processes in nature fit mathematical equations, setting out to prove a unity of life by its relationship between form and function. To expand on this, Méndez studied Stephen Wolfram's book, *A New Kind of Science* (2002), where he states that repetitive application of simple computational transformations is the true source of complexity in the world. Méndez's investigations into how to create a visual dialogue between flora, the architecture, and the site led her to select grass—specifically giant reed grass—for her artwork. Over many months and continents, Méndez photographed grass from various points of view and under the different weather conditions allowing light and wind to create visual difference, and to reveal the patterns that one simple form – a blade of grass – produces through complex organization. Over a period of five weeks the muralists James Griffith and Susanna Dadd painted the compositions Méndez created onto the cones.

How successful was your solution – both in terms of creativity and finance?
The collaboration between Architects, Muralists and myself (as Artist/ Creative Director/Photographer/Designer) was healthy and successful. The clients—Architect Thom Mayne of Morphosis and the University of Cincinnati— are both very happy with the work, which continues to be recognized by the creative community (both Architecture and Design)

with various awards, including a Merit Award from The One Club of NY. The project was published in '34' Magazine, No 8, a lifestyle magazine from Istanbul, Turkey, in an article entitled "The Making of a Masterpiece" by Albert Coupland.

In the article, Kristina Loock, the lead Architect had this to say: "Her supergraphics doubled up what the surface does with the geometrics by adding another layer of dimensionality. It was very interesting to see Rebeca deconstruct our folds and compose her own spaces. Her visuals make our shapes friendlier and better to understand." Also, James Griffith, one of the muralist painters of the grass said it most succinctly: "The way the grass criss–crosses, and comes together in fluid intersections is exactly how the geometry and the flow of the building works. It was such a beautiful collaboration and achievement, from the plasterers to our work to the Designer to the Architect; we felt like cellists in an orchestra performing for a brilliant director a piece by Beethoven the best we ever will." And Morphosis founder Architect Thom Mayne says, "She has an extremely engaging brain that understands the broader conceptual notion of Architecture."

Additionally, the project was included in an exhibit of the work of Morphosis called "Continuities of the Incomplete" at the Centre Pompidou in Paris, France.

The project was huge and lasted almost two years, yet was surprisingly on schedule and on budget.

What is your work philosophy?
In my twenty-year career—as Designer, as Creative Director, and business owner and now as Professor—my work has revolved around organization, culture and identity. In my design, creative direction and teaching, I thoroughly study the material at hand, engage my full radar of perception to understand its material, its behavior and discern patterns for organization, to determine its properties, and imagine its potential. I become the subject matter to know how to act like from within it, specifically and appropriately. It is thinking not inside or outside the box, but as the box and its context. I construct an identity with systematic structure performing individual functions that collectively achieve a particular purpose. I give presence (both material and behavioral) to a coherent experience. My role as a Designer is to imagine, invent and visualize new opportunities, and contribute in the insertion of progressive intelligence into society and culture.
The project was also published in a 2006 exhibition catalogue called "Second Natures," published by UCLA, School of Art and Architecture. The exhibition was curated by Whitney Museum Media Art Curator Christiane Paul, who served as editor of the book as well.

Collaboration has been my strength: Rebeca Mendez Design's collaborations continue to be with leading figures around the world such as 2005 Pritzker Prize Laureate Thom Mayne, UCLA AUD Professor Michael Weinstein and Architect Greg Lynn, Artists Bill Viola and Rubén Ortiz Torres, and Film Director Mike Figgis.

Other awards?
Merit Award, Design Category, Art Directors Club of New York, 2007
Merit Award, Graphic Design: Environmental Category, The One Show, New York, 2007
Nomination for National Design Award by Smithsonian's Cooper-Hewitt National Museum, 2005
Merit Award, Graphic Design: Environmental Category, The One Show, New York, 2005
Merit Award, Broadcast Design Category, The One Show, New York, 2005
Award of Excellence, American Institute of Graphic Arts, 365: AIGA Year in Design 26, 2005
Merit Award, Graphic Design Category, The One Show, New York, 2003
Award of Excellence, American Institute of Graphic Arts, AIGA 50 books/50 covers, 2003
Nomination for National Design Award by Smithsonian's Cooper-Hewitt National Design Museum, 2003
Nominated for National Design Award by Smithsonian's Cooper-Hewitt National Design Museum, 2002
Award of Excellence, American Institute of Graphic Arts, 365: AIGA Year in Design 20, 2000
www.rebecamendez.com

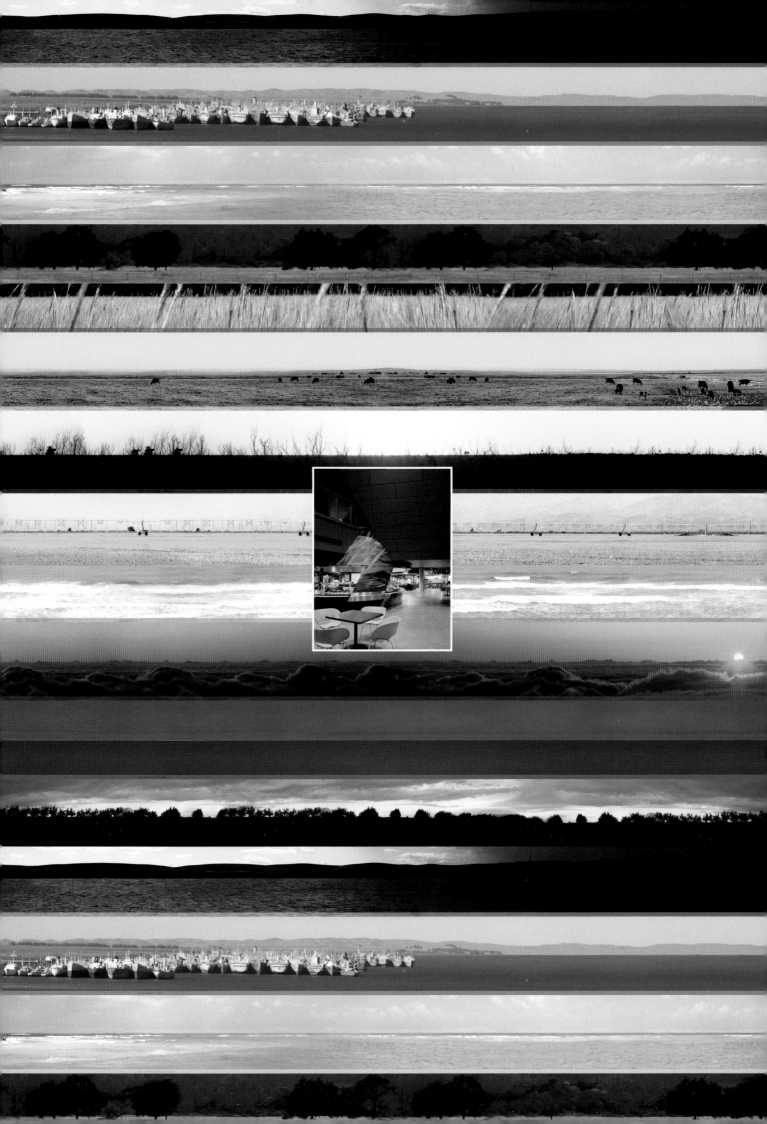

1
2
3
4
5
6
7
8
9
10
11
12
13
14
15
16
17
18
19
20
21
22
23
24
25
26
27
28
29
30
31
32
33
34
35
36
37
38
39
40

Grid-it! Notepads
Die neue Typographie
Jan Tschichold
1928

148 x 210 mm / 60 sheets / 60 hojas

Other available Grid-it! Note pads /
Otros blocs Grid-it! disponibles
: Le Modulor : A Designer's Art
: Twen magazine : The Gutenberg Bible
: Raster Systeme : The Guardian

The Art of the Grid
www.griditnotepads.co.uk

Miquelrius

Astrid Stavro: Grid-It! Notepads

Grids form an essential part of our lives. We may not always notice them, but their influence on what we see, hear and do is everywhere. By moving the grids from the background to the foreground, and divorcing them from their content, I pay homage as well as render the invisible visible. As Designers, understanding the advantages as well as the limitations of the grid helps us determine what place they should take in our own work. The grid, like any other instrument in the design process, is not an absolute. Like computers, they are simple design tools. It is the process of challenging or questioning these assumptions that is important, because in doing so we re-evaluate our perception of the environment and our role within it.

A brief note on the art of the Grid Products:
Grid-it! Notepads have extended into The Art of the Grid products, which include shelving units and cutting mats. The shelving units and cutting mats take the Grid-it! Notepads a step further by transforming the grids into 3D products and into the realm of Industrial and Product Design.

The Grid-it! Notepads series is based on the layout grids of famous publications. They are a selection of grids that played a historic role in the development of Design systems, covering a wide spectrum of classic and contemporary Editorial Design.

There are 7 notepads in total:

1. Le Modulor / Le Corbusier / 1948
2. Die neue Typographie / Jan Tschichold / 1928
3. A Designer's Art / Paul Rand / 1985
4. Twen magazine / Willy Fleckhaus / 1959
5. Raster Systeme / Jodef Muller-Brockmann / 1981
6. The Gutenberg Bible / Johannes Gutenberg / 1455
7. The Guardian newspaper / David Hillman / 1988

Each notepad has 60 gridded sheets and is reproduced at actual size. Besides their role as historic 'reminders' or homages, the notepads are useful products and may be used for practicing layouts, writing memo notes, doodling, shopping lists, love letters, etc.

What was the client's directive, the problem, and your solution?
Grid-it! Notepads were initially developed during the last week of my Master of Arts in Communication Art & Design at The Royal College of Art. They were exhibited and sold for the first time at The Show at the RCA. The first client in this sense was The Royal College of Art, but the initial brief was self-initiated. The idea behind the production of the notepads was to 'build a job for myself' after graduation, to develop a product that would bridge the gap between my student and professional career. I used the Royal College as a platform where I could increase my theoretical understanding of Design and engage with ideas that cannot normally be explored within a commercial context. The success of the notepads at the RCA Show was such that I quickly found a buyer; Miquelrius (www.miquelrius.com) bought the production and distribution rights of the notepads worldwide. I then added two more grids to the initial series: Paul Rand's "A Designer's Art" and Josef Muller-Brockmann's "Raster Systeme." In this sense, Miquelrius became a second client. It was a risky and daring move for Miquelrius, as their brand specializes in distributing commercial stationery products by 'popular' Designers such as Jordi Labanda, Agatha Ruiz de la Prada and Javier Mariscal. Taking on a product such as Grid-it! Notepads alongside their commercial best sellers was an inspiring move on their behalf and a great step forward for Graphic Design, as the notepads are not for the academia-shy. The best designs are like great marriages: a mutual understanding between the right client and the right Designer. After all, as the saying goes, "It takes two to tango." An interesting example happened recently when the Creative Director of Wallpaper* magazine approached me asking for the Wallpaper* grid to be included alongside the rest of the Grid-it! Notepads series to celebrate their 10th Anniversary. This created a moral dilemma as the Wallpaper* grid does not comply with the historic and contextual requisites of the rest of the grids

in the series. Including this grid would have been a kind of 'prostitution' of the project... The answer was a categoric 'NO'; the Wallpaper* grid could NOT be included in the original series, but I offered a simple solution. We would produce a Wallpaper* grid special 10th Anniversary edition notepad as a special one-off with a special different colored sticker explaining that this new grid was not a part of the Grid-it! Notepads series but a one-off to celebrate Wallpaper*'s birthday done in conjunction with Wallpaper* magazine.

How successful was the solution – both in terms of creativity and finance?
The first print-run, a limited edition of 500 for each of the 5 initial notepads, was sold out in one day in London. So we covered costs in less than 24 hours. Such a success inspired retailer Miquelrius to buy the distribution and production rights of the notepads, and they now take care of the production and distribution of the notepads worldwide. Because of their exclusive and specialized nature, the notepads are not very commercial in terms of mass media. They are not best sellers outside of the Design industry. However, they sell at a rate of 6000 notepads per month. In terms of creative success they went on to win some of the major and most prestigious Design awards in Europe and form part of the Victoria & Albert Museum permanent collection in London.

Please describe the physical nature of the piece.
Each notepad recreates the original grids at their original size. There are 7 different sizes representing a selection of 7 different grids. Each notepad comes shrink-wrapped with a red sticker containing the details and titles of the grids and is made out of 60 tear-off gridded sheets. They are printed in cyan on off-white 120 gr. paper.

How long has your firm been in the Design business?
The multi-disciplinary Design studio Astrid Stavro has been in business for two years and is based in Barcelona, Spain. Before moving to Barcelona, I ran other Design studios and worked as a freelancer in London for ten years. Clients include The Royal College of Art (London), Art Directors Club of Europe, ADG-FAD (Association of Graphic Designers), Museum Reina Sofia (Madrid), MACBA Museum (Barcelona), publishers such as SM, Planeta, Seix Barral, Destino, The Victoria & Albert Museum (London), Palau de la Musica (Barcelona), etc.

How large is the firm?
There are currently 3 full-time Designers working in the studio beside myself. This number fluctuates according to the volume of work and often increases as I sometimes hire particular collaborators to work on specific projects. These include Industrial and Product Designers, Typographers, or External Graphic Designers.

What other awards have you received?
3 Nominations in different Design categories, Laus Awards, Barcelona, 2007
Gold, Best in Graphic Design, Design Week Awards, London, 2007
Gold, Best in Graphic Design, Art Directors Club of Europe, 2006
Gold, Best in Graphic Design, Laus Awards, Barcelona, 2006
D&AD Annual, In-Book nomination, London, 2006
The Annual (Creative Review, London, 2006)
Best British Design 2005 (Grafik magazine, London, 2006)
Winner, Loman Studio Award, The Royal College of Art, London, 2005
Distinction in the MA thesis, Royal College of Art, London, 2004
Short listed, National Magazine Award, London, 2003
Short listed, Varley Advertising Award, London, 2003
First, Central Saint Martins College of Art & Design, London, 2000

What is your work philosophy?
1% inspiration and 99% perspiration: A great, solid and functional idea followed by impeccable execution, aesthetic brilliance, and...lots of sweat! This is the philosophy. In practice we try to get as close to the philosophy as possible with each new project.

Finally, how do you approach a problem?
Coffee & cigarettes.

www.artofthegrid.com/www.miquelrius.com

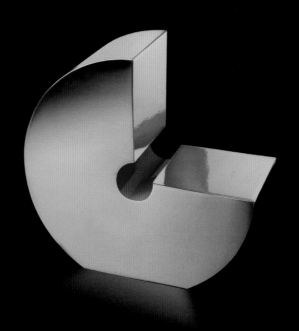

WOODWORKING TO PLAN

Books on design and complete blueprints for homes like this one are just some of the offerings of Creative Homeowner, newest member of Courier's publishing segment.

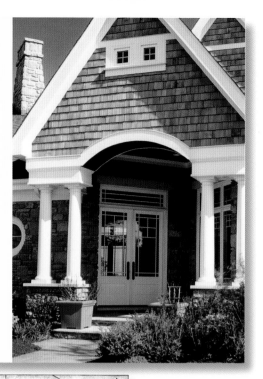

Rear Elevation

Left Elevation

Right Elevation

The Ultimate Book
of Home Plans

Pg. 504 | Pg. 279

COURIER CORPORATION

2006 ANNUAL REPORT

Built to Last

TWO CAR GARAGE

CLOSET
8' CLG. HT.

SHELVES

Financial Review

34 • 35

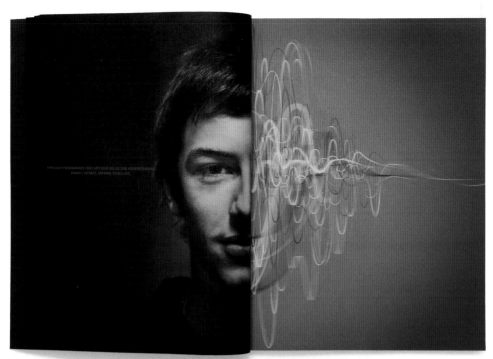

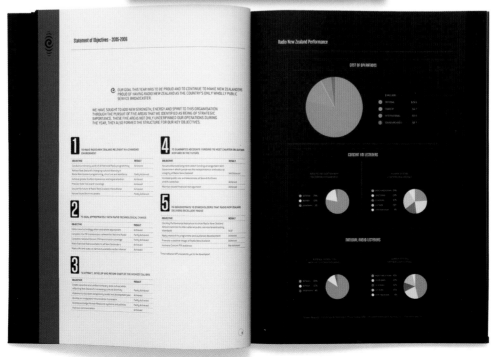

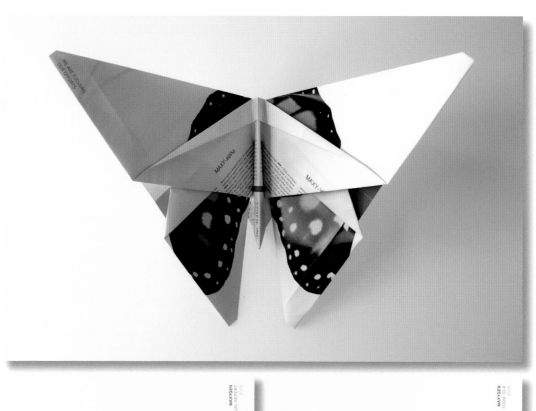

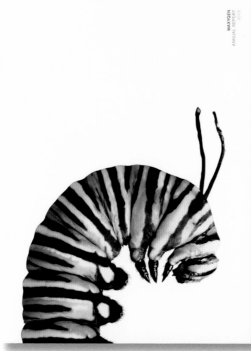

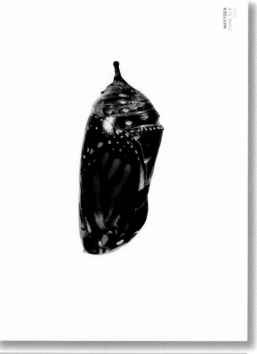

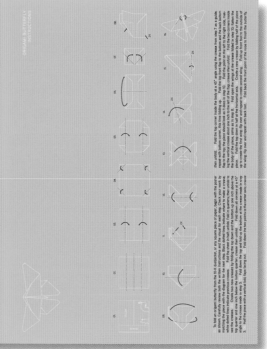

MAXYGEN'S TRANSFORMATION IS DRIVEN BY
THE ADVANCEMENT OF ITS PRODUCTS THROUGH
THE PRECLINICAL PHASE AND INTO PLANNED
CLINICAL DEVELOPMENT IN 2006.

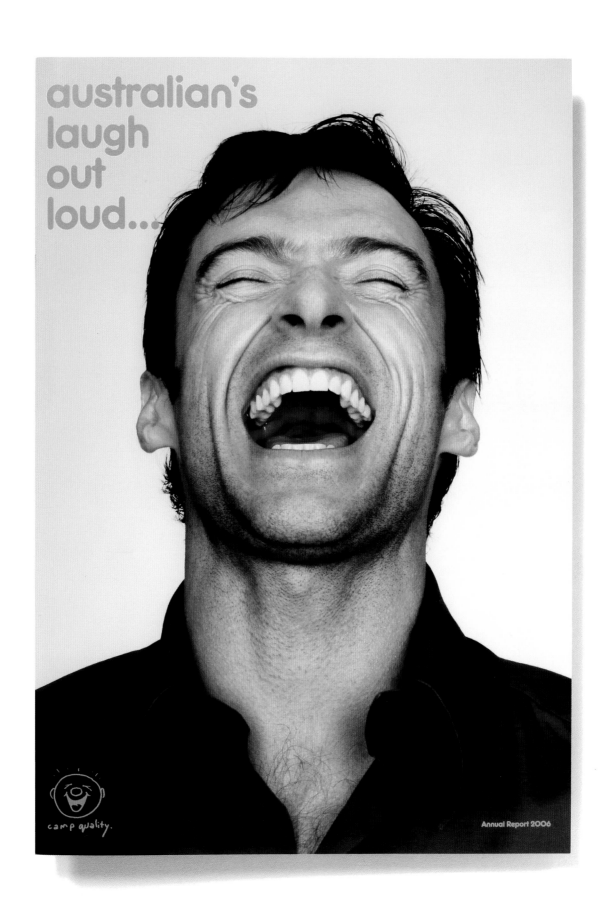

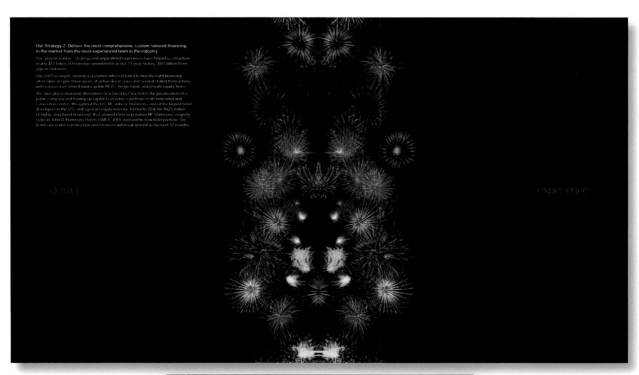

Our Strategy 2: Deliver the most comprehensive, custom tailored financing in the market from the most experienced team in the industry

Our "private banker" strategy and unparalleled experience have helped us structure nearly $17 billion of financing commitments in our 11-year history, $18.7 billion from repeat customers.

One 2005 example: serving a customer who had failed to find the right financing alternative despite three years of active discussions and several stalled transactions with various investment banks, public REITs, hedge funds and private equity firms.

The two-phase financing alternative structured by iStar led to the privatization of a public company and freeing up capital to develop a portfolio of 40 new hotel and convention center throughout the US. Mr. John Q. Hammons, one of the largest hotel developers in the US, and a private equity investor, turned to iStar for $425 million of highly structured financings that allowed them to privatize Mr. Hammons' majority stake in John Q. Hammons Hotels (AMEX: JQH) and fund his new hotel portfolio. Six hotels are under construction and ten more will break ground in the next 12 months.

deliver experience

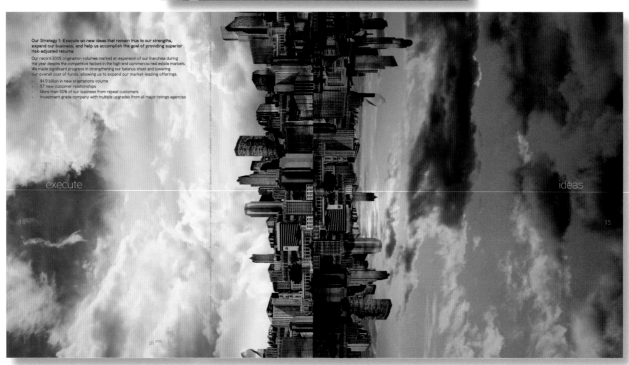

Our Strategy 1: Execute on new ideas that remain true to our strengths, expand our business, and help us accomplish the goal of providing superior risk-adjusted returns

Our record 2005 origination volumes marked an expansion of our franchise during the year despite the competitive factors in the high-end commercial real estate markets. We made significant progress in strengthening our balance sheet and lowering our overall cost of funds, allowing us to expand our market-leading offerings.

- $4.9 billion in new originations volume
- 57 new customer relationships
- More than 50% of our business from repeat customers
- Investment grade company with multiple upgrades from all major ratings agencies

execute ideas

14 15

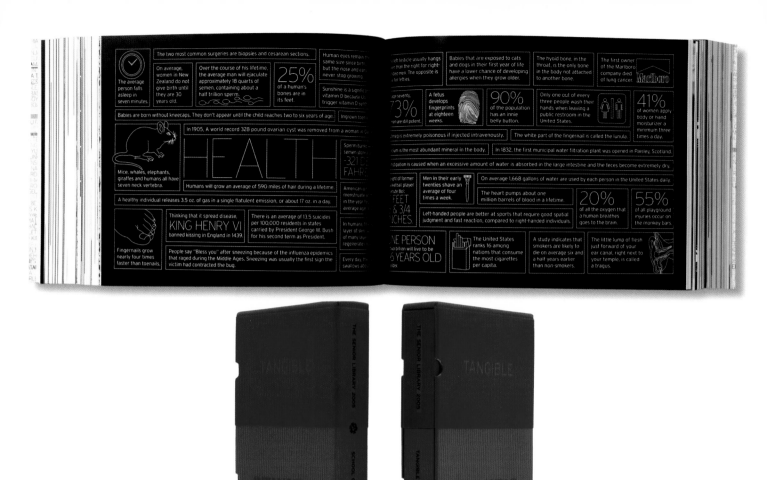

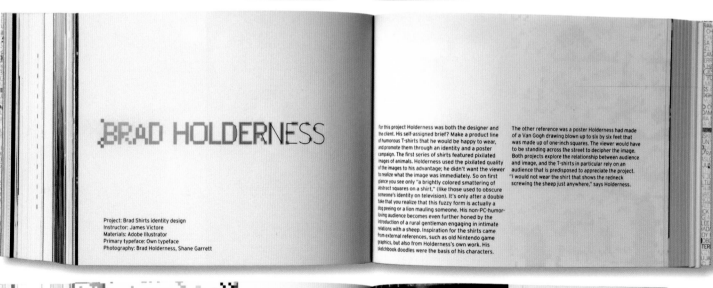

BRAD HOLDERNESS

Project: Brad Shirts identity design
Instructor: James Victore
Materials: Adobe Illustrator
Primary typeface: Own typeface
Photography: Brad Holderness, Shane Garrett

For this project Holderness was both the designer and the client. His self-assigned brief? Make a product line of humorous T-shirts that he would be happy to wear, and promote them through an identity and a poster campaign. The first series of shirts featured pixilated images of animals. Holderness used the pixilated quality of the images to his advantage; he didn't want the viewer to realize what the image was immediately. So on first glance you see only "a brightly colored smattering of abstract squares on a shirt," (like those used to obscure someone's identity on television). It's only after a double take that you realize that this fuzzy form is actually a dog peeing or a lion mauling someone. His non-PC-humor-loving audience becomes even further honed by the introduction of a rural gentleman engaging in intimate relations with a sheep. Inspiration for the shirts came from external references, such as old Nintendo game graphics, but also from Holderness's own work. His sketchbook doodles were the basis of his characters.

The other reference was a poster Holderness had made of a Van Gogh drawing blown up to six by six feet that was made up of one-inch squares. The viewer would have to be standing across the street to decipher the image. Both projects explore the relationship between audience and image, and the T-shirts in particular rely on an audience that is predisposed to appreciate the project. "I would not wear the shirt that shows the redneck screwing the sheep just anywhere," says Holderness.

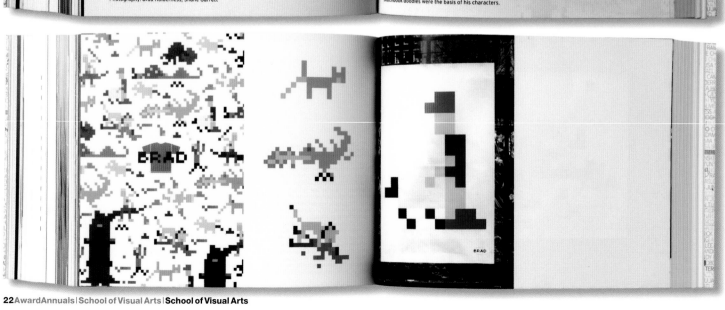

freestyle

NEW AUSTRALIAN DESIGN FOR LIVING

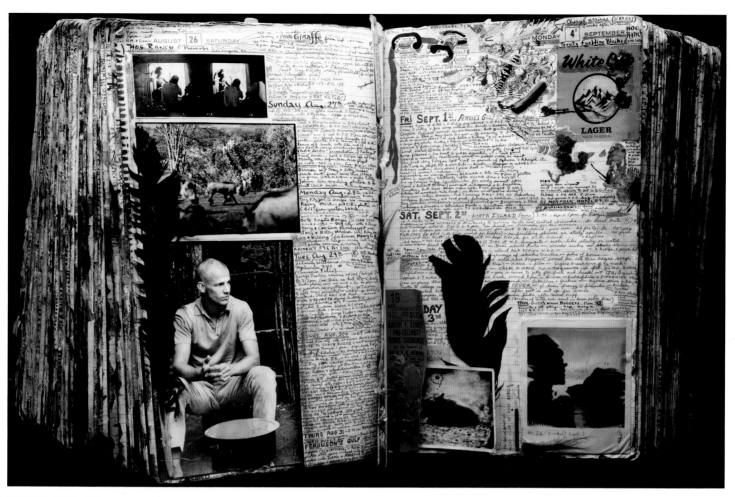

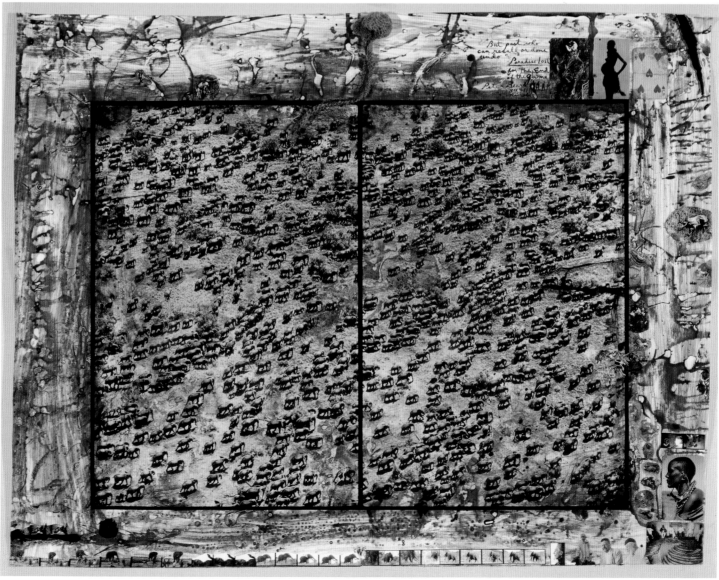

ANGLOMANIA

THE METROPOLITAN MUSEUM OF ART

domus
arte e stile nella casa
arte e stile nell'industria (industrial design)

269 aprile 1952

TASCHEN

domus
MONTHLY MAGAZINE OF ARCHITECTURE INTERIORS DESIGN ART

OSCAR NIEMEYER A TORINO
VIAGGIO NEGLI I.A.C.P.
PIANO E ROGERS QUATTRO PROGETTI
GALLERIE COMMERCIALI A BUENOS AIRES
EDIFICIO PER UFFICI A PARIGI
COLORI NEGLI INTERNI
DESIGN
ARTE

TASCHEN

domus
MONTHLY REVIEW OF ARCHITECTURE INTERIORS DESIGN ART

NUMERO 674 LUGLIO/AGOSTO 1986

TASCHEN

domus
MONTHLY REVIEW OF ARCHITECTURE INTERIORS DESIGN ART

Luigi Colani

America: il grattacielo camaleonte
Snake skin sky-scraper
Luigi Colani, radiografia di un designer
Abitare tra le piramidi

TASCHEN

domus
MONTHLY REVIEW OF ARCHITECTURE INTERIORS DESIGN ART

BEWARE WET PAINT

TASCHEN

DOMUS
Direttore: Architetto Gio Ponti
Maggio 1940 - XVIII - N.149

TASCHEN

domus
architettura arredamento arte

362 gennaio 196

TASCHEN

domus
architettura arredamento arte

465 agosto 196

TASCHEN

domus
architettura arredamento arte

518 gennaio 1973

Cancer

RE
DI
SPADE

TASCHEN

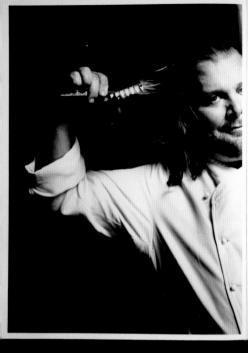

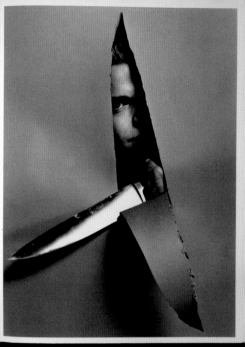

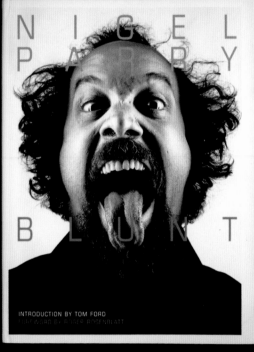

NIGEL PARRY

BLUNT

INTRODUCTION BY TOM FORD
FOREWORD BY ROGER ROSENBLATT

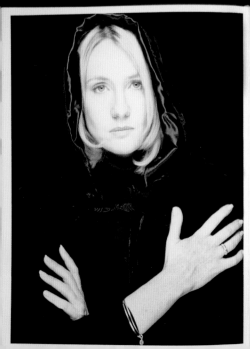

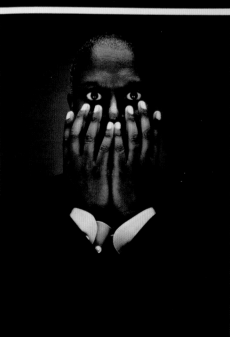

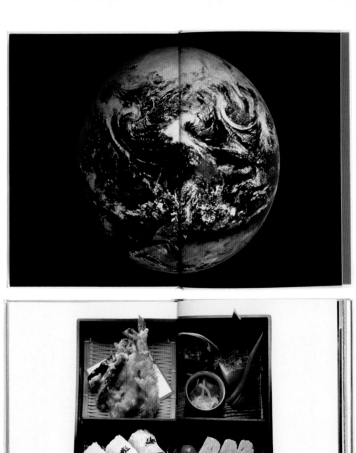

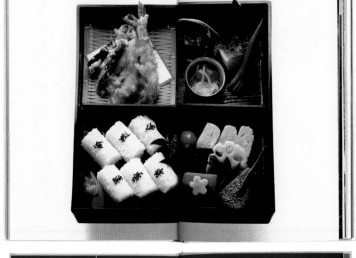

me & miss menta she was a dutch play boy model I was teachers pet

Marcola Oregon, 72, we had just come onto a few million dollars. we had a fast on brewers yeast.

DIRTY BLONDE

THE DIARIES OF
Courtney Love

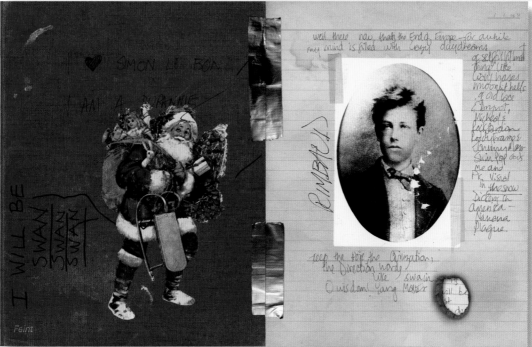

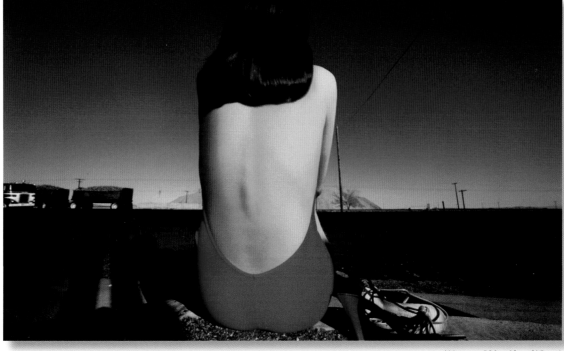

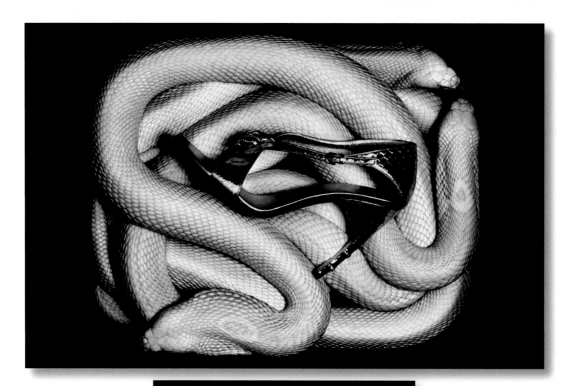

Gucci

BY GUCCI

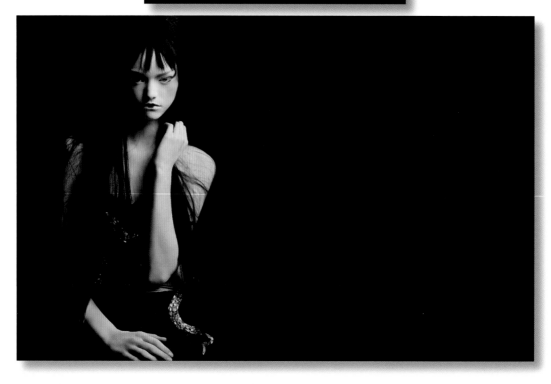

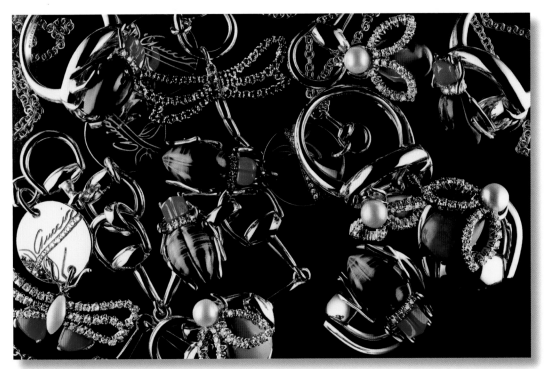

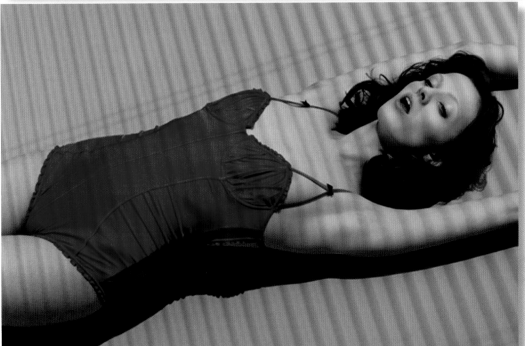

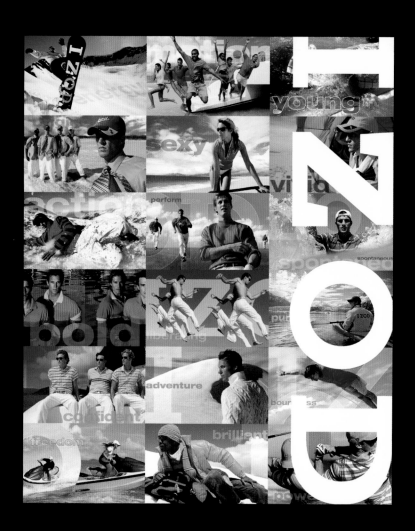

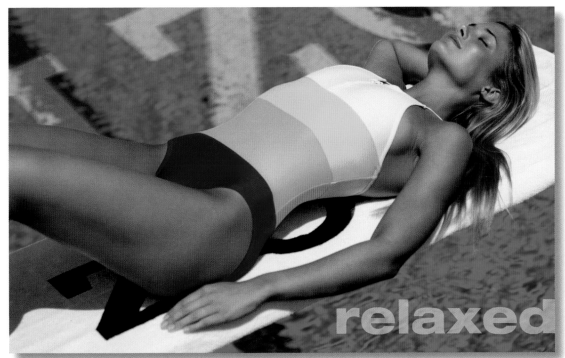

relaxed

IZOD

IZOD iS

CANYON

CANYON

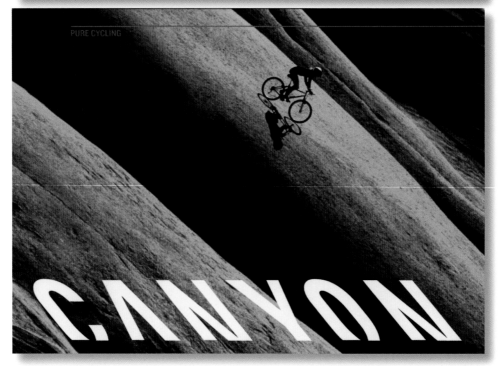

CANYON

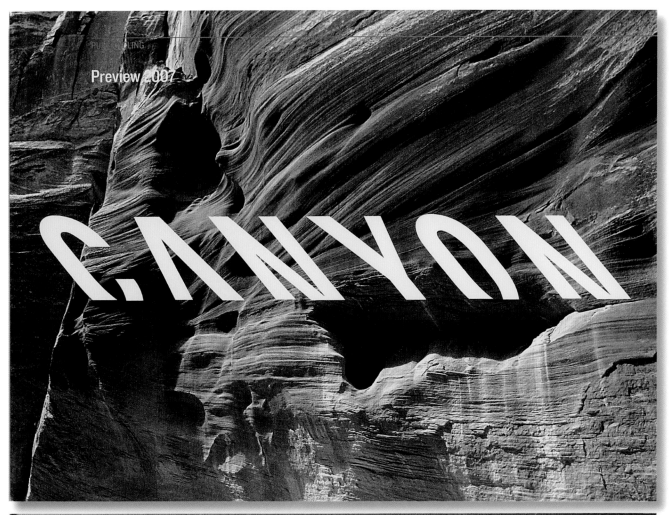

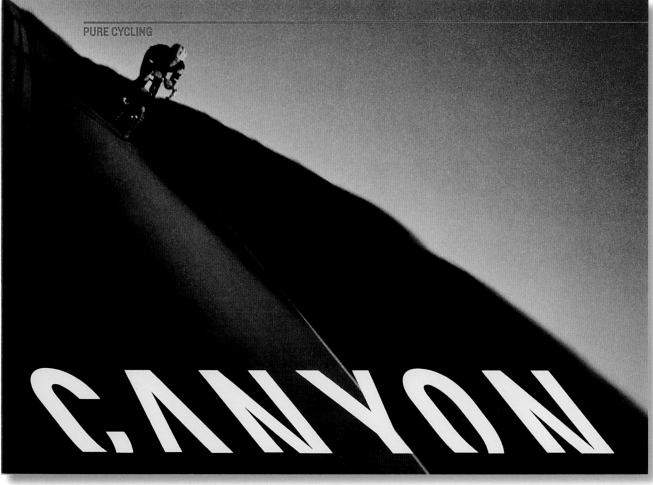

PURE CYCLING

Lovelace

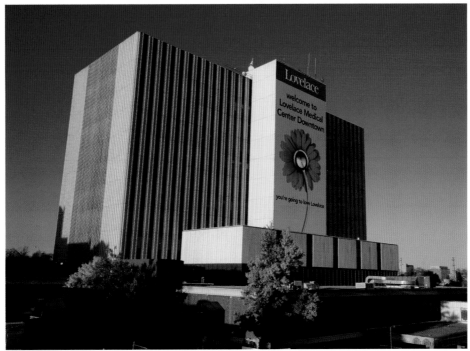

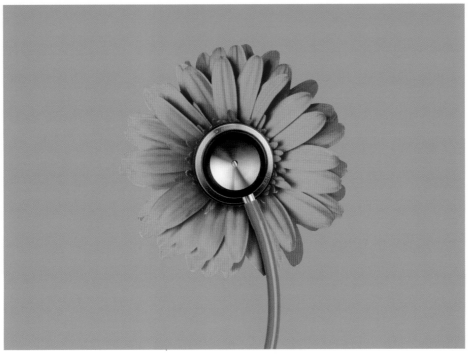

Joclyn McCahon
joclyn@flipp.com.au

Food
Lifestyle
Images
Production
Photography

Suite 201 50 Marshall St
Surry Hills Sydney
NSW 2010 Australia
Tel +61 2 8003 4667
Fax +61 2 8356 9658
Mob +61 413 750 667
www.flipp.com.au

FLIPP

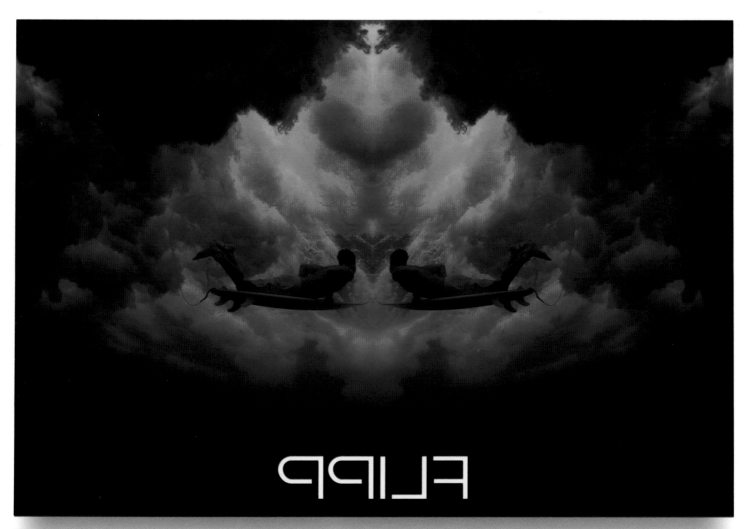

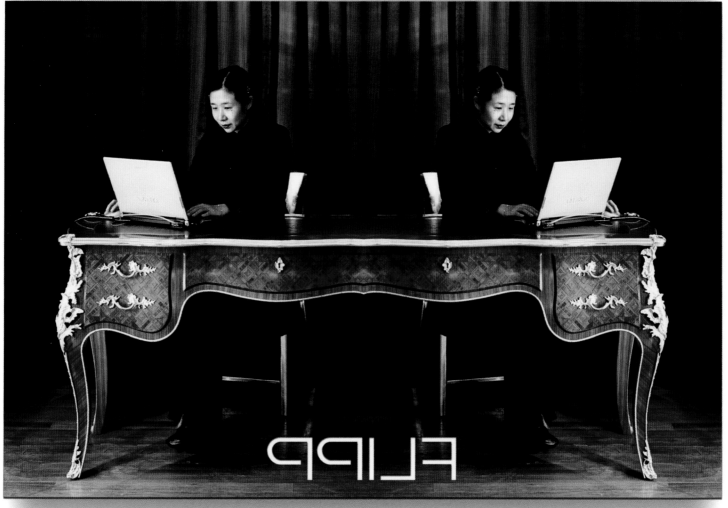

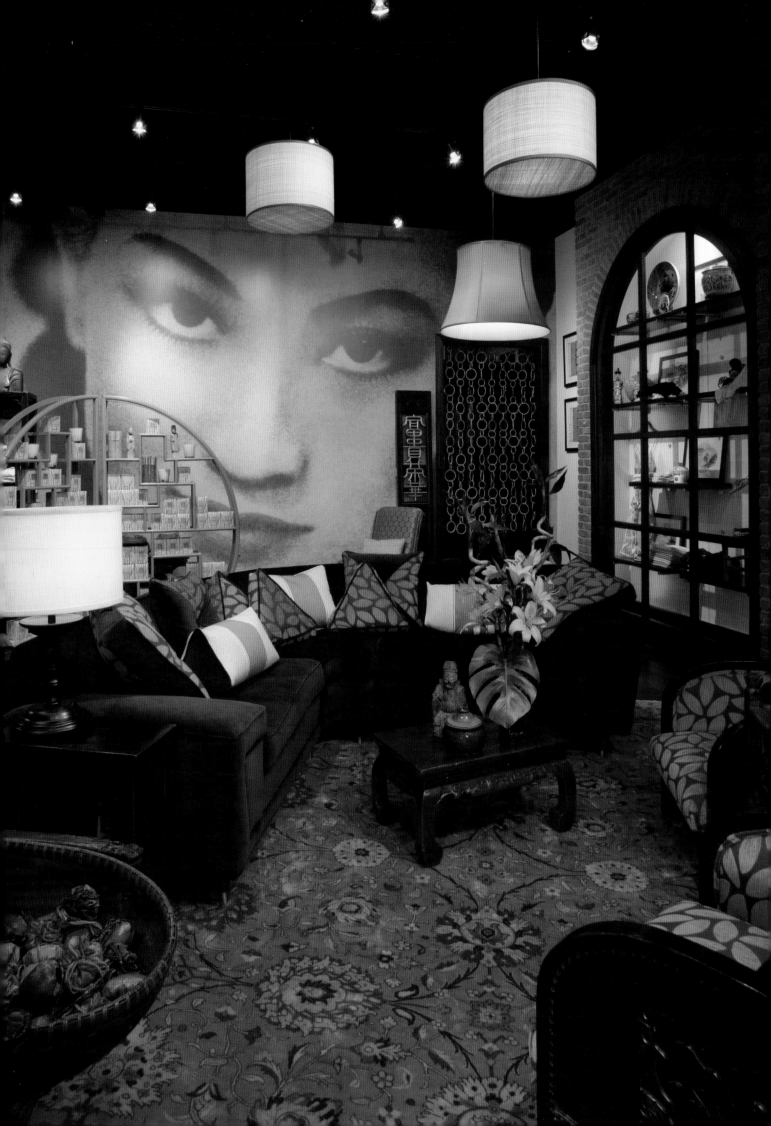

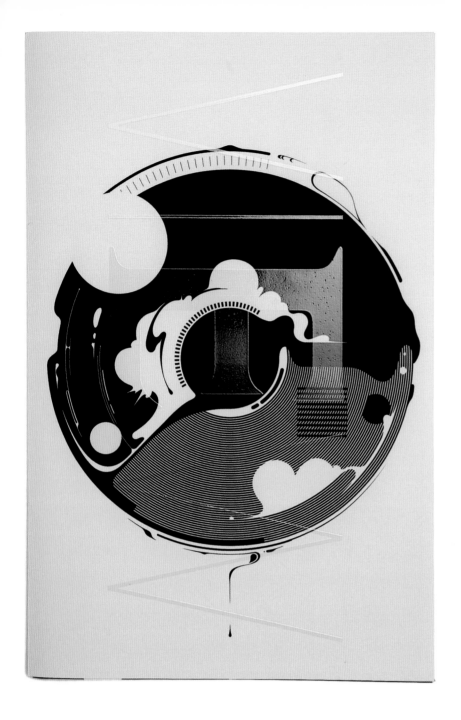

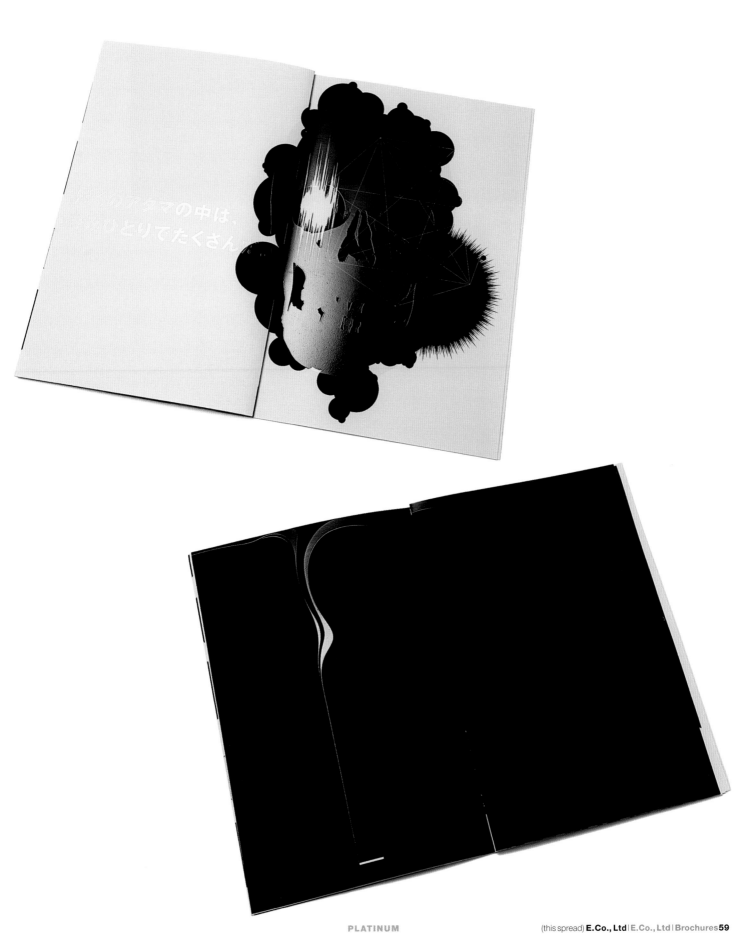

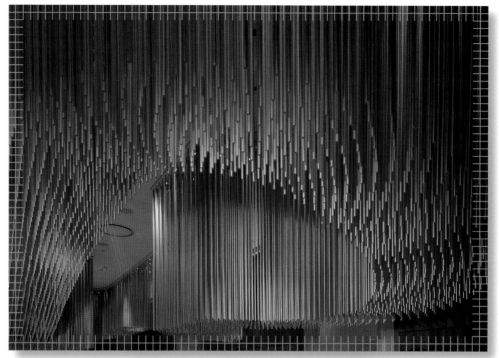

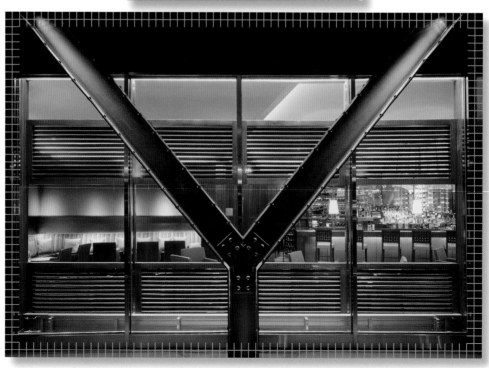

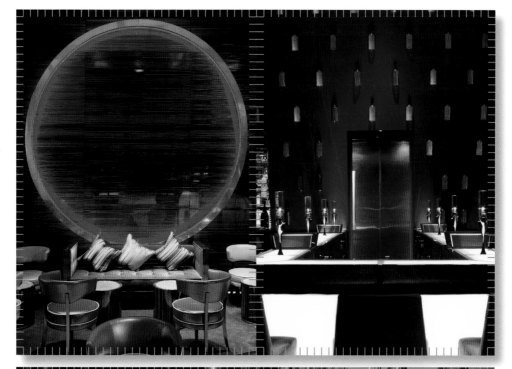

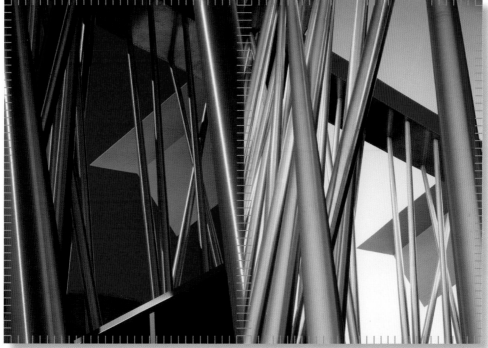

ENGINEERING AND WHY IT MATTERS

SIX SHORT STORIES
AND A PARABLE

WALTER P MOORE

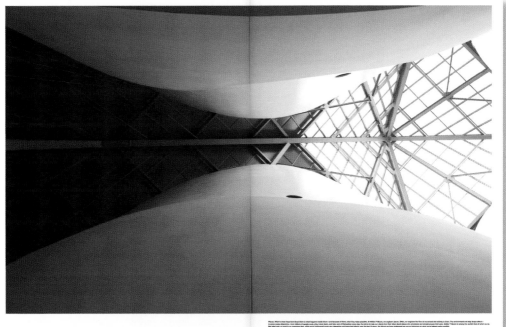

Places. What is most important about them is what happens inside them—and because of them, what they make possible. At Walter P Moore, our engineers make them possible. At Walter P Moore, our engineers make them possible.

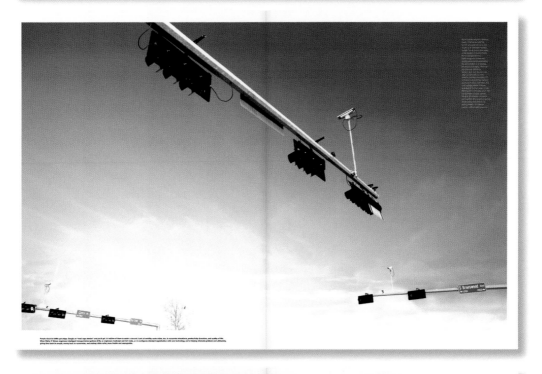

People stuck in traffic get angry. Google an "road rage stories" and you'll get 3.3 million of them in under a second.

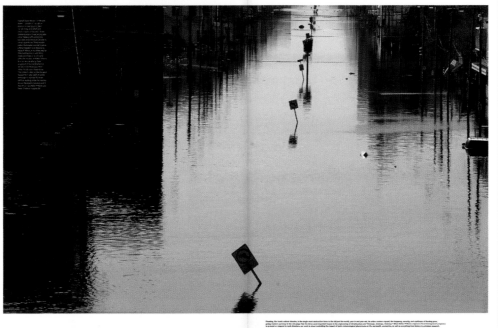

Flooding. For most cabinet theatre, in the single most destructive force in the world, year in and year out, its urban centers equals, the frequency, severity, and stillness of flooding gives.

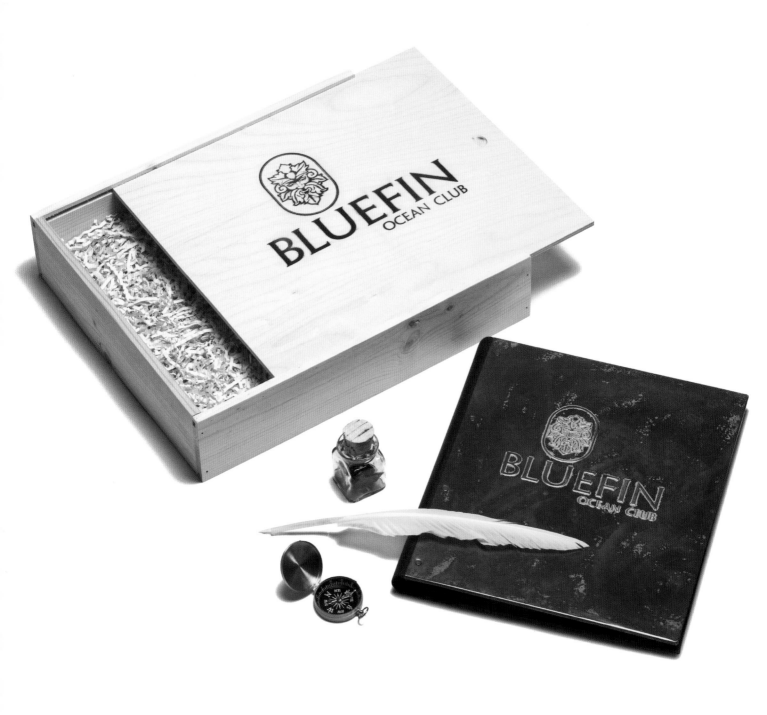

SAFECO CONFERENCE OF CHAMPIONS 2006

CHOICES

HAWAII: JUNE 3-7 OR NEW MEXICO: MAY 15-18

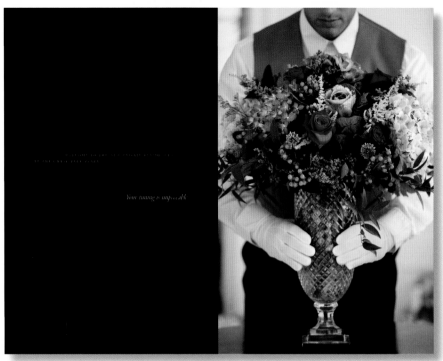

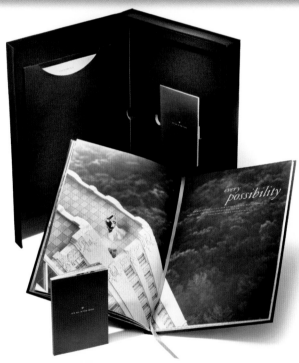

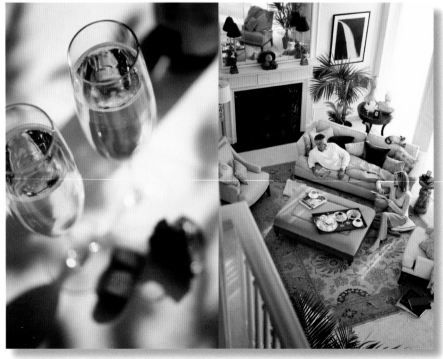

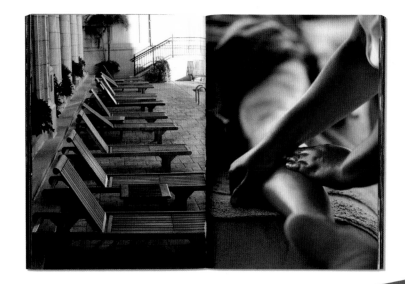

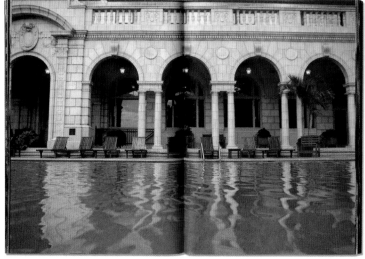

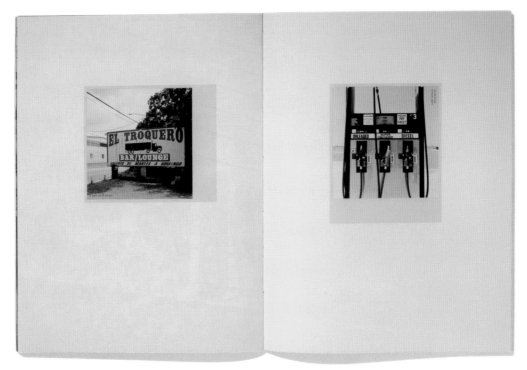

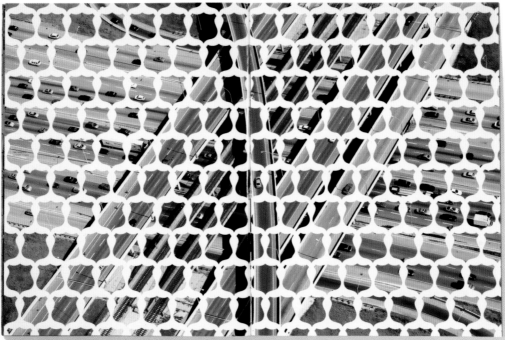

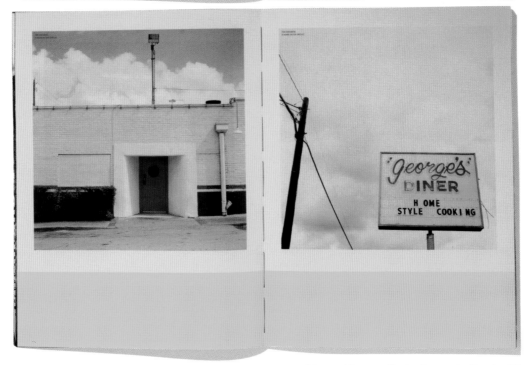

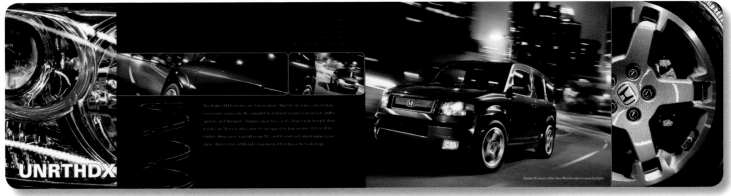

UNRTHDX

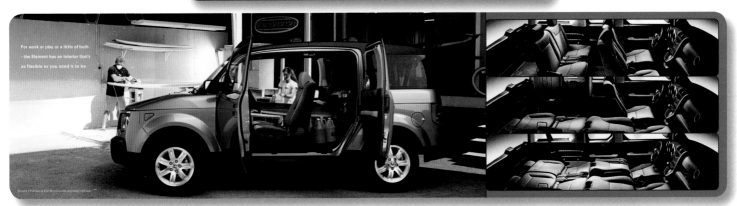

For work or play or a little of both
– the Element has an interior that's
as flexible as you need it to be.

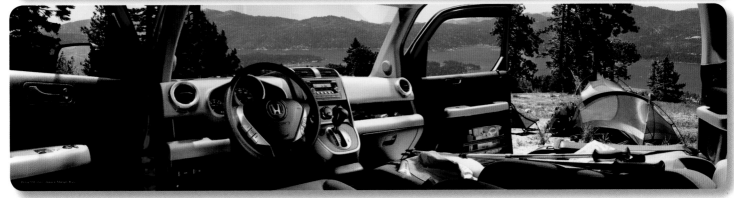

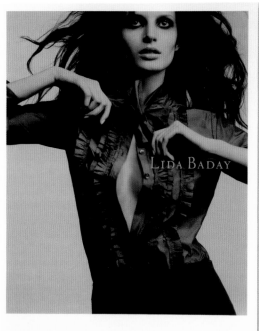

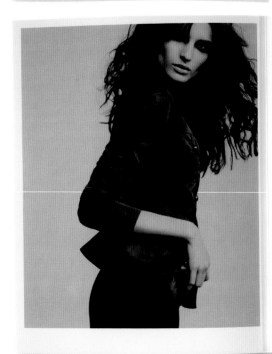

LIDA BADAY

FALL COLLECTION 2005

Rhymes with

Which company has printing, packaging, promotions, mail and fulfilment under one roof?

Here's a clue

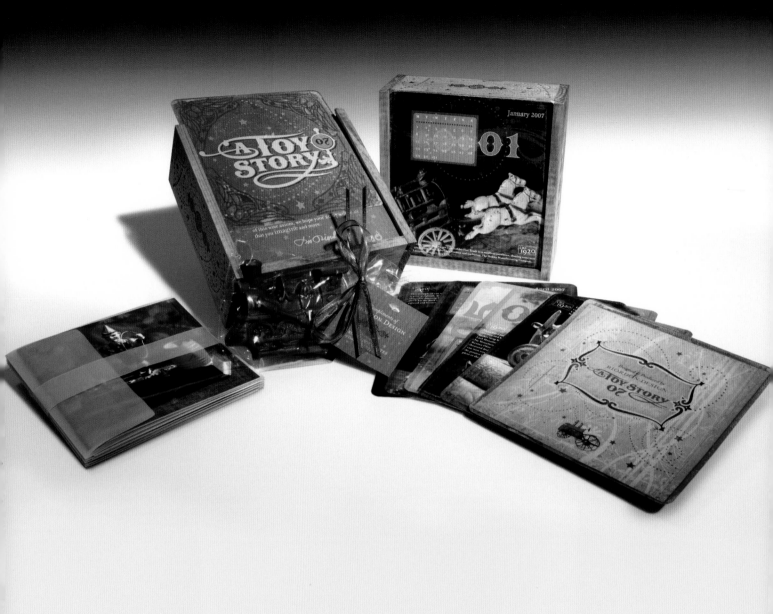

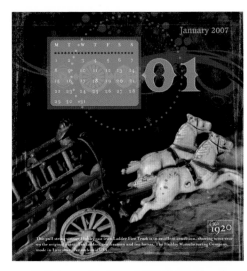

January 2007

01

This pull strong vintage Hubley cast iron Ladder Fire Truck is in excellent condition, showing some wear on the original paint. Two ladders, two firemen and two horses. The Hubley Manufacturing Company, made in Lancaster, Pennsylvania USA.

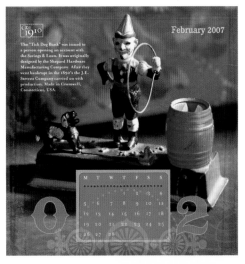

February 2007

The "Tick Dog Bank" was issued to a person opening an account with the Savings & Loan. It was originally designed by the Shepard Hardware Manufacturing Company. After they went bankrupt in the 1890's the J.E. Stevens Company carried on with production. Made in Cromwell, Connecticut, USA.

02

March 2007

This tin boat was among the first manufactured to use a "friction motor", otherwise known as a "hill climber". Designed by Edith & Israel Boyer and made by D.P. Clark Manufacturing, Dayton, Ohio USA.

03

April 2007

This example of cast iron from Hubley, is pure storybook. At the feet of this whimsical doorstop is a little worm, which has the duck's attention - hand painted and featuring the original paint.

04

May 2007

05

This hand carved wooden toy is in perfect condition with real horse hair for the mane and the tail and featuring a miniature leather harness with exacting details. It's origins are uncertain, but it looks like from Mennonite Waterloo County.

June 2007

06

These hand painted "Nodders" are cast iron and hand painted with a leather strap harness. The Kenton Lock Manufacturing Company, of Kenton Ohio, created close to ten thousand designs of hand painted cast iron toys and was, at one time, the greatest iron toy manufacturing plant in the world.

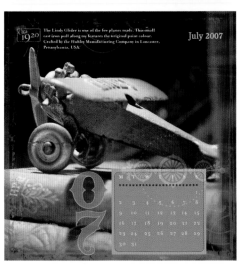

July 2007

The Lindy Glider is one of the few planes made. This small cast iron pull along toy features the original paint colour. Crafted by the Hubley Manufacturing Company in Lancaster, Pennsylvania, USA.

07

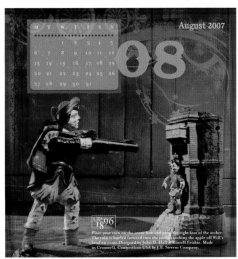

August 2007

08

Place your coins on the arrow, bow and press the right foot of the archer. The coin is hurled forward into the slot, taking the apple off Will's head en route. Designed by John D. Hall & Russell Frisbie. Made in Cromwell, Connecticut USA by J.E. Stevens Company.

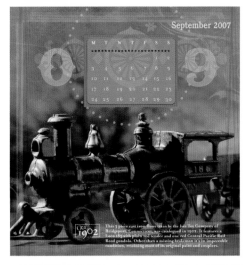

September 2007

09

This 5 piece cast iron floor train by the Ives Toy Company of Bridgeport, Connecticut, was catalogued in 1902. It features a Loco 185 with plain red tender and one red Central Pacific Rail Road gondola. Other than a missing brakeman it is in impeccable condition, retaining most of its original paint and couplers.

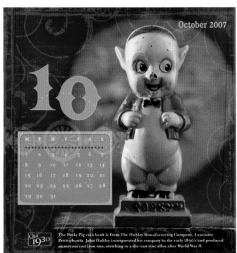

October 2007

10

The Porky Pig coin bank is from The Hubley Manufacturing Company, Lancaster Pennsylvania. John Hubley incorporated his company in the early 1890's and produced numerous cast iron toys, switching to a die-cast zinc alloy after World War II.

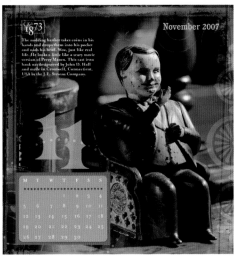

November 2007

The nodding banker takes coins in his hands and drops them into his pocket and nods his head. Wow, just like real life. He looks a little like a scary movie version of Perry Mason. This cast iron bank was designed by John D. Hall and made in Cromwell, Connecticut, USA by the J.E. Stevens Company.

11

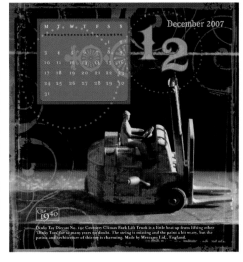

December 2007

12

Dinky Toy Diecast No. 14c Coventry Climax Fork Lift Truck is a little beat up from lifting other Dinky Toys for so many years no doubt. The string is missing and the paint is wary, but the patina and architecture of this toy is charming. Made by Meccano Ltd., England.

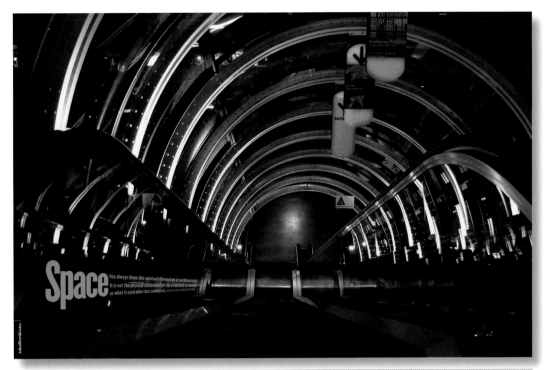

Space has always been the spiritual dimension of architecture. It is not the physical statement of the structure so much as what it contains that moves us. ARTHUR ERICKSON

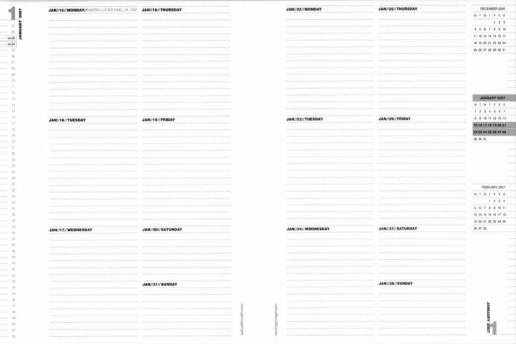

				DECEMBER 2006
JAN//15//MONDAY//MARTIN LUTHER KING, JR. DAY	JAN//18//THURSDAY	JAN//22//MONDAY	JAN//25//THURSDAY	M T W T F S S
				1 2 3
				4 5 6 7 8 9 10
				11 12 13 14 15 16 17
				18 19 20 21 22 23 24
				25 26 27 28 29 30 31

JANUARY 2007
M T W T F S S
1 2 3 4 5 6 7
8 9 10 11 12 13 14
15 16 17 18 19 20 21
22 23 24 25 26 27 28
29 30 31

JAN//16//TUESDAY	JAN//19//FRIDAY	JAN//23//TUESDAY	JAN//26//FRIDAY

FEBRUARY 2007
M T W T F S S
1 2 3 4
5 6 7 8 9 10 11
12 13 14 15 16 17 18
19 20 21 22 23 24 25
26 27 28

JAN//17//WEDNESDAY	JAN//20//SATURDAY	JAN//24//WEDNESDAY	JAN//27//SATURDAY
	JAN//21//SUNDAY		JAN//28//SUNDAY

JANUARY 2007

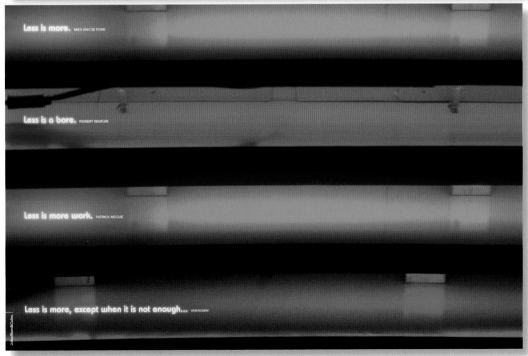

Less is more. MIES VAN DE ROHE

Less is a bore. ROBERT VENTURI

Less is more work. PATRICK MCGUE

Less is more, except when it is not enough... UNKNOWN

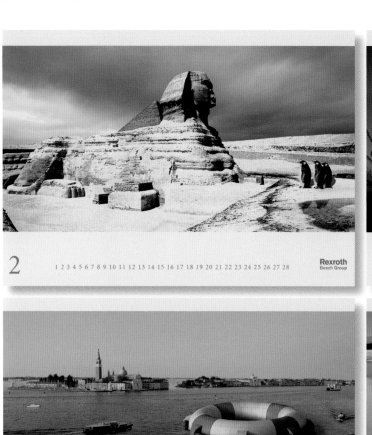

2 1 2 3 4 5 6 7 8 9 10 11 12 13 14 15 16 17 18 19 20 21 22 23 24 25 26 27 28 **Rexroth** Bosch Group

3 1 2 3 4 5 6 7 8 9 10 11 12 13 14 15 16 17 18 19 20 21 22 23 24 25 26 27 28 29 30 31 **Rexroth** Bosch Group

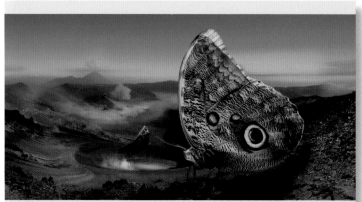

5 1 2 3 4 5 6 7 8 9 10 11 12 13 14 15 16 17 18 19 20 21 22 23 24 25 26 27 28 29 30 31 **Rexroth** Bosch Group

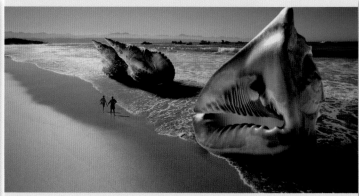

7 1 2 3 4 5 6 7 8 9 10 11 12 13 14 15 16 17 18 19 20 21 22 23 24 25 26 27 28 29 30 31 **Rexroth** Bosch Group

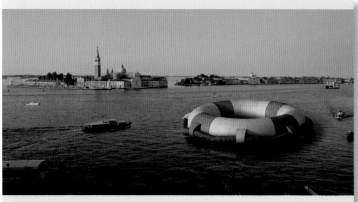

9 1 2 3 4 5 6 7 8 9 10 11 12 13 14 15 16 17 18 19 20 21 22 23 24 25 26 27 28 29 30 **Rexroth** Bosch Group

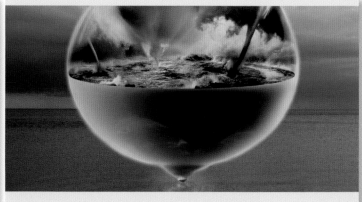

10 1 2 3 4 5 6 7 8 9 10 11 12 13 14 15 16 17 18 19 20 21 22 23 24 25 26 27 28 29 30 31 **Rexroth** Bosch Group

11 1 2 3 4 5 6 7 8 9 10 11 12 13 14 15 16 17 18 19 20 21 22 23 24 25 26 27 28 29 30 **Rexroth** Bosch Group

12 1 2 3 4 5 6 7 8 9 10 11 12 13 14 15 16 17 18 19 20 21 22 23 24 25 26 27 28 29 30 31 **Rexroth** Bosch Group

barnhart **rayGUNS** calendar

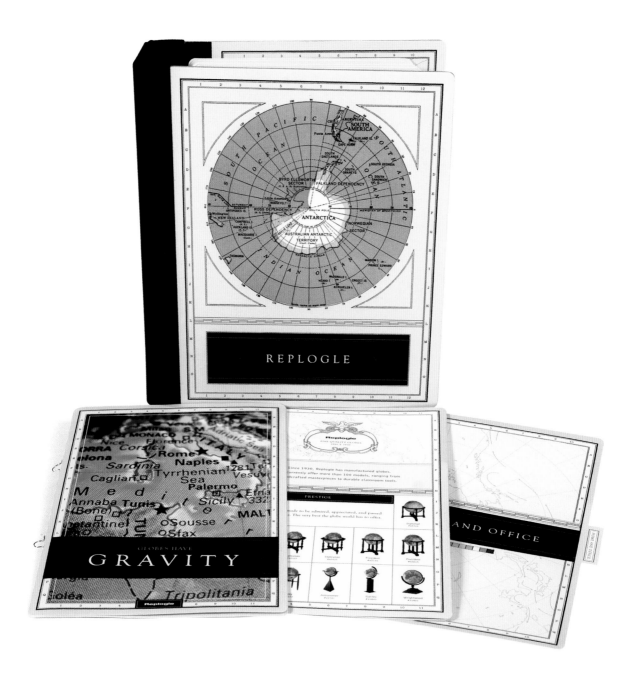

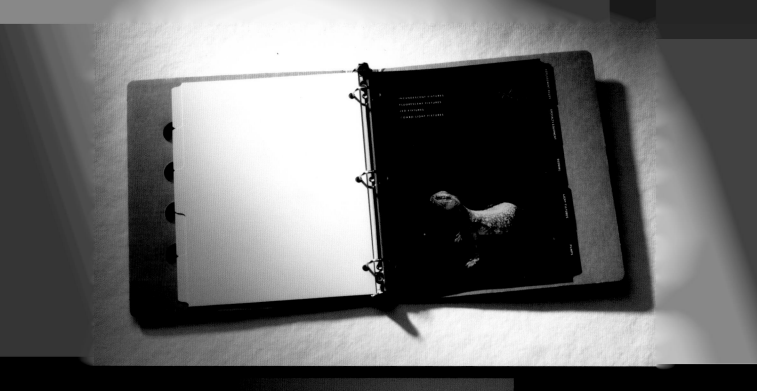

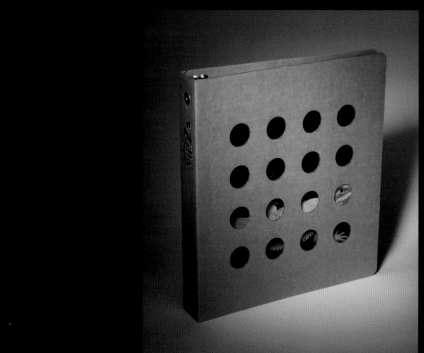

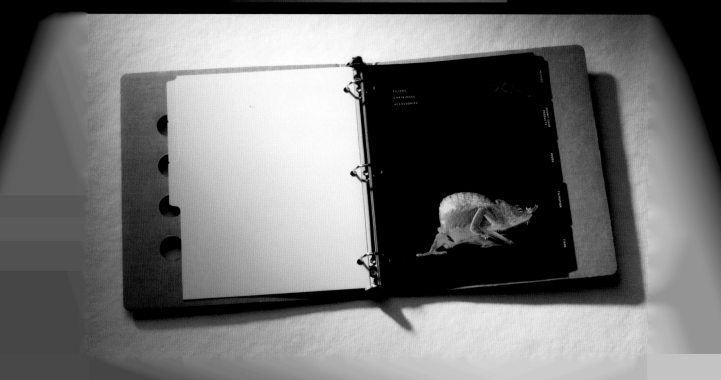

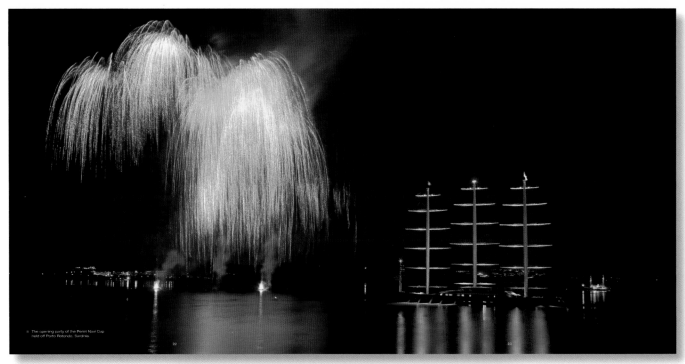

The opening party of the Perini Navi Cup held off Porto Rotondo, Sardinia.

22

23

EDMISTON

59m SENSES see page 90. Off the Andaman Islands where elephants go snorkelling...

44

45

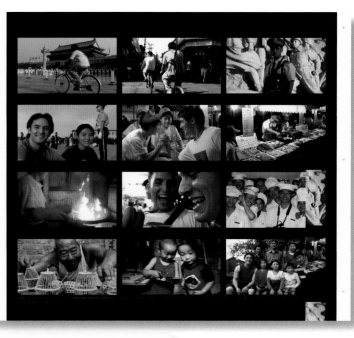

● Art Center College of Design

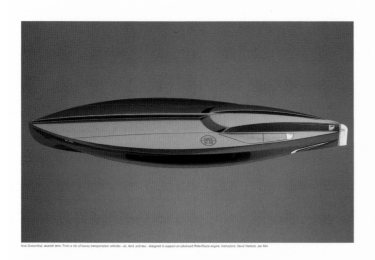

Nick Gronenthal, seventh term. From a trio of luxury transportation vehicles—air, land, and sea—designed to support an advanced Rolls-Royce engine. Instructors: David Hackett, Jae Min

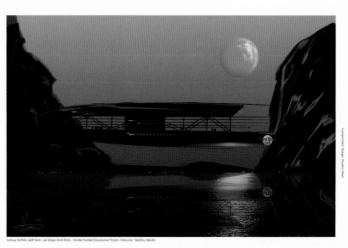

Joshua Hoffeld, sixth term. Las Vegas Hard Rock—Honda Funded Educational Project. Instructor: Geoffrey Wardle

Transportation Design Student Work

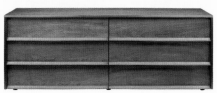

DRIFT

Like the subtle ridges of a snowdrift, the bent ply drawers and doors of the Drift series create a soothing topography. A smooth, seamless look for credenzas, dressers and nightstands. Store undies in the bedroom, watch a flat screen in the living room, or serve dinner in the dining room. Available in cherry or walnut.

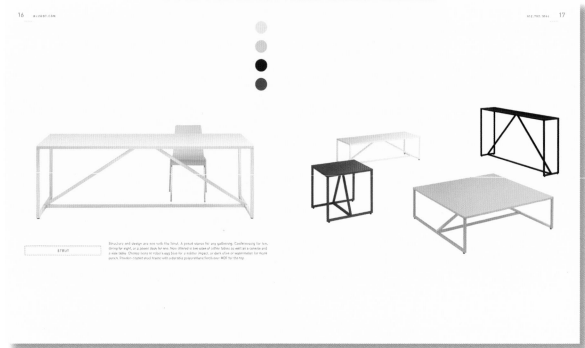

STRUT

Structure and design are one with the Strut. A proud stance for any gathering. Conferencing for ten, dining for eight, or a power desk for one. Now offered in two sizes of coffee tables as well as a console and a side table. Choose ivory or robin's egg blue for a subtler impact, or dark olive or watermelon for more punch. Powder-coated steel frame with a durable polyurethane finish over MDF for the top.

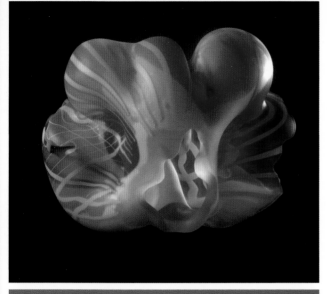

Marvin Lipofsky, *Australian Landscape 2004 #8*, 2004. Founder of CCAC Glass Program. Chair 1967–1987.

\\FOREWARD
Marvin Lipofsky
Founder of the Glass Program at CCAC

It's hard to imagine that 40 years has past since Trude Guermonprez invited me to hold the first glass workshop at the California College of Arts and Crafts for the summer of 1967. Alan Miesel wrote enthusiastically about the workshop in *Craft Horizons* that year:

*Some 18 adventuresome and highly motivated people participated in what turned out to be an extremely successful three-week glass workshop (June 19–July 7), held at the California College of Arts and Crafts in Oakland and co-sponsored by the American Craft Council. Led by Marvin Lipofsky, the dynamic assistant professor at the University of California, Berkeley, who had introduced glassblowing to that institution as part of the design curriculum, the members of the workshop immediately set out to build a furnace and annealing oven. Lipofsky drew, from what soon became a remarkably enthusiastic and cohesive group, the knowledge, manual skills and experience which could be pooled in the designing and fabrication of the equipment and tools needed to start producing glass. Standards of quality were set even before the gas was turned on. Slides and films introduced and reinforced the glassblower's vocabulary of words and forms and opened up some of the possibilities of the medium. Initial discussions dislodged information and opinions about furnace structure, plumbing, electrical connections and lists of parts needed.**

These early days of the glass workshop eventually grew into a full program and an exciting international movement. The following year, along with UC Berkeley, we established the Great California Glass Symposium (1968–1986). This event hosted 107 guest artists from 13 countries who came to share their skills and passions with students and other participants. From these early efforts, the program has had an international influence and the Studio Glass Movement has been able to take root worldwide as an art form.

It was exciting to be part of the first 20 years of the glass program at CCAC at a time when artistic exploration was reaching new heights. Boundaries were being pushed in lifestyles, politics, music and the arts. It was a stimulating time for the students and for those who were teaching, as the use of glass became part of the media.

Now, 40 years after the initial 1967 workshop, I take great pride in having established the department and appreciate those students who took part in the "wonderful world of glass."

It's been a great run.

Marvin Lipofsky
October 30, 2006

**Craft Horizons, September/October 1967*

Timeline chart (1967–2007) listing names:

MELODIE BEYLIK · LYNNE-RACHEL ALTMAN · ELIN CHRISTOPHERSON · NICOLE CHESNEY · BELLA FELDMAN · MICHAEL FOX · LANCE FRIEDMAN · KRISTIN GUDJONSDOTTIN · ELODIE HOLMES · DUNCAN HOUSE · KATRINA HUDE · WILEY JACKSON · COREY JONES · MICHELLE KNOX · LAWRENCE LABIANCA · MARVIN LIPOFSKY · JOHN LEIGHTON · ANDREW MAGDANZ · STEVEN MASLACH · MARK MCDONNELL · MICHIKO MIYAKE · BENJAMIN MOORE · ANN MORHAUSER · JAY MUSLER · MICHAEL NOUROT · BRUCE PIZZICHILLO · CHARLES PARRIOTT · JEREMY POPELKA · CLIFFORD RAINEY · DAVID RUTH · SUSAN SHAPIRO · WILLIAM SISTEK · MICHAEL SOSIN · RUTH TAMURA · PAMINA TRAYLOR · MARY WHITE · HIROSHI YAMANO · 2007

In his own work in the California Loop Series of the 1960s, Marvin Lipofsky emphasized form and volume over the dazzling materiality and surface beauty of glass. By flocking his free form and abstract designs, he forced viewers to examine the shape of his work and to abandon their preconceived notions about the functional and decorative history of glass. Like his contemporaries Peter Voulkos and Robert Arneson in the field of ceramics, Lipofsky expanded the boundaries of sculpture by exploiting new practices in an ancient medium, which led to new forms and a dramatic increase in the scale of his work. By the time he left CCAC in 1987, he had also expanded the number of artists working in glass by launching hundreds of students into a field that hadn't even existed twenty years earlier. Lipofsky students Mary White (BFA 1970, MFA 1982), Lance Friedman (BFA 1975), Charles Parriott (BFA 1976), Melodie Beylik (BFA 1983), David Ruth (MFA 1987), and Michiko Miyake (BFA 1988), have all contributed to the sculptural traditions of glass with their artwork. The fourteen-foot cast glass representation of a boat created by Steven Maslach (CCAC 1968–70) in 2006 for the Kitsap County Public Administration Building in Port Orchard, Washington, is a powerful expression of the traditions that Lipofsky set in motion in 1967.

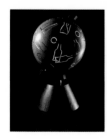
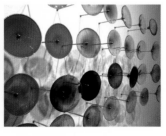

"I AM DRAWN TO FORMS
THAT EXIST AS A RESULT OF PURPOSE.
THE HUMAN BODY, THE VESSEL AND THE
BOAT TAKE SHAPE FROM THE RESULT
OF USE, OF EFFICIENCY, AND OF GRACE.
I INVOLVE MYSELF, AS AN ARTIST, WITH
THE REPRESENTATION AND EVOLUTION
OF THESE FORMS."

STEVEN MASLACH, ATTENDED CCAC 1968–1970

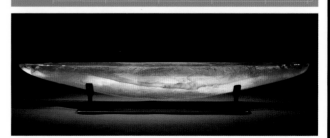

(OPPOSITE PAGE, LEFT) Michiko Miyake, *Alea Globe*, 1998. CCAC BFA 1998. (OPPOSITE PAGE, RIGHT) Melodie Beylik, *Calendar*, 2006. CCAC BFA 1983. (THIS PAGE, TOP) Lynne-Rachel Altman, *Chrysalis*, 2003. CCAC MFA 1994. (THIS PAGE, BOTTOM) Steven Maslach, *Red Long Boat*, 2006. Attended CCAC 1968–70.

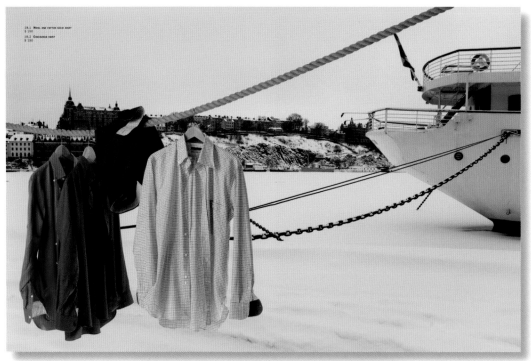

19.1 Wool and cotton solid shirt
$ 190
19.2 Checkered shirt
$ 190

DAVIDE CENCI

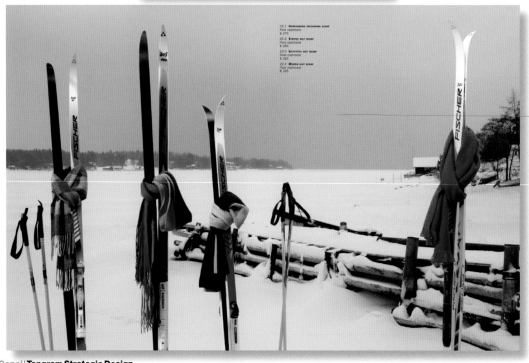

22.1 Herringbone herringbone scarf
Pure cashmere
$ 275
22.2 Striped knit scarf
Pure cashmere
$ 250
22.3 Butterfly knit scarf
Pure cashmere
$ 325
22.4 Mohair knit scarf
Pure cashmere
$ 325

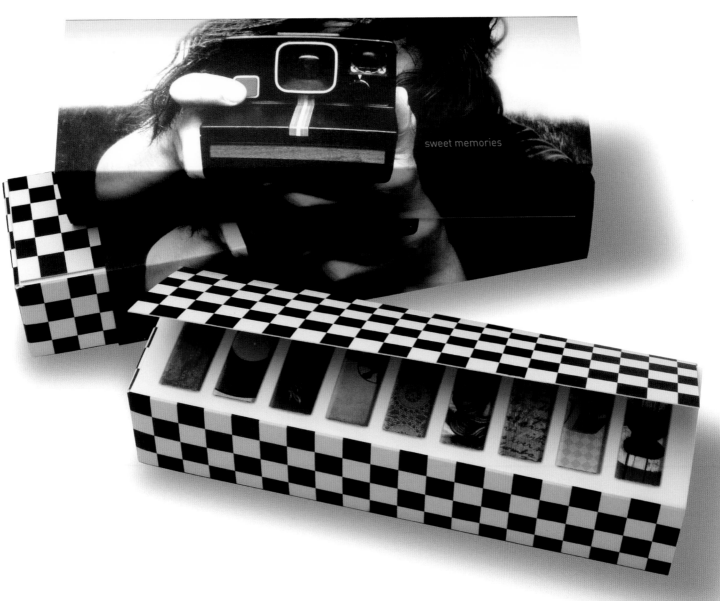

sweet memories

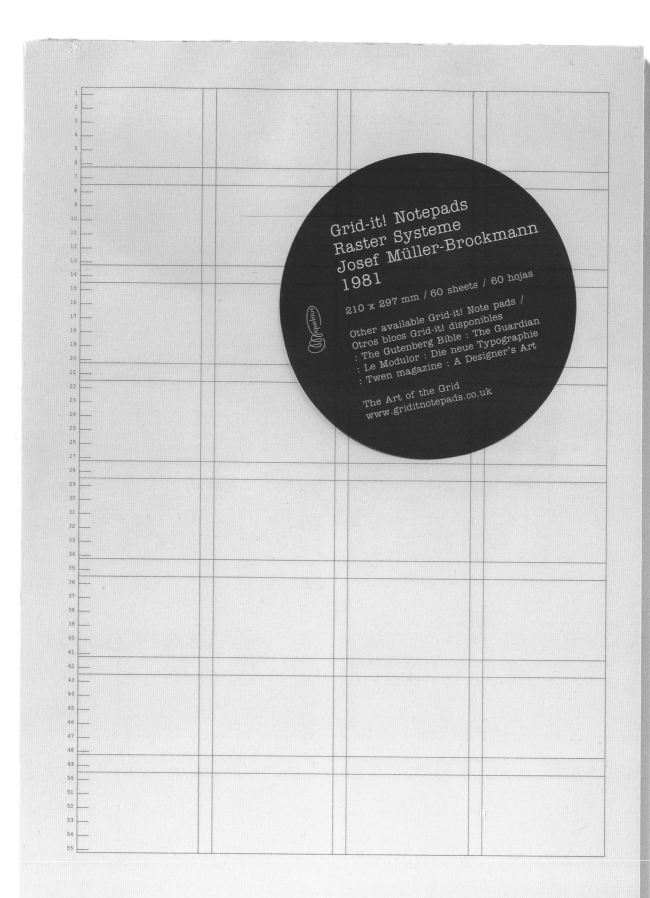

Grid-it! Notepads
Raster Systeme
Josef Müller-Brockmann
1981

210 x 297 mm / 60 sheets / 60 hojas

Other available Grid-it! Note pads /
Otros blocs Grid-it! disponibles
: The Gutenberg Bible : The Guardian
: Le Modulor : Die neue Typographie
: Twen magazine : A Designer's Art

The Art of the Grid
www.griditnotepads.co.uk

Raster Systeme, Josef Müller-Brockmann, 1981, 210x297mm

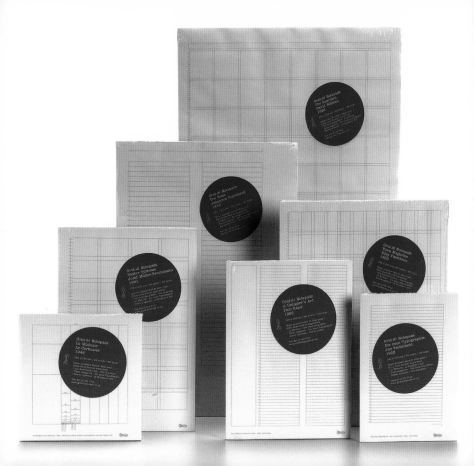

Grid-it! Notepads
The Guardian
David Hillman
1988

170 x 170 mm / 80 sheets / 90 gram

Grid systems in graphic design
Clear sense of order & proportion
Precise mathematical grid
Reproduce in any media
Text is where it is

The Art of the Grid
www.gridsystem.co.uk

Grid-it! Notepads
The Bible
Johannes Gutenberg
1455

170 x 170 mm / 80 sheets / 90 gram

Grid systems in graphic design
Clear sense of order & proportion
Precise mathematical grid
Reproduce in any media
Text is where it is

The Art of the Grid
www.gridsystem.co.uk

Grid-it! Notepads
Neue Typographie
Willy Fleckhaus
1955

148 x 210 mm / 80 sheets / 90 gram

Grid systems in graphic design
Clear sense of order & proportion
Precise mathematical grid
Reproduce in any media
Text is where it is

The Art of the Grid
www.gridsystem.co.uk

Grid-it! Notepads
Raster Systeme
Josef Müller-Brockmann
1961

170 x 240 mm / 80 sheets / 90 gram

Grid systems in graphic design
Clear sense of order & proportion
Precise mathematical grid
Reproduce in any media
Text is where it is

The Art of the Grid
www.gridsystem.co.uk

Grid-it! Notepads
A Designer's Art
Paul Rand
1985

148 x 210 mm / 80 sheets / 90 gram

Wider sense is one of them
Precise mathematical grid
Reproduce in any media
Text is where it is

The Art of the Grid
www.gridsystem.co.uk

Grid-it! Notepads
Le Modulor
Le Corbusier
1948

148 x 148 mm / 80 sheets / 90 gram

Grid systems in graphic design
Clear sense of order & proportion
Precise mathematical grid
Reproduce in any media
Text is where it is

The Art of the Grid
www.gridsystem.co.uk

Grid-it! Notepads
Die Neue Typographie
Jan Tschichold
1928

148 x 210 mm / 80 sheets / 90 gram

Grid systems in graphic design
Clear sense of order & proportion
Precise mathematical grid
Reproduce in any media
Text is where it is

The Art of the Grid
www.gridsystem.co.uk

DREAMING OF MARRAKECH

DESIGNED BY INARIA
INARIA-DESIGN.COM

CUT-IN LASERCRAFT
PAPER BY GSM Th

Changing the "numbers" culture

An overdependence on "numbers" creates an enormous and incongruous disconnect. People, not numbers, make the financial difference to companies. Jeanne Di Francisco of ProOrbis puts it this way: "The company's human capital is a business asset that is the sum total of the skills, knowledge, talent, and enthusiasm that people invest in the work of an organization." Former Secretary of Labor Robert Reich uses the term "relational capital," those relationships employees have with customers and related associates. Retaining this kind of capital must be at the heart of all corporate measurements. People and their ingenuity, creativity, skills, and commitment keep a company moving and business profitable. "They have in their hands the oil that lubricates the work processes, but you don't get what is in there unless they want to give it to you," says Dr. Sandra Burud of Claremont College. These minds and the people that go with them determine success in the Information Age and the Knowledge Economy. Henry Ford once complained, "I keep hiring workers and I keep getting people." That description of angst from the manufacturing era is a far cry from the definition Dan Phelan at GlaxoSmithKline uses today to express how important people are to business. Echoing Max De Pree's conclusion in his classic on leadership and management, Leadership Is an Art, Phelan says, "Employees are volunteers and we have to convince them every day that this is the best place for them to work."

Clarity precedes balance

Being clear about personal priorities and making those priorities clear to teams and managers lays a foundation for successfully managing the demands that life and work create for us each day. Gretchen Addi of IDEO says, "My team knows that I have a 'hard stop' at five o'clock. I'm out the door. It helps us focus but whether we are done or not, I leave." Making the personal adjustments to refuse to feel guilty about putting your foot down when it comes to time is an acquired skill, she explains. But it is essential in managing the multi-generational, fast-moving demands of family life today.

Corporate leaders who genuinely understand the central part our families play in our lives are not only inspiring, they are successful. Rich Sheridan, is founder of Menlo Innovations, a software firm in Ann Arbor, Michigan, limits employees to a 40-hour work week. "We think having a life outside work actually makes people more creative and productive." Eileen Fisher, a top-selling fashion designer and CEO, says, "We ask about balance in reviews. It is part of Wellness for us. We ask, are you taking care of yourself? How? I'm thinking about forbidding work on weekends and nights after 8 p.m. Often you don't do a better job if you are always working or tired."

"I ask people to keep their leaders informed and have leaders be aware if someone in the group is working too much on a project. Sometimes we have to say, 'O.K., you have to take next Friday off.' People must know that they are supported in having private time. Wellness really is an all-important part of our message. I take personal responsibility for making that balance. A whole person has to feel that they do more than good work."

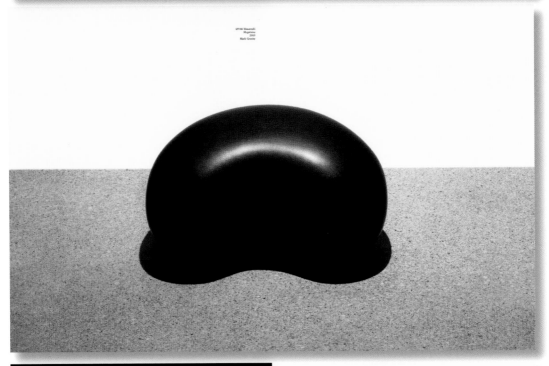

IZUMI Masatoshi
Mugaiso
2003
Black Granite

20%

Only 20 percent of today's workforce belongs to the traditional family of dad at work and mom at home to manage children and family responsibilities.

60%

60 percent of women with children younger than six are employed.

86%

86 percent of workers say that work fulfillment and balance is a top priority.

330

330 Boomers will turn 60 each day for the next 18 years, creating huge knowledge gaps in critical areas from engineering to teaching and medicine.

70-82

Over the past 25 years, the average combined weekly work hours of all couples has increased from 70 to 82 hours.

42%

42 percent of workers are not satisfied with the work/life balance programs offered at work.

25%

25 percent of Ernst & Young's "experienced" new recruits are former employees returning after an absence.

UEMATSU Eiji
Air Under the Tree
(2005)
Clayworks No. 25

PASTFUTURE

OLD NEW

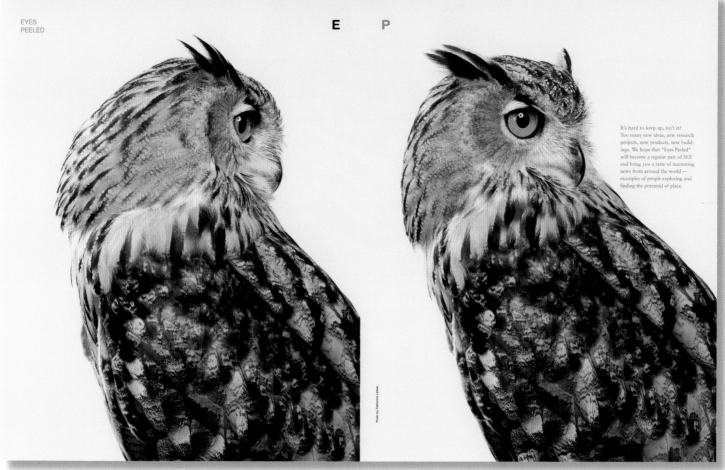

EYES
PEELED

E P

It's hard to keep up, isn't it?
Too many new ideas, new research
projects, new products, new build-
ings. We hope that "Eyes Peeled"
will become a regular part of *SEE*
and bring you a taste of interesting
news from around the world—
examples of people exploring and
finding the potential of place.

Photo by Catherine Ledner

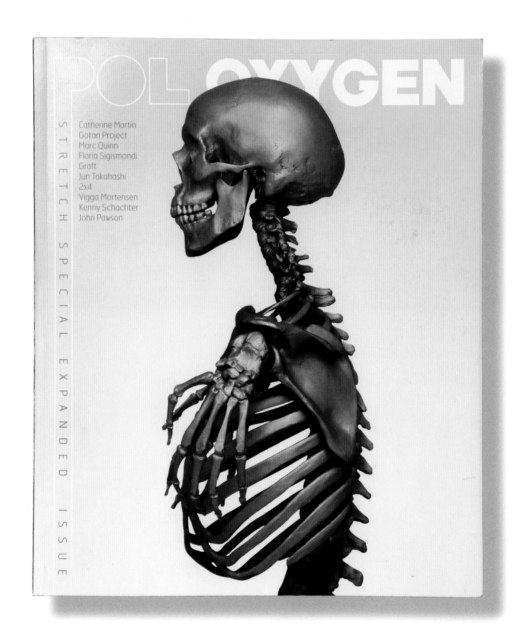

POL OXYGEN

Catherine Martin
Gotan Project
Marc Quinn
Floria Sigismondi
Graft
Jun Takahashi
2x4
Viggo Mortensen
Kenny Schachter
John Pawson

STRETCH SPECIAL EXPANDED ISSUE

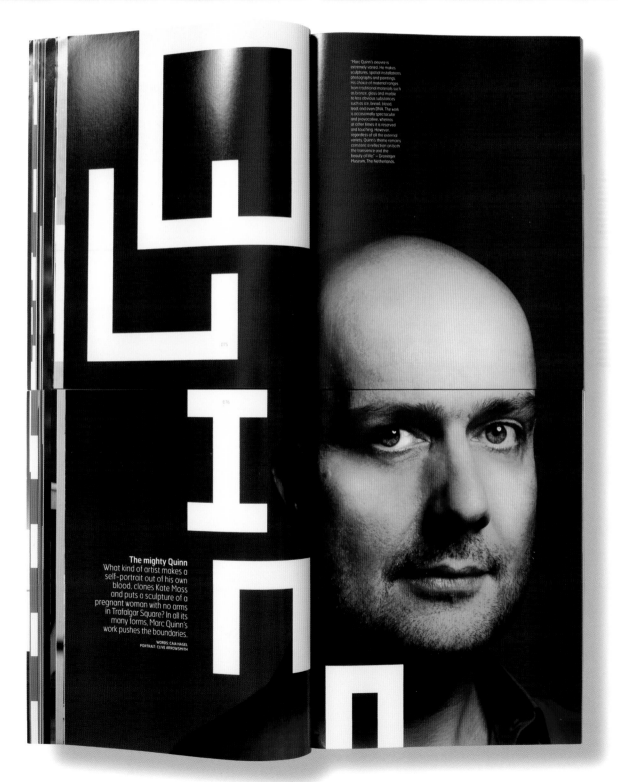

The mighty Quinn
What kind of artist makes a self-portrait out of his own blood, clones Kate Moss and puts a sculpture of a pregnant woman with no arms in Trafalgar Square? In all its many forms, Marc Quinn's work pushes the boundaries.

WORDS: CAIA HAGEL.
PORTRAIT: CLIVE ARROWSMITH

"Marc Quinn's oeuvre is extremely varied. He makes sculptures, spatial installations, photographs and paintings. His choice of material ranges from traditional materials such as bronze, glass and marble to less obvious substances such as ice, bread, blood, lead, and even DNA. The work is occasionally spectacular and provocative, whereas at other times it is reserved and touching. However, regardless of all the external variety, Quinn's theme remains constant: a reflection on both the transience and the beauty of life." — Groninger Museum, The Netherlands.

obsession n 4. an irrational motive
for performing repetitive actions
against one's will

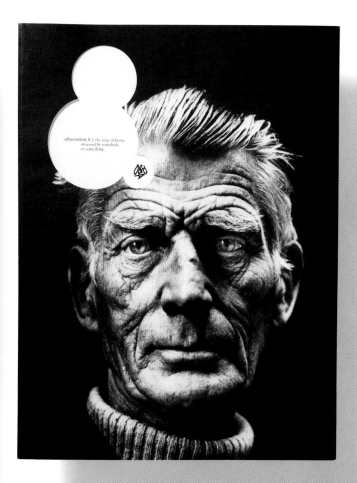

obsession n 2. the state of being
obsessed by somebody
or something

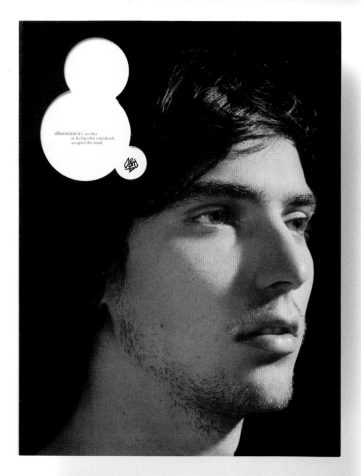

obsession n 1. an idea
or feeling that completely
occupies the mind

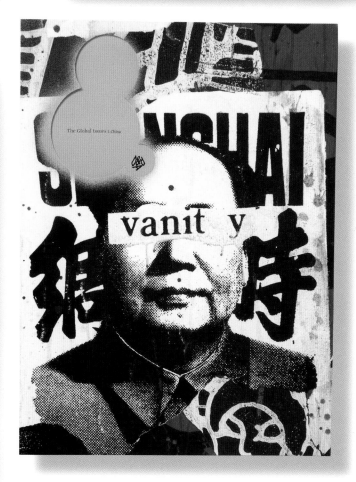

The Global Issues 1: China

vanit y

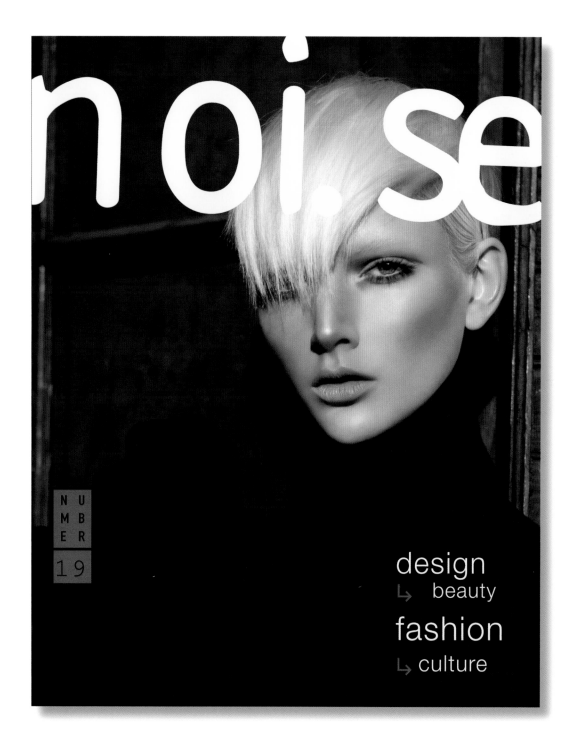

Issue 014

Issue 013

AND NOW, 972
WORDS FROM ROBERT

DENIRO

BY CHRIS HEATH
PHOTOGRAPH BY DAVID BAILEY

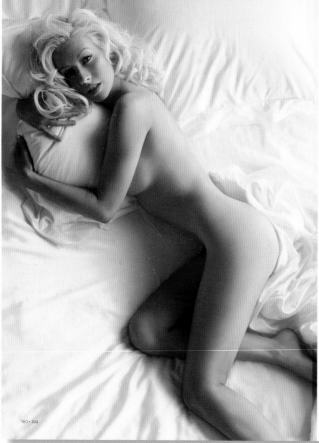

QUEEN CHRISTINA

IN A POP LANDSCAPE LITTERED WITH MACHINE-MADE POSEURS, CRAZY-PIPED **Christina Aguilera** IS THE REAL DEAL. BUT WILL MARRIED LIFE AND A STIRRING NEW ALBUM SOFTEN HER GLORIOUSLY RAUNCHY IMAGE? · BY **Chris Norris** · PHOTOGRAPHS BY **Michael Thompson**

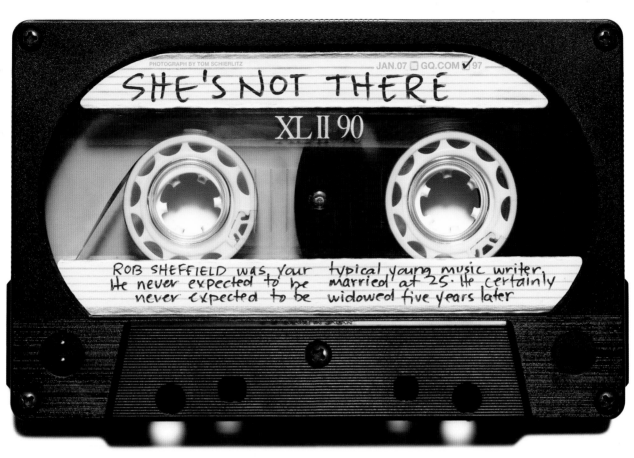

JAN.07 ☐ GQ.COM ✓ 97

SHE'S NOT THERE

XL II 90

ROB SHEFFIELD was your typical young music writer.
He never expected to be married at 25. He certainly
never expected to be widowed five years later

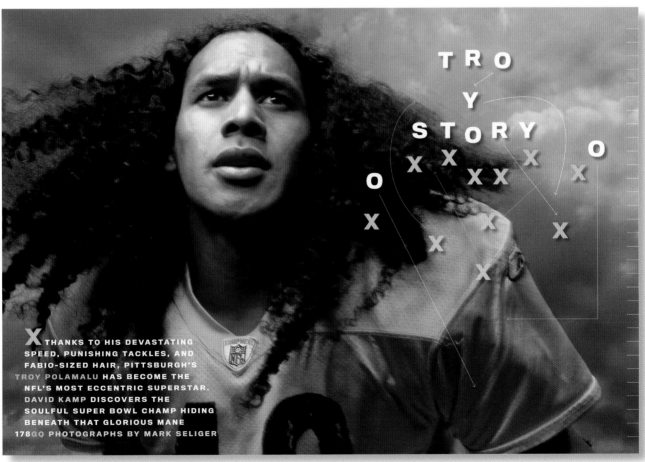

T R O
Y
S T O R Y
O
O
X X X X
X X X
X

X THANKS TO HIS DEVASTATING
SPEED, PUNISHING TACKLES, AND
FABIO-SIZED HAIR, PITTSBURGH'S
TROY POLAMALU HAS BECOME THE
NFL'S MOST ECCENTRIC SUPERSTAR.
DAVID KAMP DISCOVERS THE
SOULFUL SUPER BOWL CHAMP HIDING
BENEATH THAT GLORIOUS MANE
178GQ PHOTOGRAPHS BY MARK SELIGER

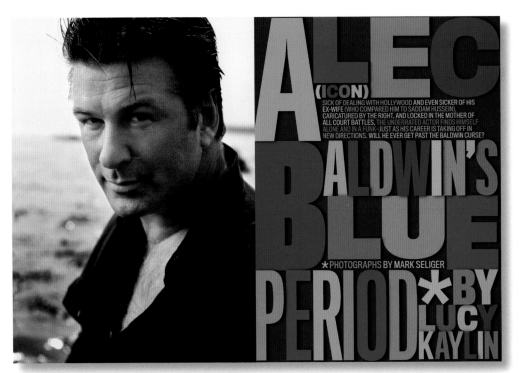

ALEC

(ICON)

SICK OF DEALING WITH HOLLYWOOD AND EVEN SICKER OF HIS EX-WIFE (WHO COMPARED HIM TO SADDAM HUSSEIN), CARICATURED BY THE RIGHT, AND LOCKED IN THE MOTHER OF ALL COURT BATTLES, THE UNDERRATED ACTOR FINDS HIMSELF ALONE AND IN A FUNK—JUST AS HIS CAREER IS TAKING OFF IN NEW DIRECTIONS. WILL HE EVER GET PAST THE BALDWIN CURSE?

BALDWIN'S
BLUE

*PHOTOGRAPHS BY MARK SELIGER

PERIOD*BY LUCY KAYLIN

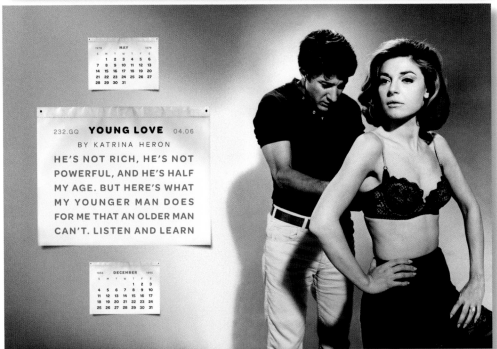

232.GQ **YOUNG LOVE** 04.06

BY KATRINA HERON

HE'S NOT RICH, HE'S NOT POWERFUL, AND HE'S HALF MY AGE. BUT HERE'S WHAT MY YOUNGER MAN DOES FOR ME THAT AN OLDER MAN CAN'T. LISTEN AND LEARN

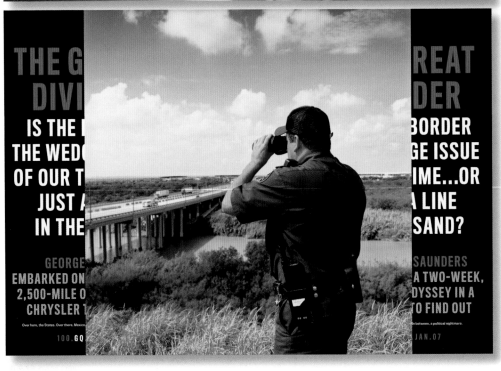

THE GREAT
DIVIDER

IS THE [] BORDER
THE WEDGE ISSUE
OF OUR TIME...OR
JUST A A LINE
IN THE SAND?

GEORGE SAUNDERS
EMBARKED ON A TWO-WEEK,
2,500-MILE ODYSSEY IN A
CHRYSLER 1 TO FIND OUT

Over here, the States. Over there, Mexico. in between, a political nightmare.

100.GQ JAN.07

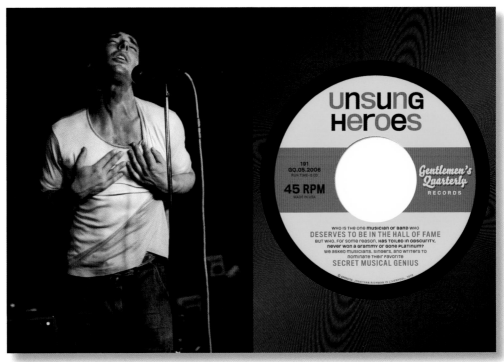

unsung Heroes

191
GQ.05.2006
RUN TIME-6:00

45 RPM
MADE IN USA

Gentlemen's Quarterly RECORDS

WHO IS THE one **musician or band** WHO
DESERVES TO BE IN THE HALL OF FAME
BUT WHO, FOR SOME REASON, HAS TOILED IN OBSCURITY,
NEVER WON A GRAMMY OR GONE PLATINUM?
WE ASKED MUSICIANS, SINGERS, AND WRITERS TO
NOMINATE THEIR FAVORITE
SECRET MUSICAL GENIUS

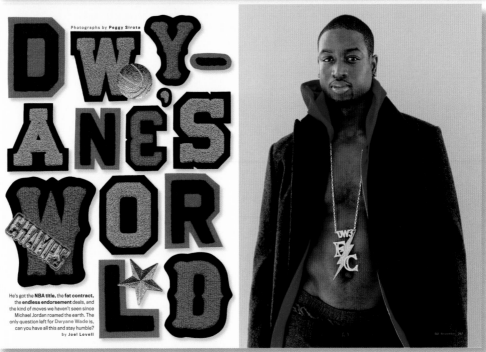

Photographs by **Peggy Sirota**

DWY-ANE'S WORLD

CHAMPS

He's got the **NBA title,** the **fat contract,** the **endless endorsement** deals, and the kind of moves we haven't seen since Michael Jordan roamed the earth. The only question left for **Dwyane Wade** is, can you have all this and stay humble?
by **Joel Lovell**

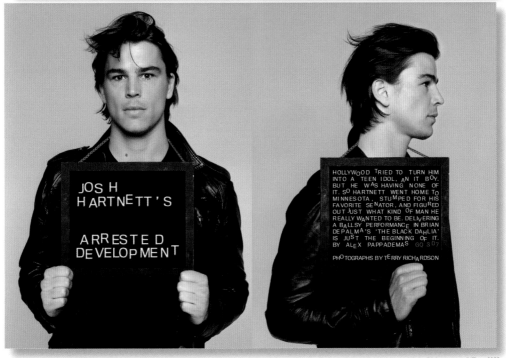

JOSH HARTNETT'S

ARRESTED DEVELOPMENT

HOLLYWOOD TRIED TO TURN HIM INTO A TEEN IDOL, AN IT BOY. BUT HE WAS HAVING NONE OF IT. SO HARTNETT WENT HOME TO MINNESOTA, STUMPED FOR HIS FAVORITE SENATOR, AND FIGURED OUT JUST WHAT KIND OF MAN HE REALLY WANTED TO BE. DELIVERING A BALLSY PERFORMANCE IN BRIAN DE PALMA'S "THE BLACK DAHLIA" IS JUST THE BEGINNING OF IT. BY ALEX PAPPADEMAS GQ 3.07

PHOTOGRAPHS BY TERRY RICHARDSON

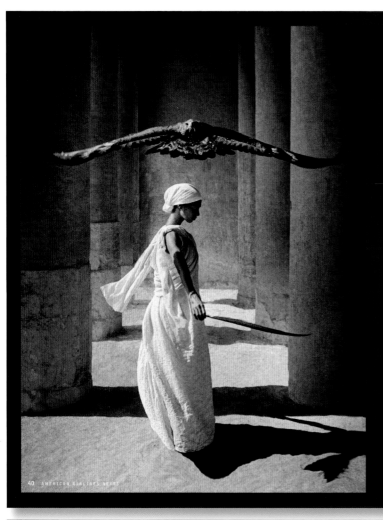

Cenizas y Nieve

Ashes and Snow (Cenizas y Nieve) es un proyecto perpetuo del fotógrafo canadiense Gregory Colbert que durante catorce años ha viajado por el mundo captando extraordinarios encuentros entre el hombre y las bestias.

Colbert asegura que las imágenes, aunque preparadas, son auténticas y ninguna es el resultado de un montaje fotográfico.

Escrito por Ana Cristina Reymundo

Escrito por Keyla Medina-Rosa

María Celeste,
en busca de nuevos retos

A pesar de estar ocupadísima con su exitoso programa "Al Rojo Vivo", la periodista y presentadora puertorriqueña María Celeste Arrarás acepta nuevos retos sin pensárselo dos veces. No es, ni mucho menos, por aburrimiento sino porque siente la imperiosa necesidad de diversificarse profesional y artísticamente.

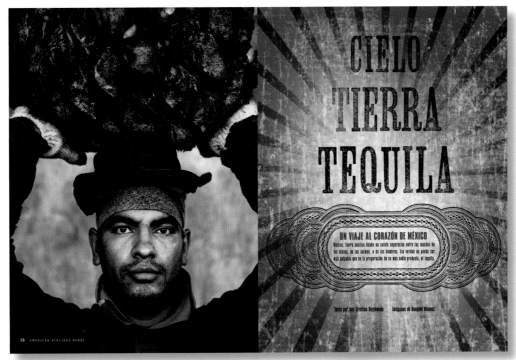

CIELO
TIERRA
TEQUILA

UN VIAJE AL CORAZÓN DE MÉXICO

México, tierra mística donde no existe separación entre los mundos de los dioses, de los animos, o de los hombres. Esa verdad no puede ser más palpable que en la preparación de su más noble producto, el tequila.

Texto por Ana Cristina Reymundo Imágenes de Douglas Menuez

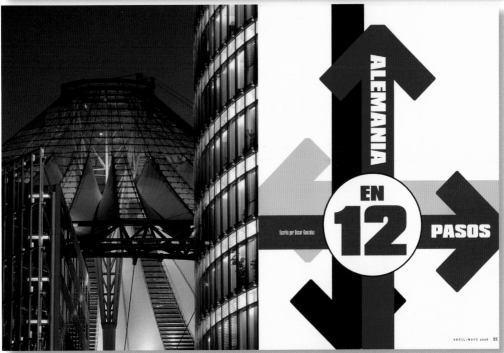

Escrito por Oscar González

ALEMANIA
EN
12
PASOS

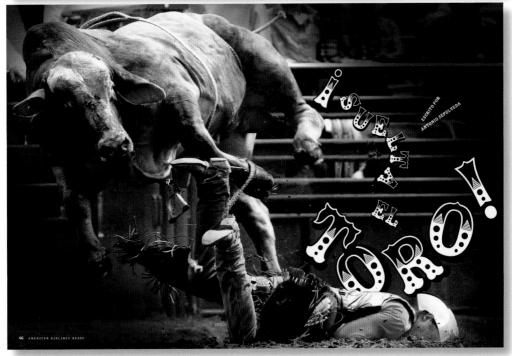

¡SUELTA EL TORO!

Escrito por Antonio Sepúlveda

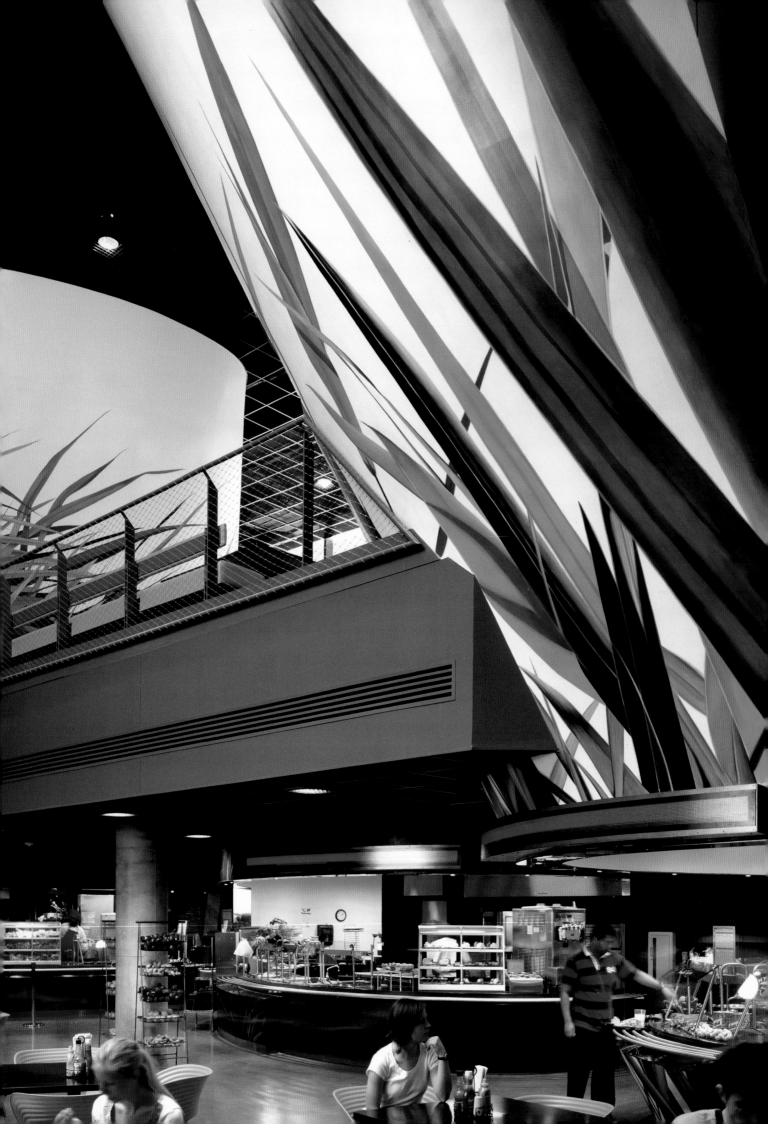

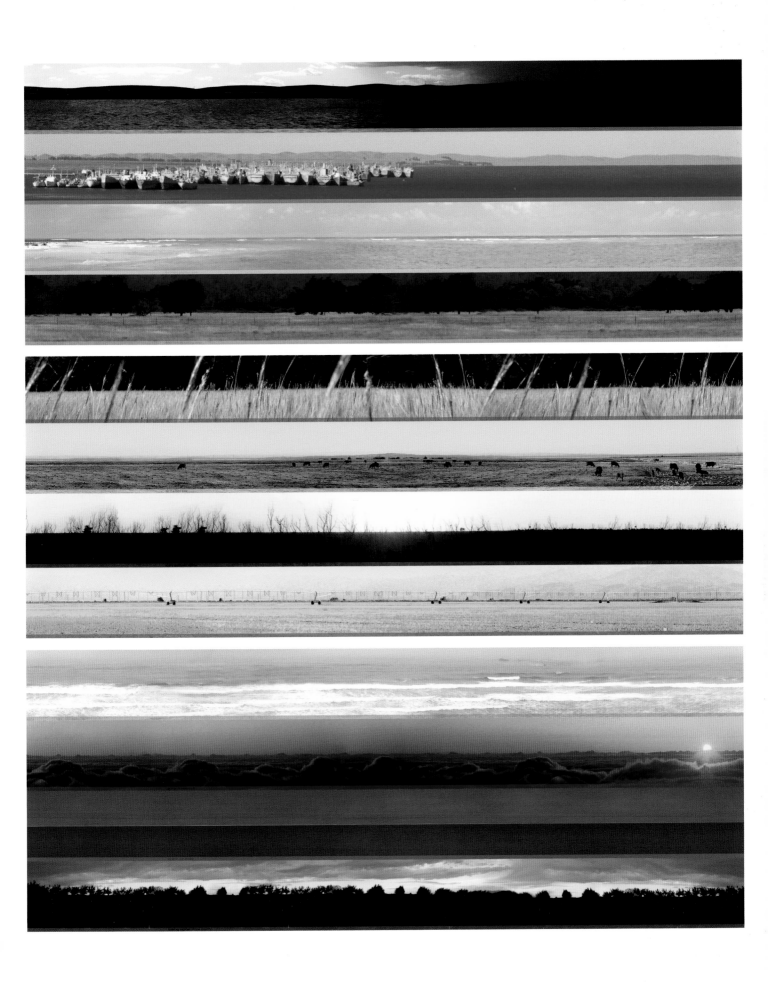

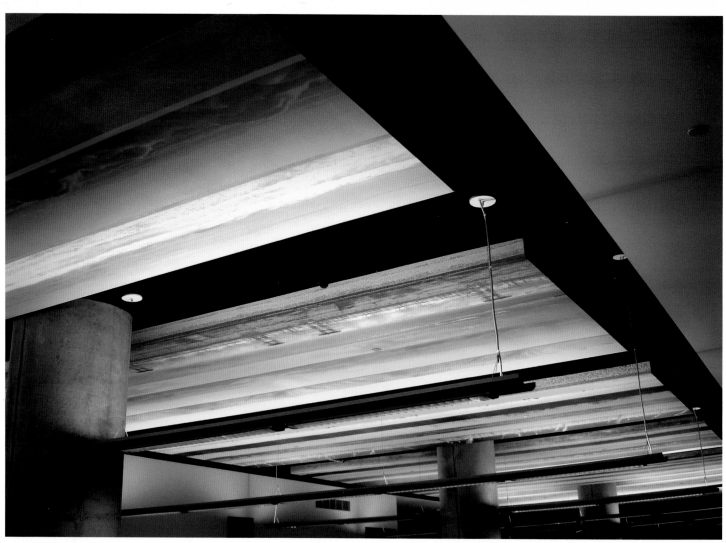

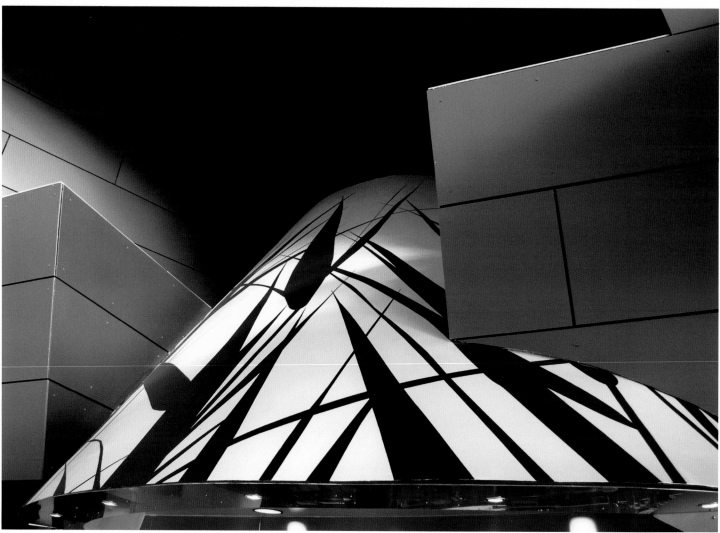

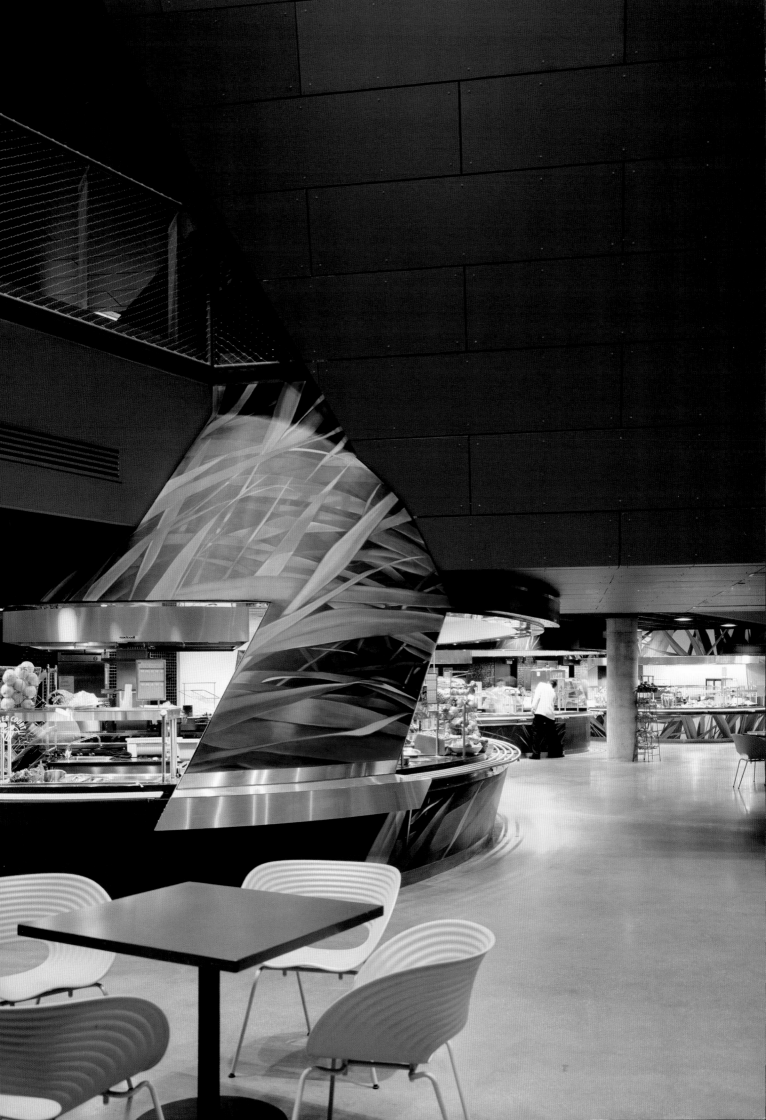

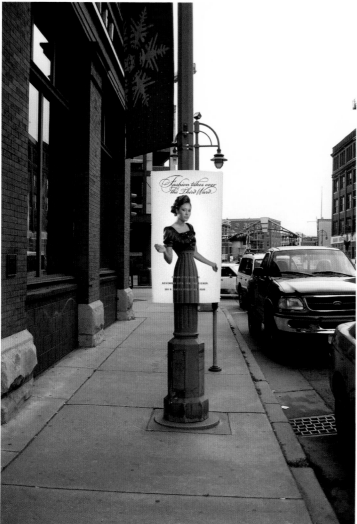
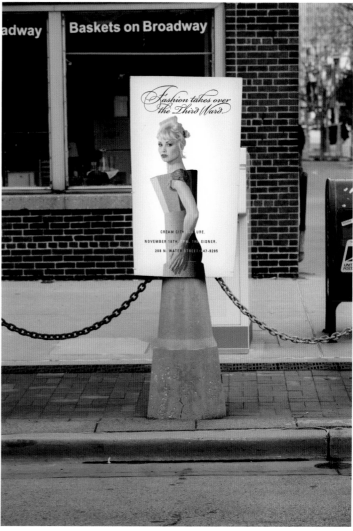

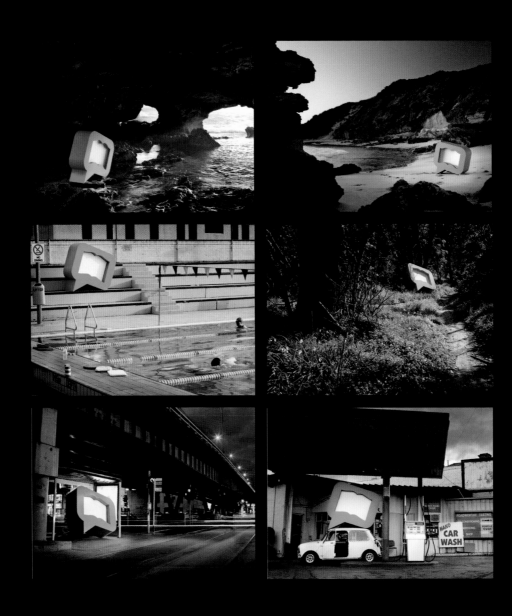

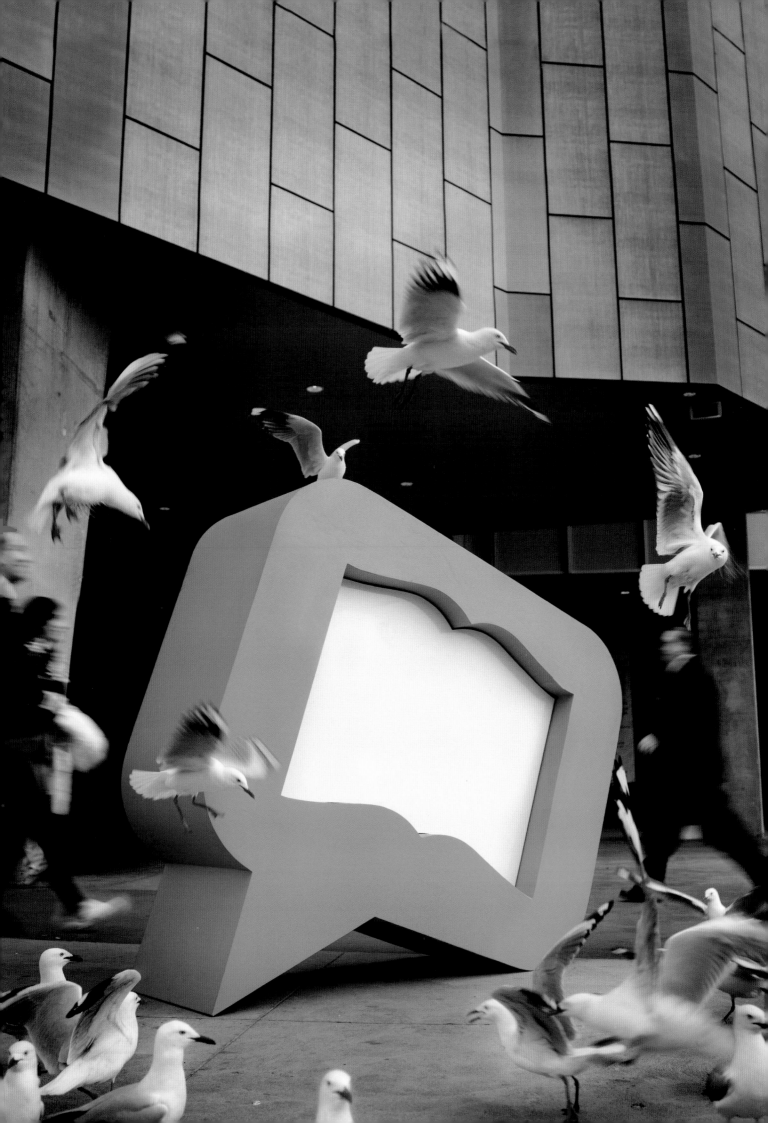

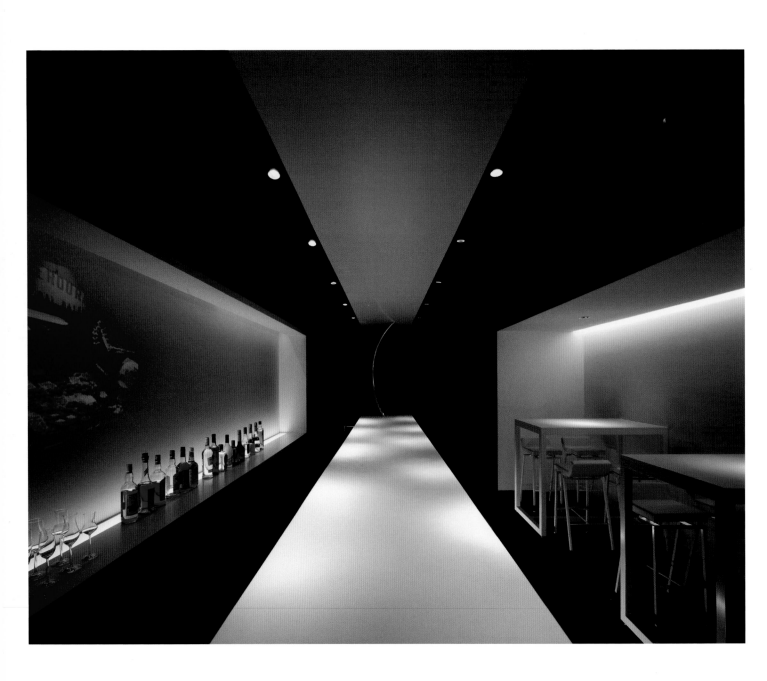

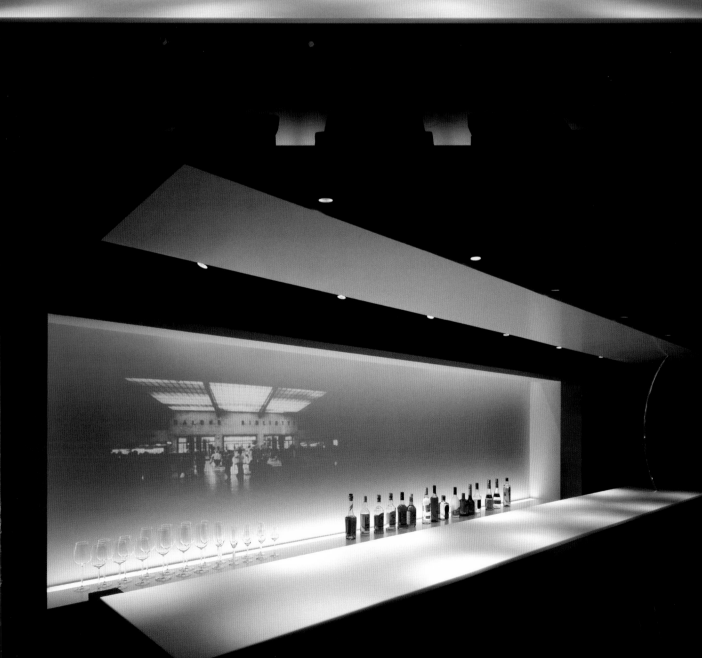

MOUNTAIN EQUIPMENT CO-OP

ALL MEC-LABEL COTTON CLOTHING IS MADE OF 100% ORGANIC COTTON.

mec.ca/belief

MOUNTAIN EQUIPMENT CO-OP

MEN'S

Sportif
Trailhead Organic Pants

Burly and robust canvas hiking pants designed to take the punishment of the trails and the stress of the urban jungle in stride.

• heavy duty 8oz. organic cotton canvas
• articulated knees and gusseted crotch for maximum mobility
• reinforced bar tarks for maximum durability
• expect 2-3% shrinkage

5002902
919-210-20-22

MEN'S 30-42

$43

MEC GREEN BUILDING TOUR
T5 FLUORESCENT BULBS REDUCE INTERIOR HEATING LOADS BY OVER 50% COMPARED TO THE BASE BUILDING MODEL.

mec.ca/belief

YOUR COMMUNITY
Connect with us at mec.ca/belonging

KIOSK

CLUBS + ORGANIZATIONS

GEAR FOR SA

mec.ca

BIKE

CLIMB

HIKE

CAMP

PADDLE

WHY DO I RIDE? THE ADRENALIN RUSH, FOR SURE. BUT IT'S MORE THAN THAT. WHAT'S THE WORD? CAMARADERIE. I LOVE RIDING WITH MY FRIENDS.

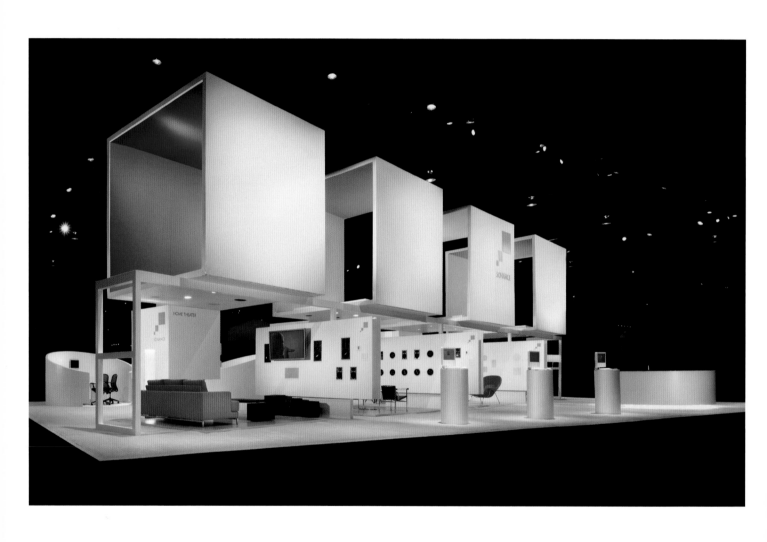

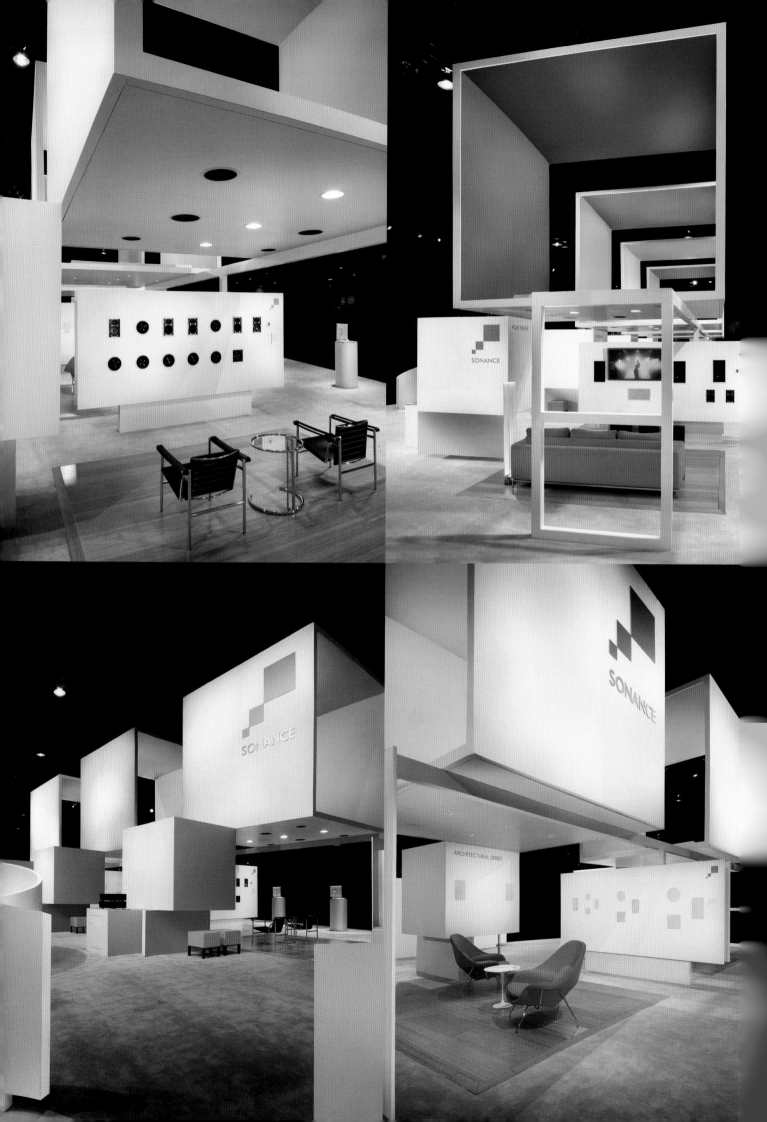

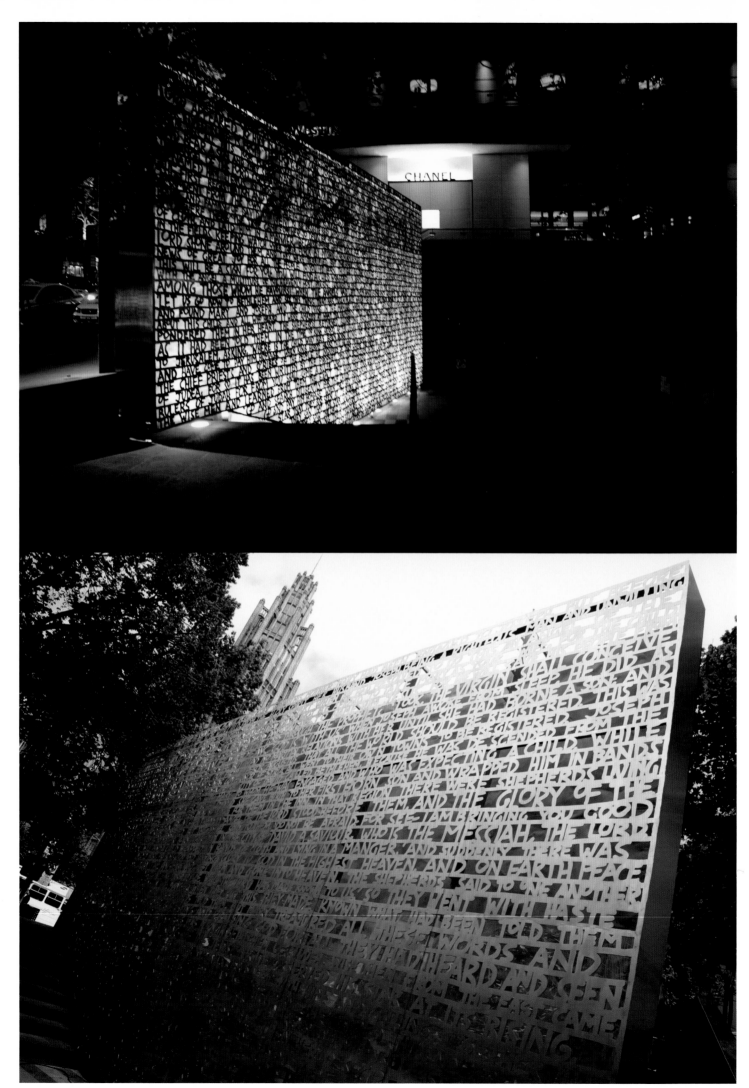

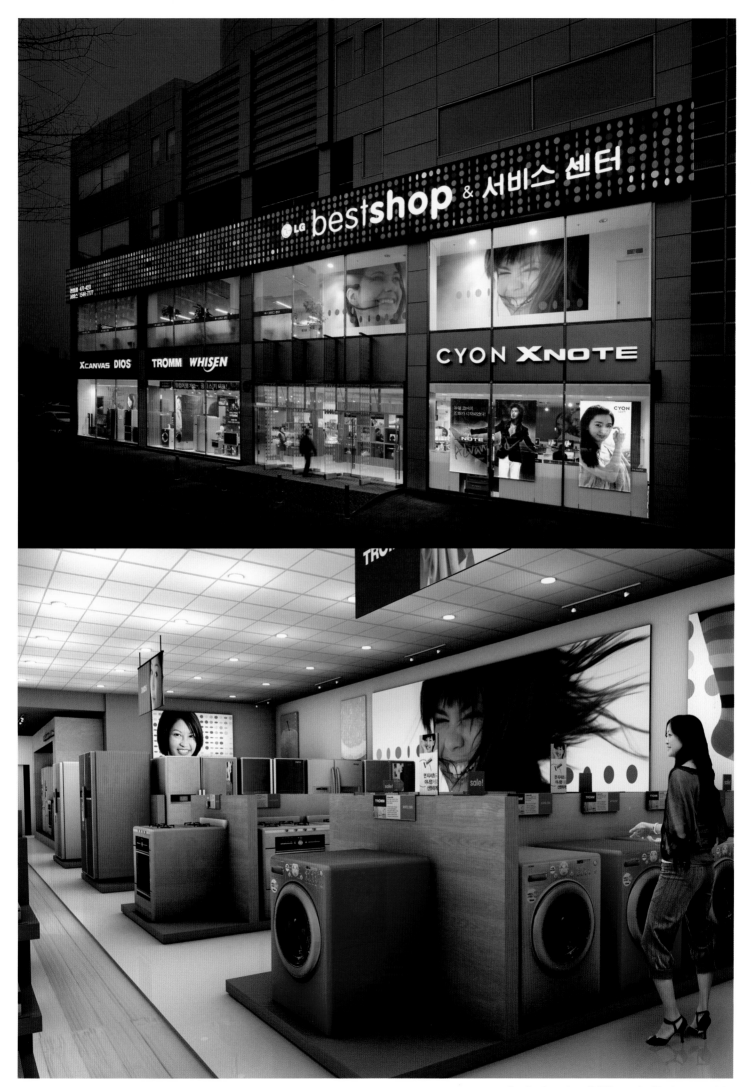

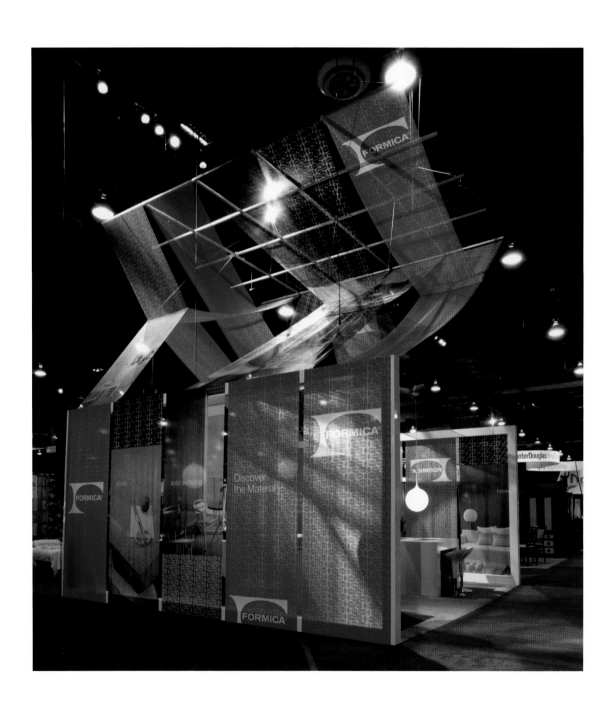

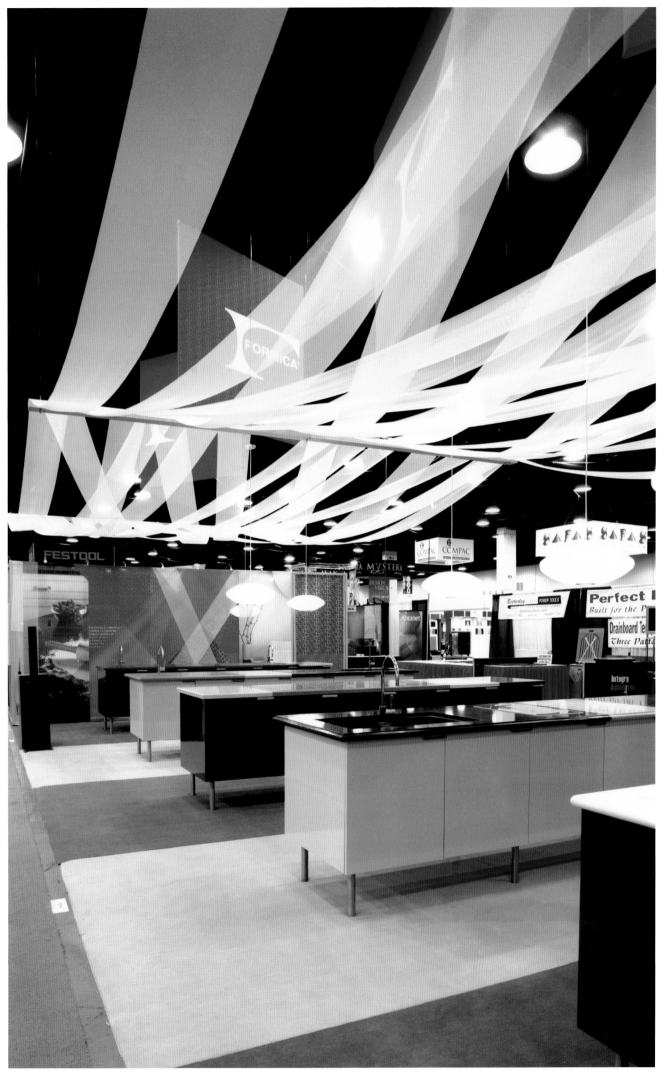

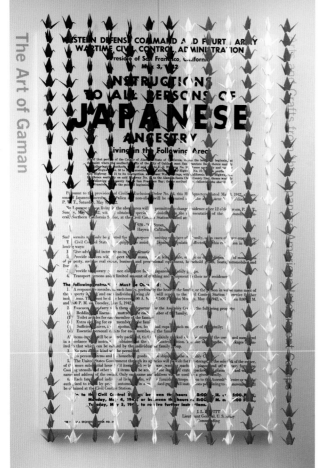

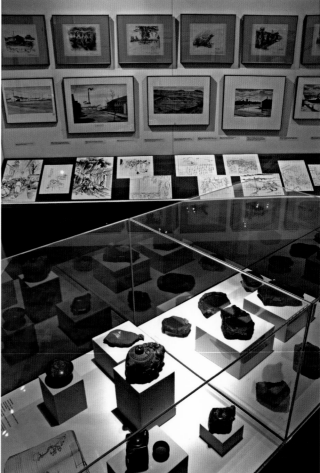

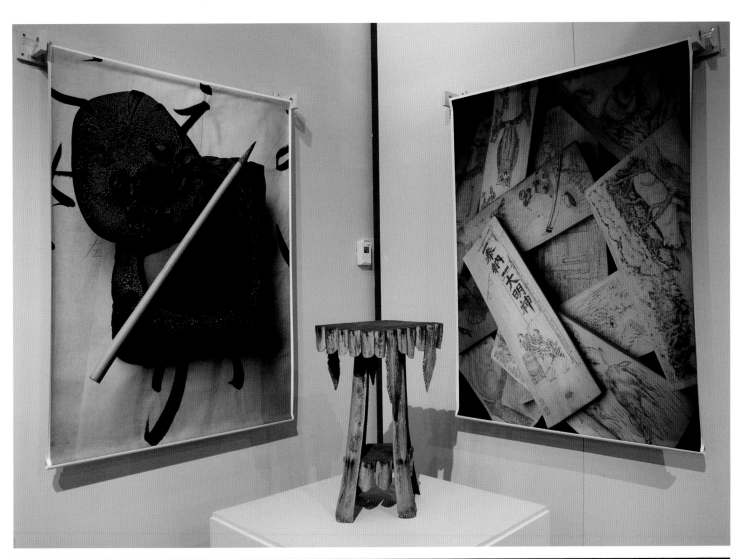

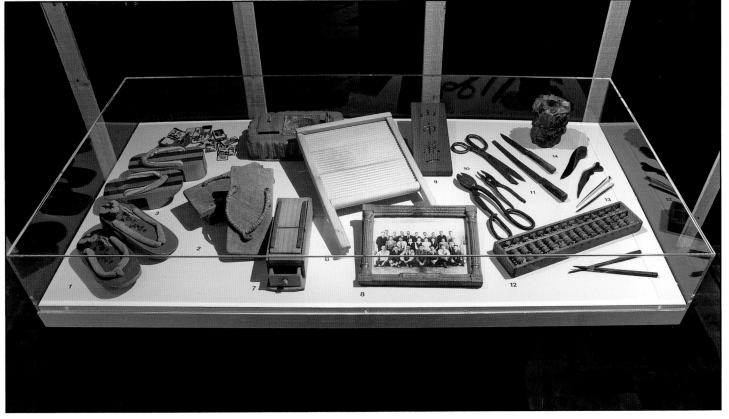

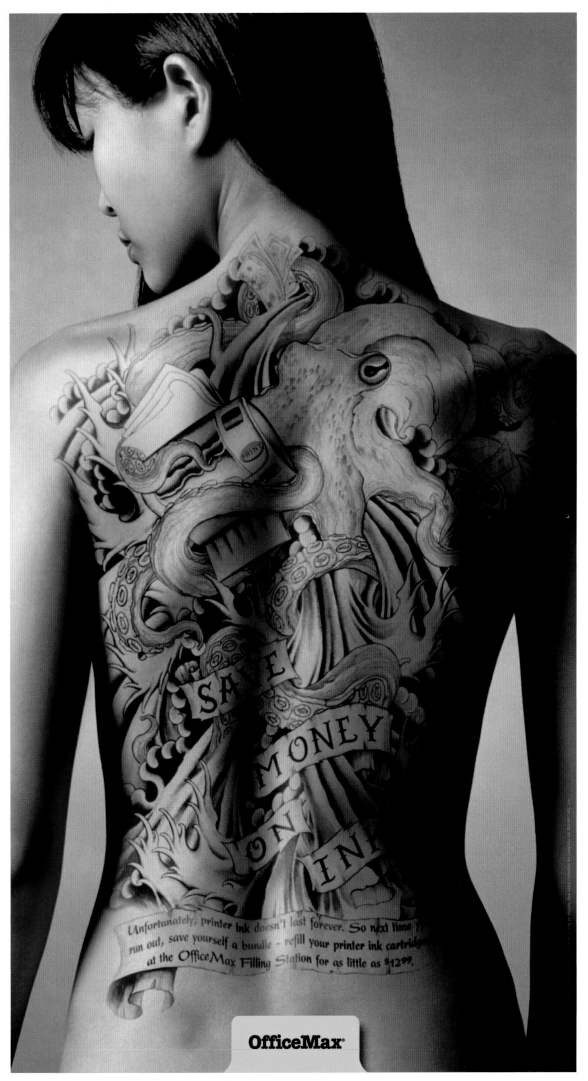

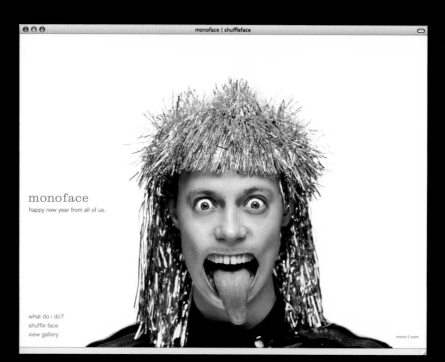

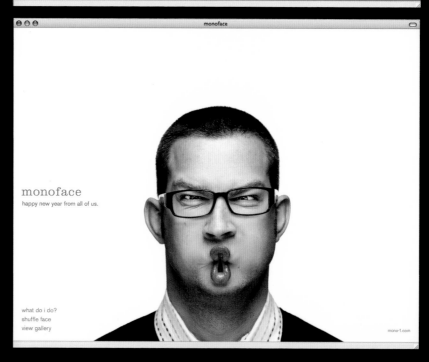

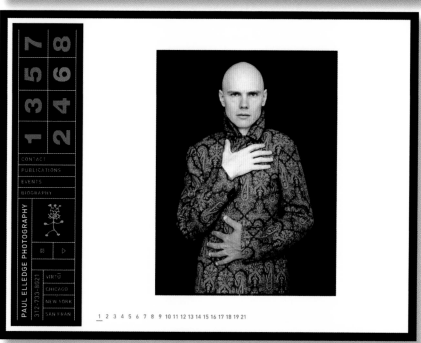

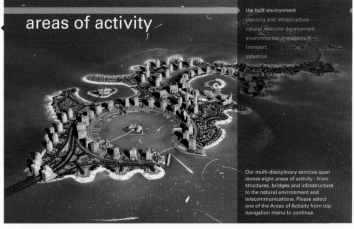

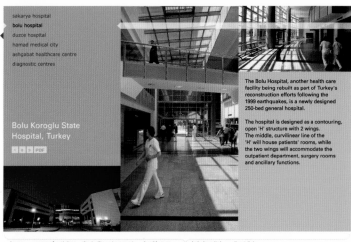

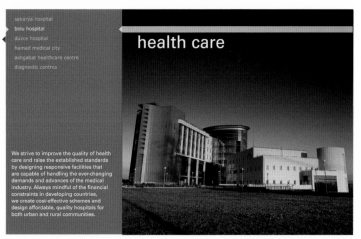

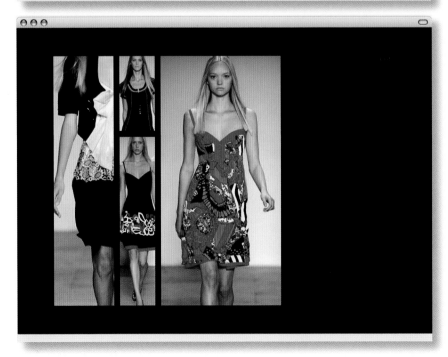

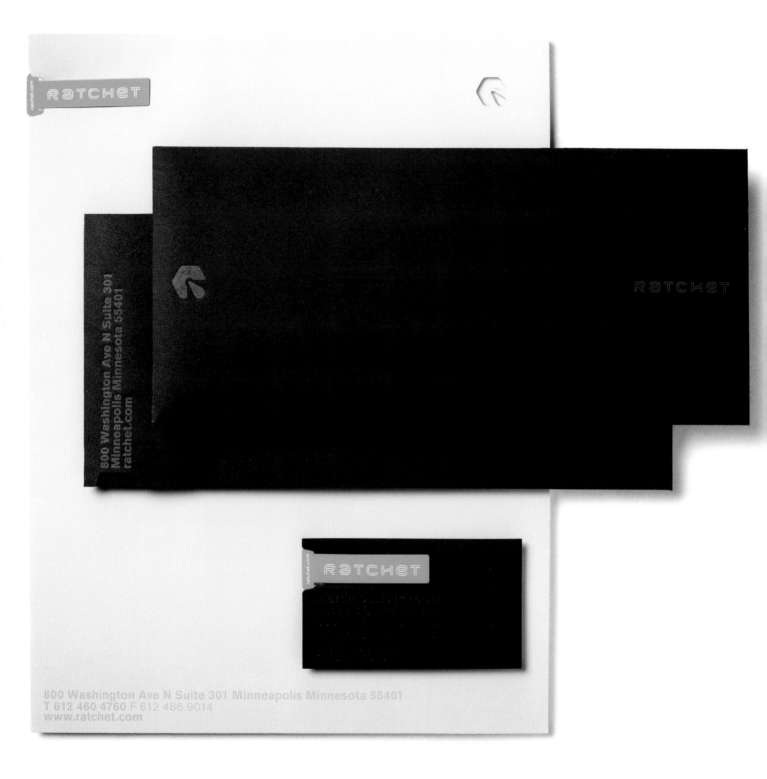

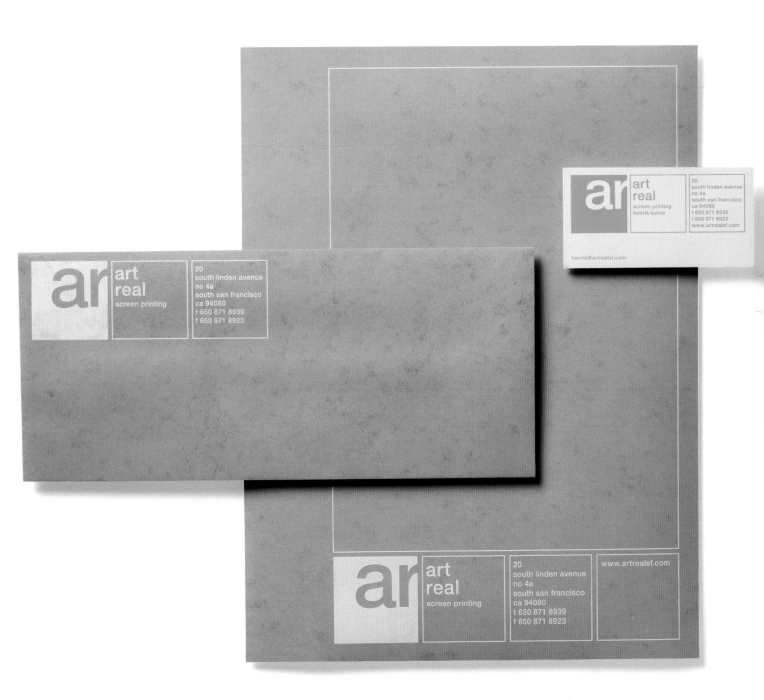

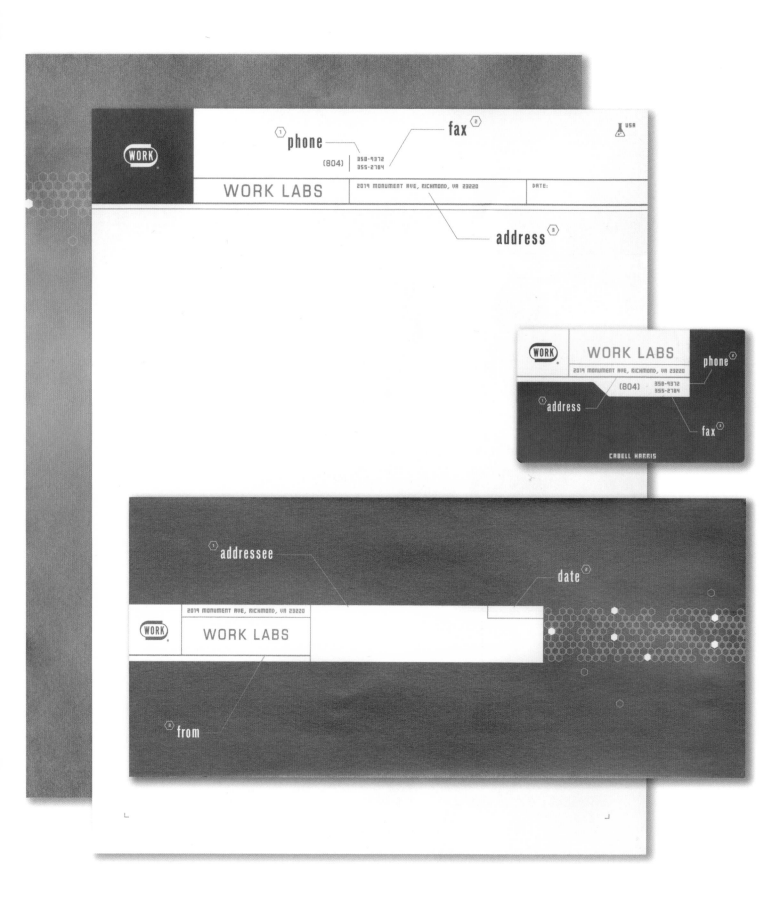

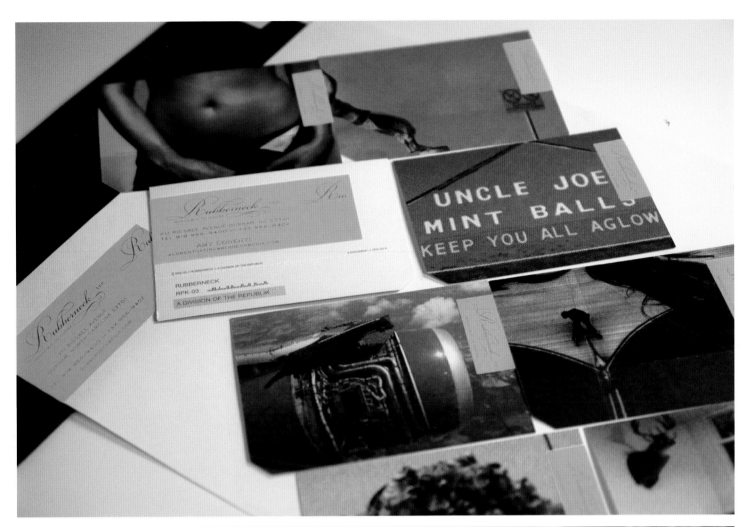

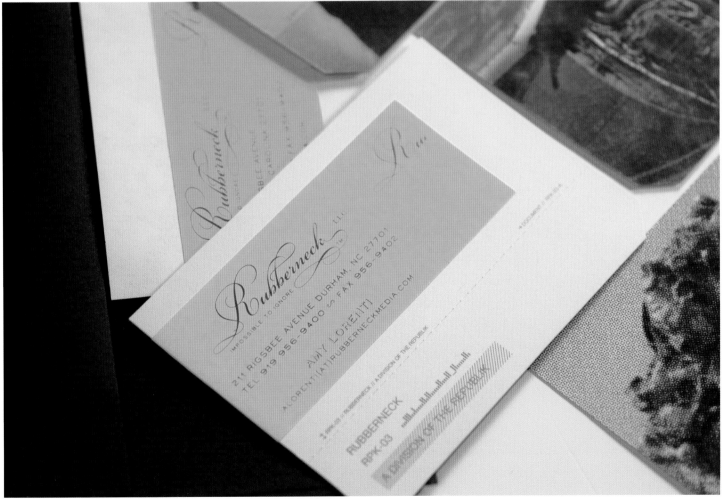

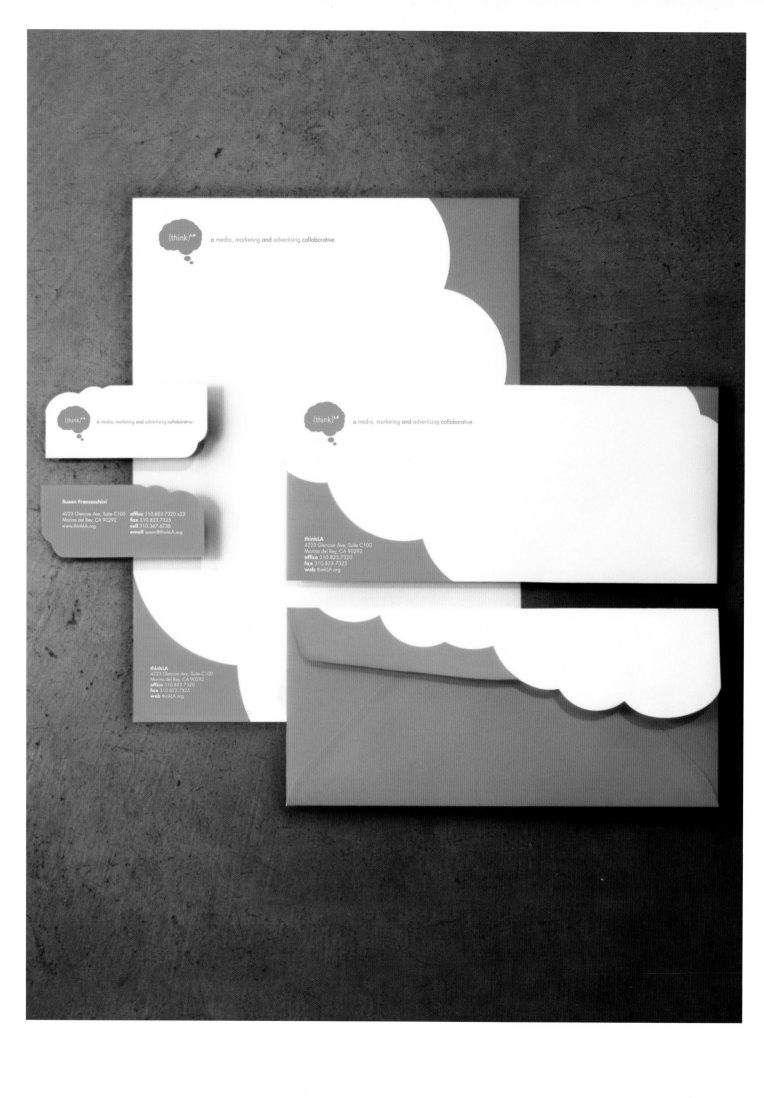

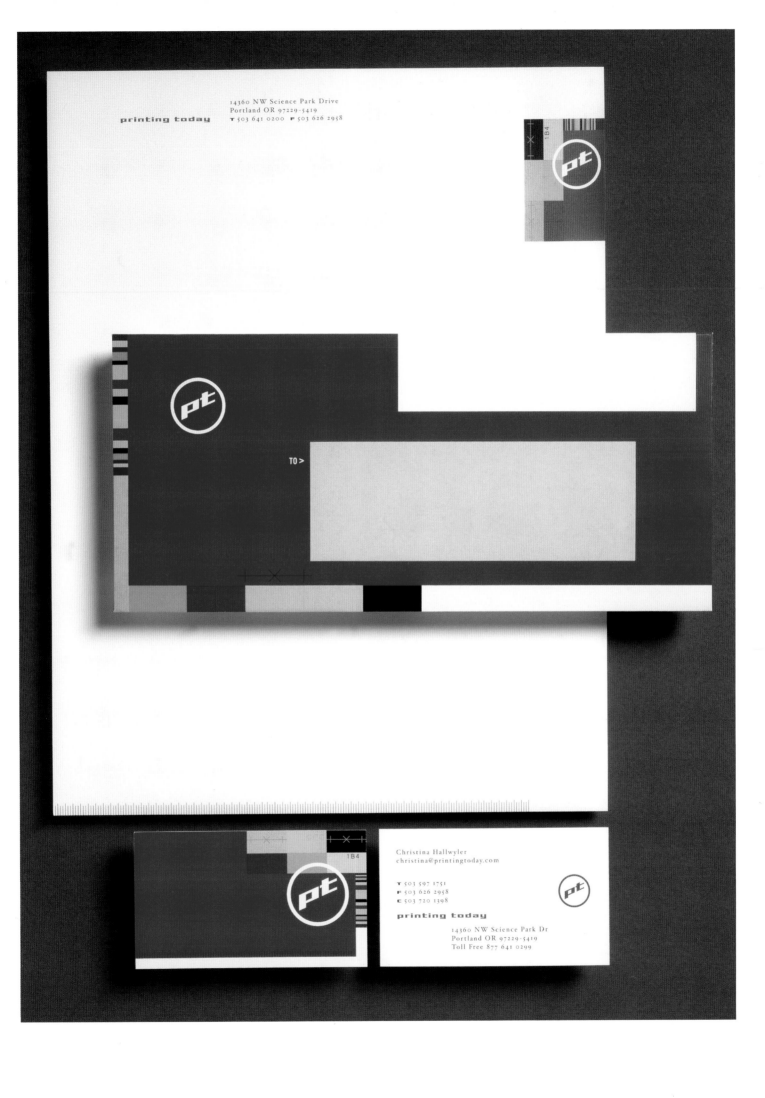

14360 NW Science Park Drive
Portland OR 97229-5419
printing today T 503 641 0200 F 503 626 2958

TO >

Christina Hallwyler
christina@printingtoday.com

T 503 597 1751
F 503 626 2958
C 503 720 1398

printing today

14360 NW Science Park Dr
Portland OR 97229-5419
Toll Free 877 641 0299

14360 NW Science Park Drive
Portland OR 97229-5419
printing today T 503 641 0200 F 503 626 2958

Wall-to-Wall Studios, Inc. | Pittsburgh Arts & Lectures
Ó! | Square One Films
McCann Erickson Russia | fund of SOCIAL COMMUNICATIONS
Hahmo Design Ltd. | ArkOpen Ltd.
601 Design, Inc. | Lynne Bier/Interior Designer

Fox Atomic/Karen Crawford | **Intralink Film Graphic Design**

cinch™

VIVA DESIGN! studio | Pool Bar
Young & Laramore | Tamarindo
David Clark Design | Cherry Street Association
Turner Duckworth | Shaklee
Sibley/Peteet Design | El Pato Fresh Mexican Food

CODEBREAKERS

Ó! | Askja
Ventress Design Group | Zia Music Production
RBMM | CodeBreakers
MBA | St. Mark's Episcopal Day School
Pentagram SF | Fuego North America

SARDEGNA

Synergy Graphix | Piranha Extreme Sports
RBMM | Nomacorc
Duffy&Partners | V.I.O.
Sibley/Peteet Design | Montgomery Farm
Brandoctor | Gajba
(opposite page) **Les Kerr Creative** | Levenson&Hill

152Logos

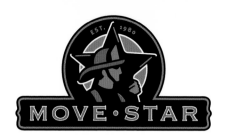

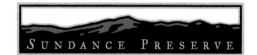

NEW YORK

NEW YORK

NEW YORK

NEW YORK

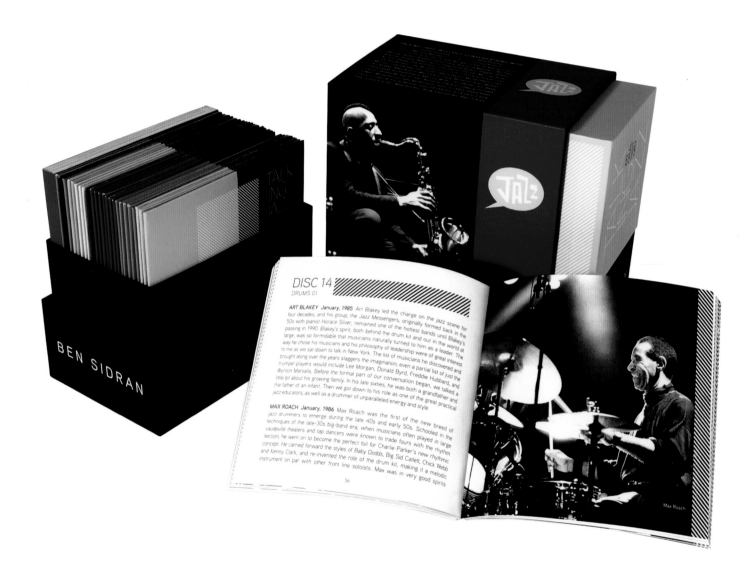

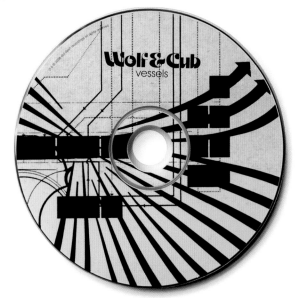
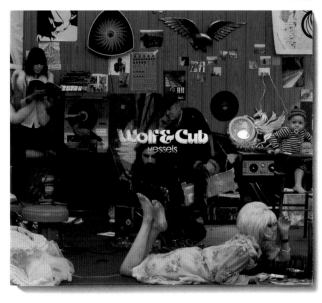

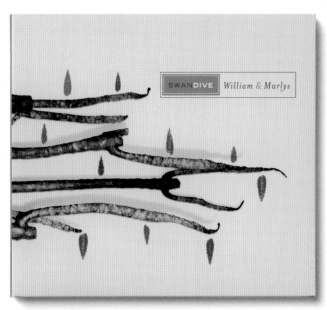

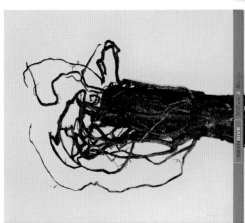

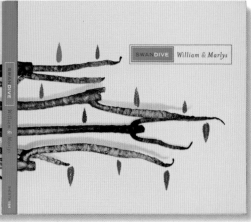

1 Good To Be Free 2 Hometown 3 Almost Over You
4 Leftover 5 Happy For You 6 That Hat 7 Up With Love
8 Becoming 9 A Few Thousand Days Ago 10 Where Am I Going?

Bonus Tracks

11 Truly, Madly, Deeply 12 Go With Love
13 Rome Will Fall 14 And She Dreams

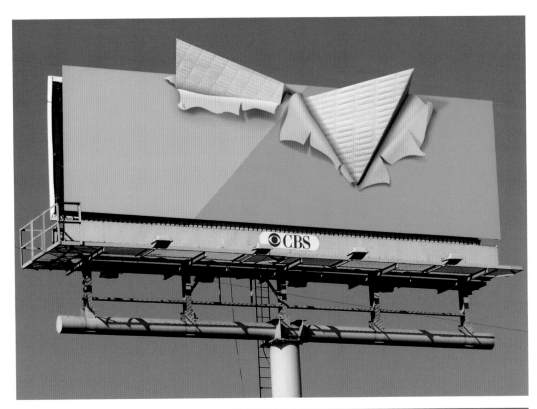

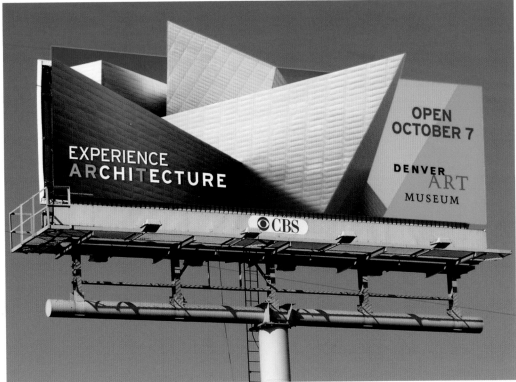

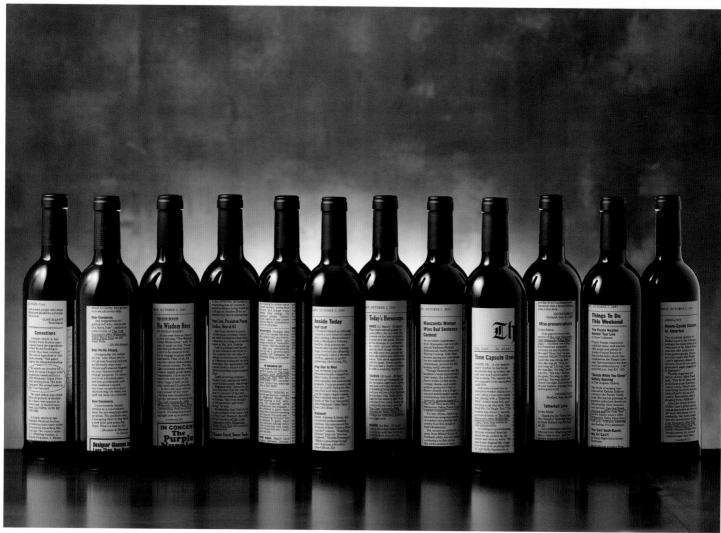

TOM FORD
BLACK ORCHID

EAU DE PARFUM
VAPORISATEUR SPRAY
3.4 FL. OZ./OZ. LIQ./100 ml ℮

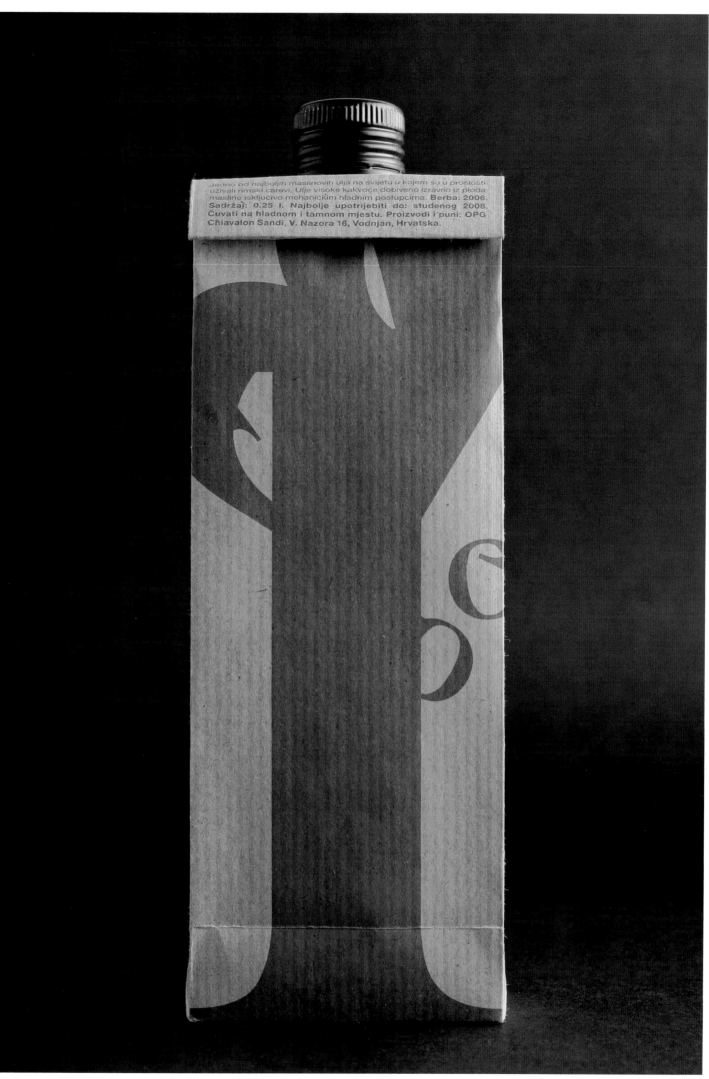

Jedno od najboljih maslinovih ulja na svijetu u kojem su u prošlosti uživali rimski carevi. Ulje visoke kakvoće dobiveno izravno iz ploda masline isključivo mehaničkim hladnim postupcima. Berba: 2006. Sadržaj: 0.25 l. Najbolje upotrijebiti do: studenog 2008. Čuvati na hladnom i tamnom mjestu. Proizvodi i puni: OPG Chiavalon Sandi, V. Nazora 16, Vodnjan, Hrvatska.

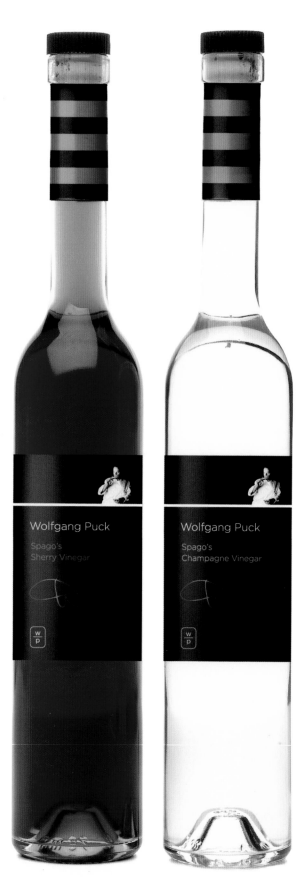
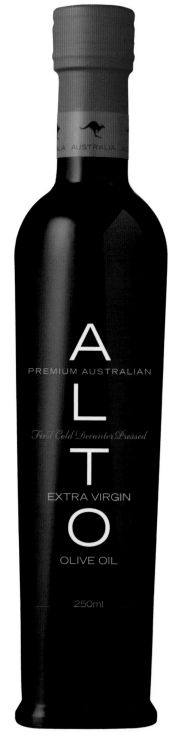

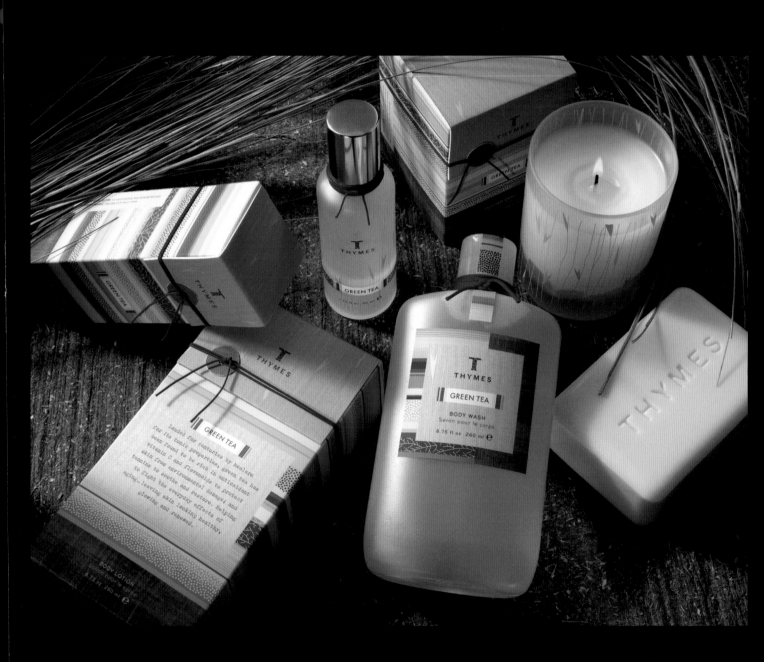

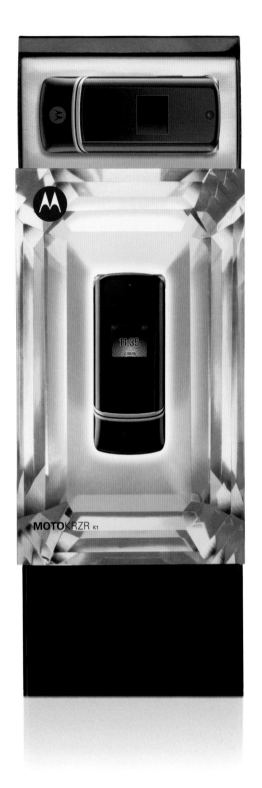
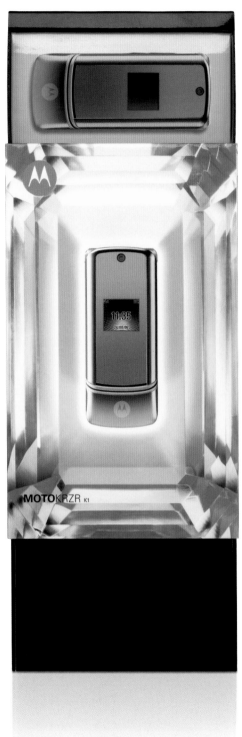

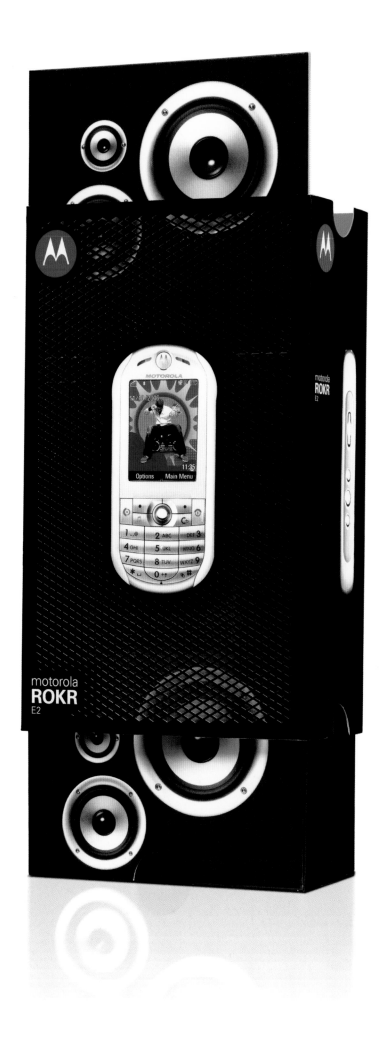

AMERICAN EAGLE
OUTFITTERS

WOMEN'S

6
PET.

FIT CATEGORY

HIPSTER

DETAILS

No 1
Low
Rise

No 2
Bootcut

WASH

EMBELLISHED
ANTIQUE SULFUR

AMERICAN EAGLE
OUTFITTERS

TRIED
& TRUE

AMERICAN EAGLE
OUTFITTERS

MEN'S

W 32
L 34

FIT CATEGORY

BOOTCUT

DETAILS

NO. 1
RELAXED
FIT

NO. 2
MORE
COMFORT
THROUGH
LEG

WASH

DARK REPAIR
DESTROY WASH

AMERICAN EAGLE
OUTFITTERS

TRIED
& TRUE

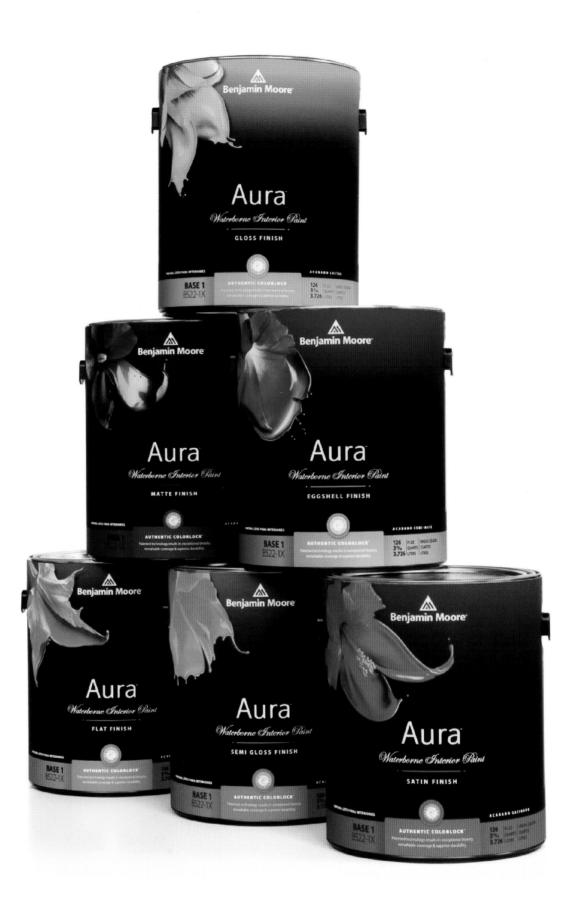

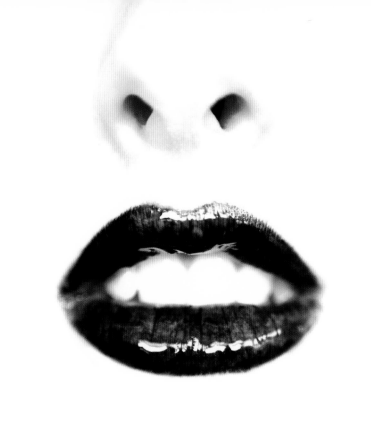

Touch me baby

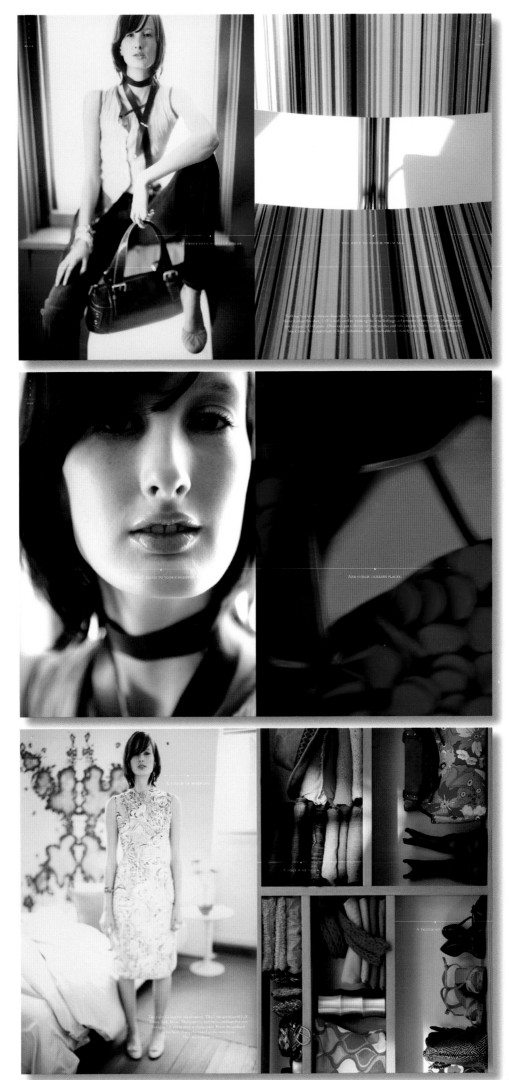

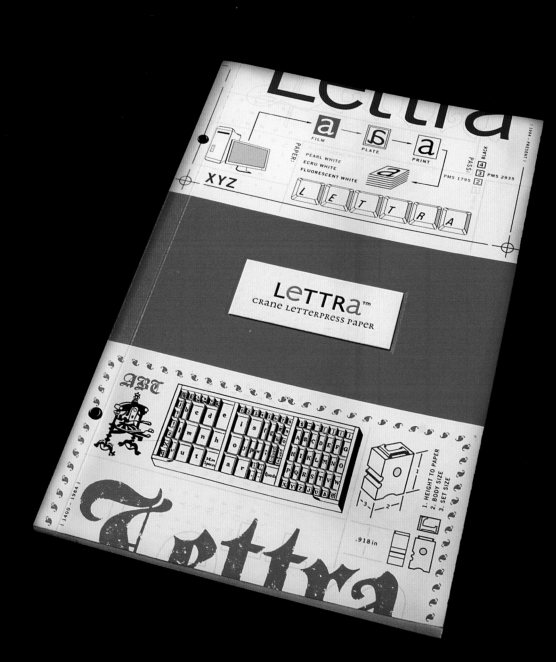

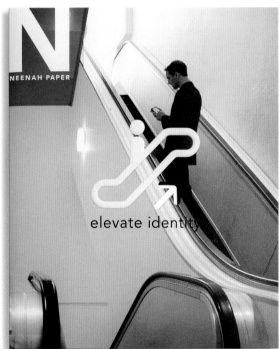

elevate identity

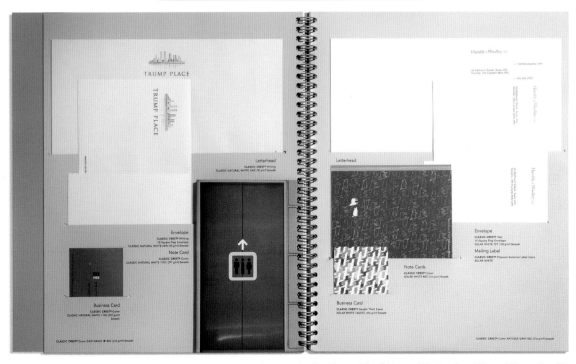

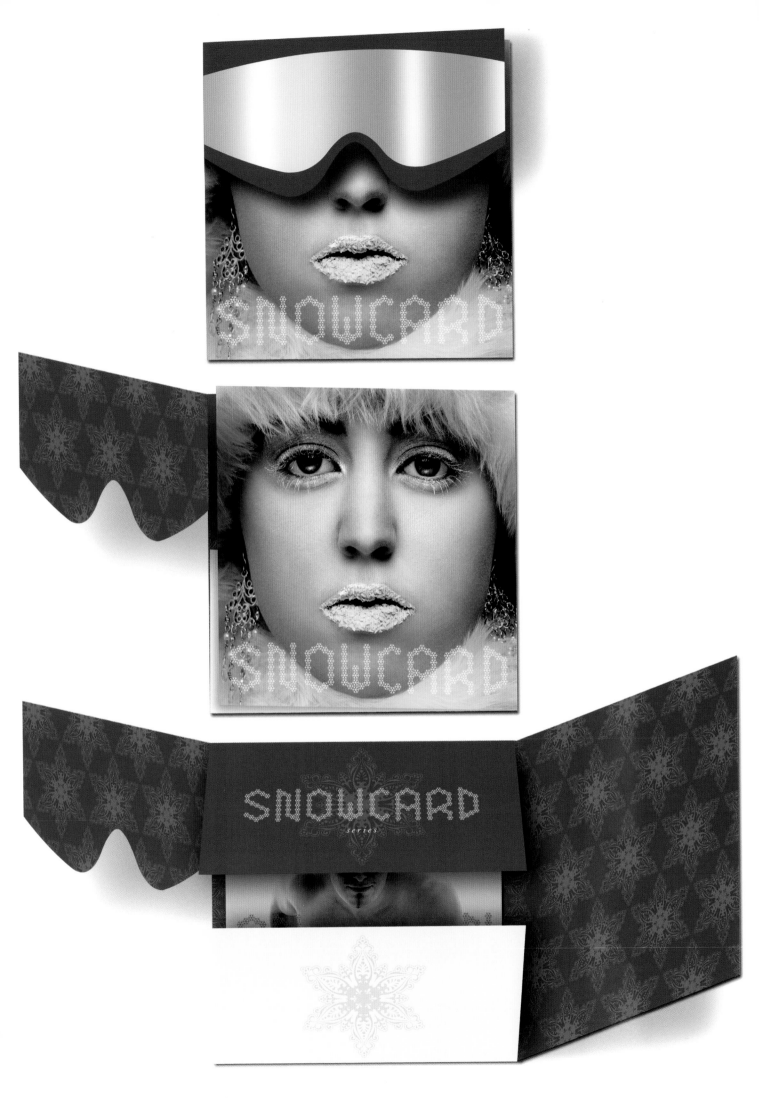

sappi

Sappi Printers of the Year

2006 North American Awards Catalog

NITPICK

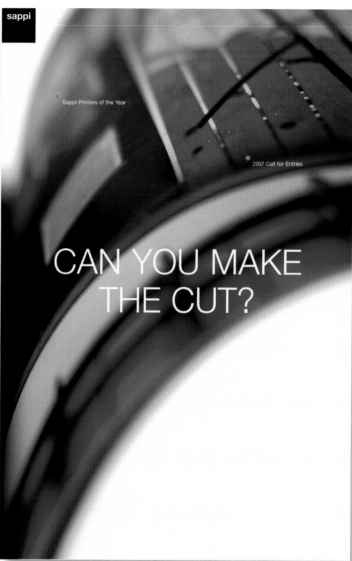

sappi

Sappi Printers of the Year

2007 Call for Entries

CAN YOU MAKE THE CUT?

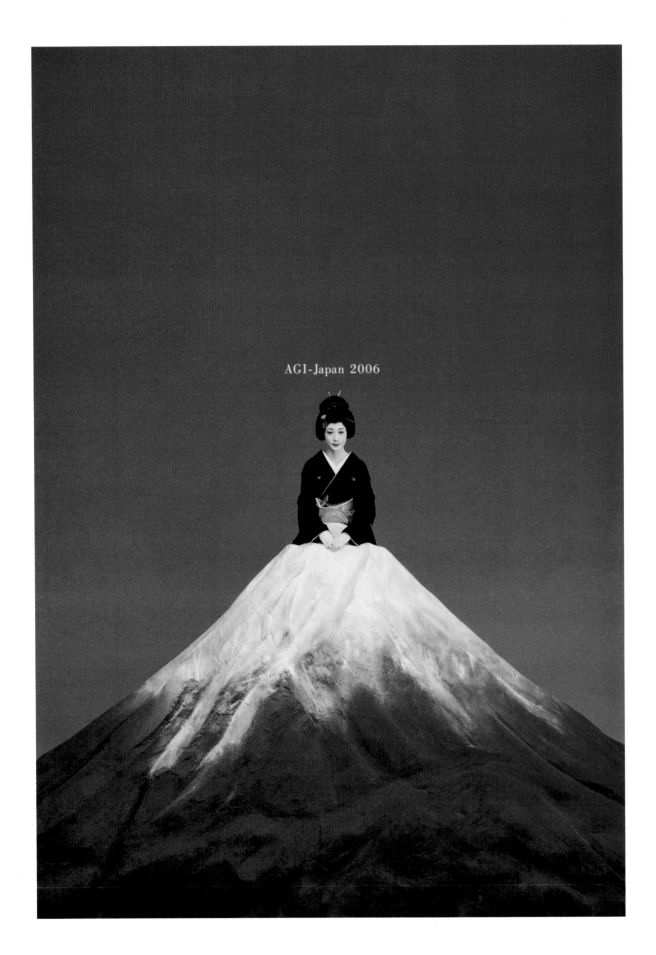

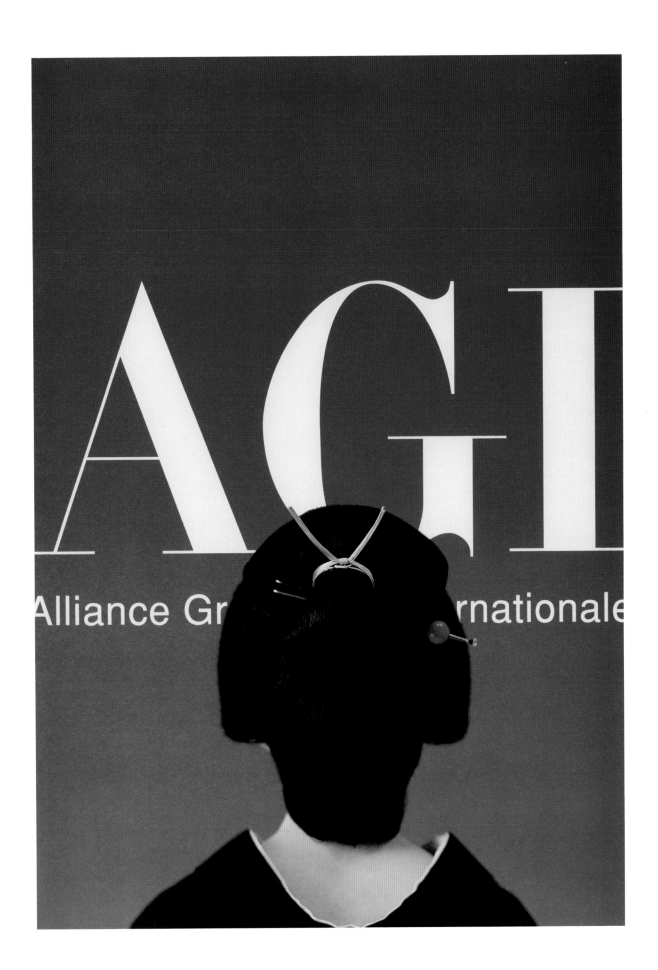

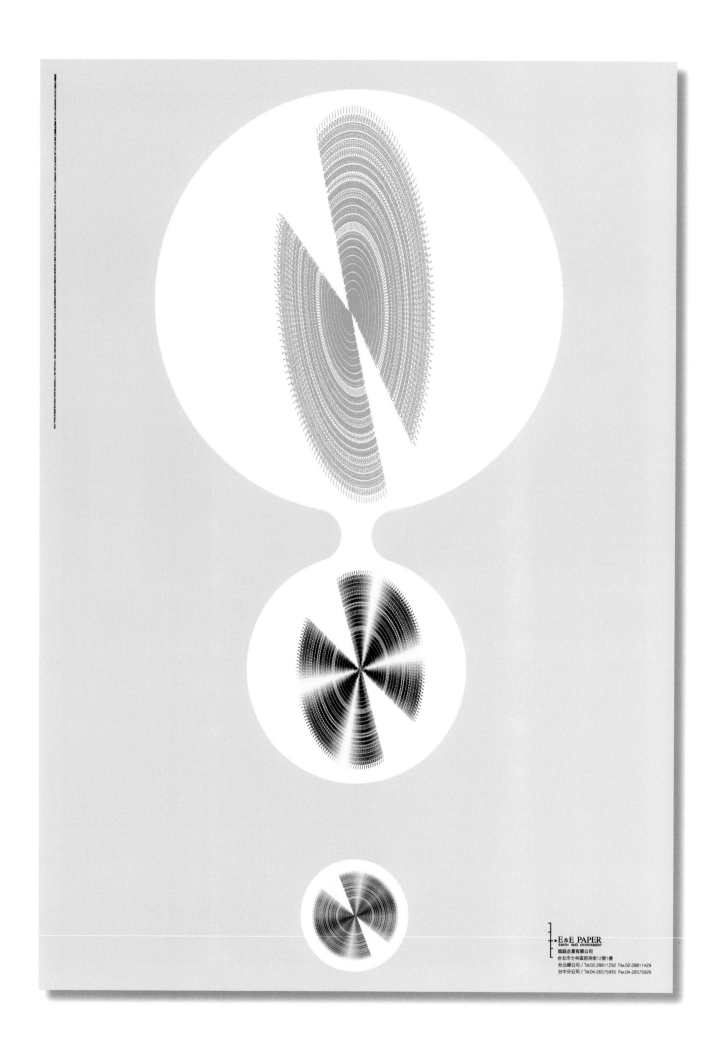

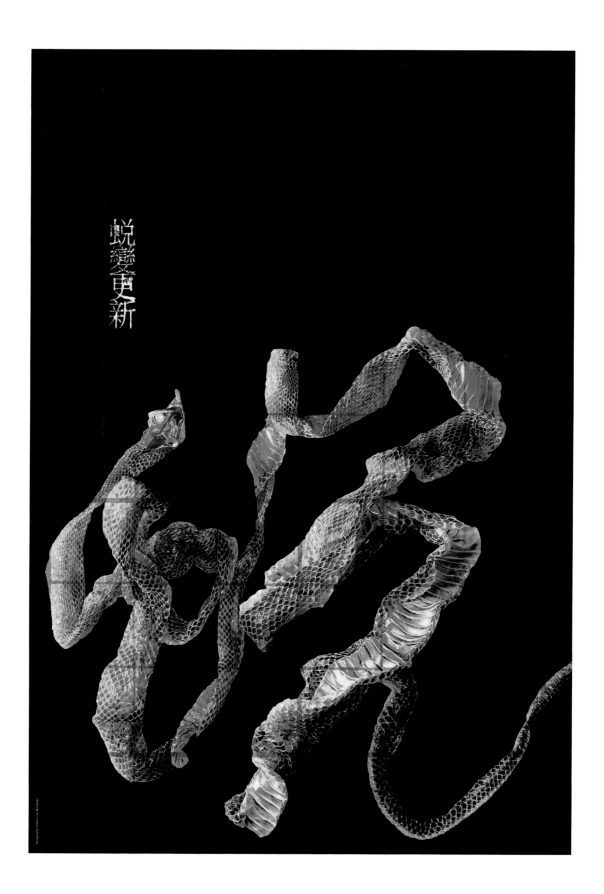

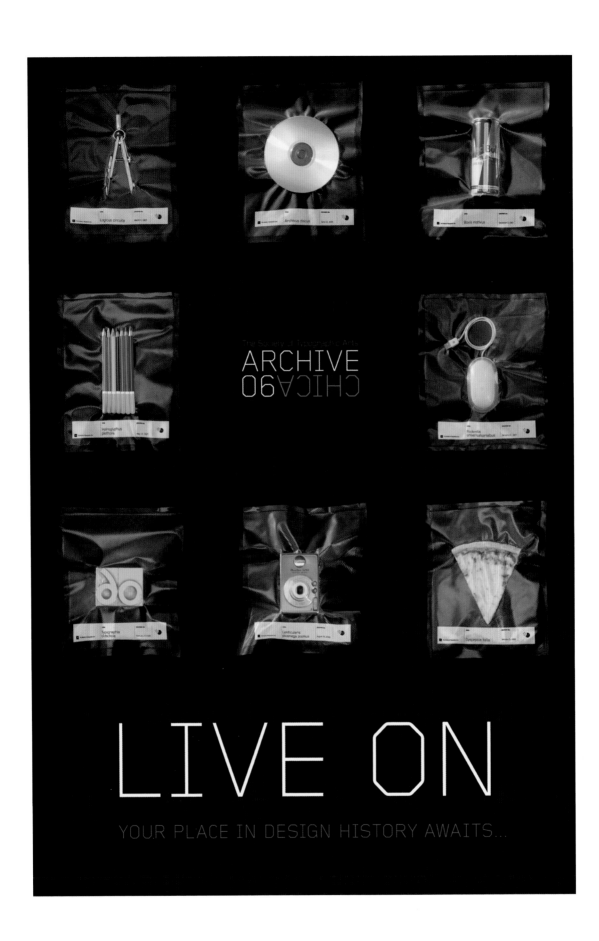

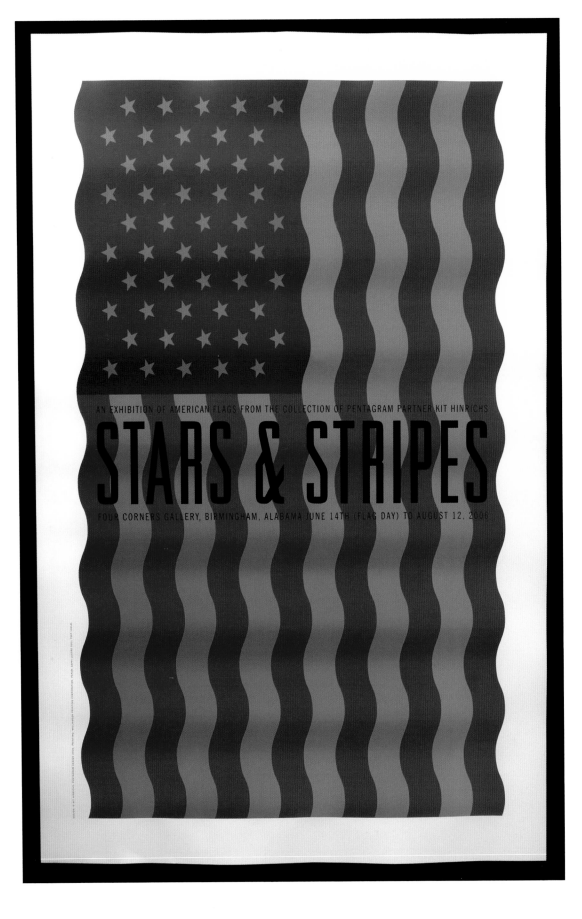

AN EXHIBITION OF AMERICAN FLAGS FROM THE COLLECTION OF PENTAGRAM PARTNER KIT HINRICHS

STARS & STRIPES

FOUR CORNERS GALLERY, BIRMINGHAM, ALABAMA JUNE 14TH (FLAG DAY) TO AUGUST 12, 2006

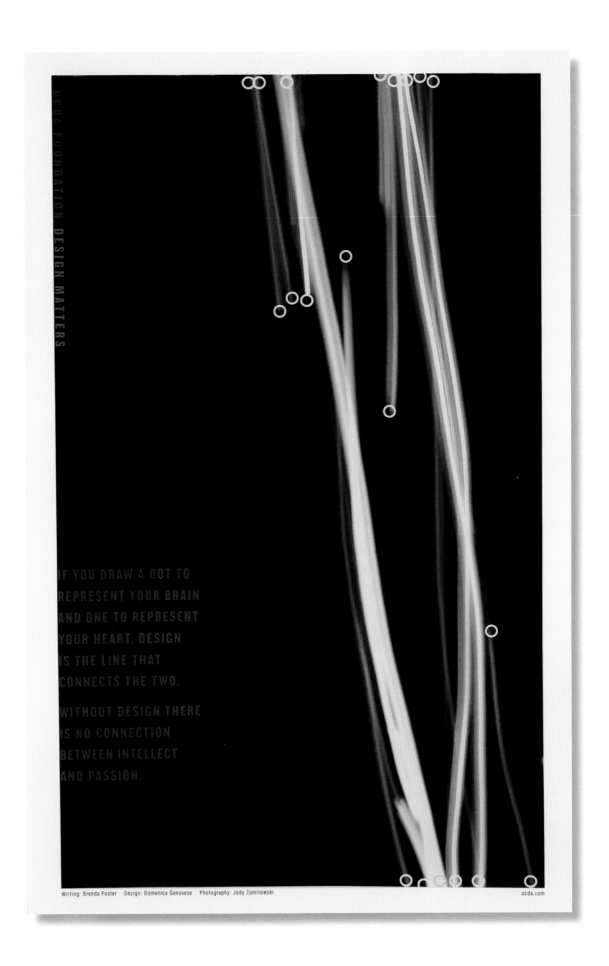

UCDA FOUNDATION DESIGN MATTERS

IF YOU DRAW A DOT TO
REPRESENT YOUR BRAIN
AND ONE TO REPRESENT
YOUR HEART. DESIGN
IS THE LINE THAT
CONNECTS THE TWO.

WITHOUT DESIGN THERE
IS NO CONNECTION
BETWEEN INTELLECT
AND PASSION.

Writing: Brenda Foster Design: Domenica Genovese Photography: Jody Zamirowski ucda.com

FILLMORE JAZZ FESTIVAL

SCHWAB

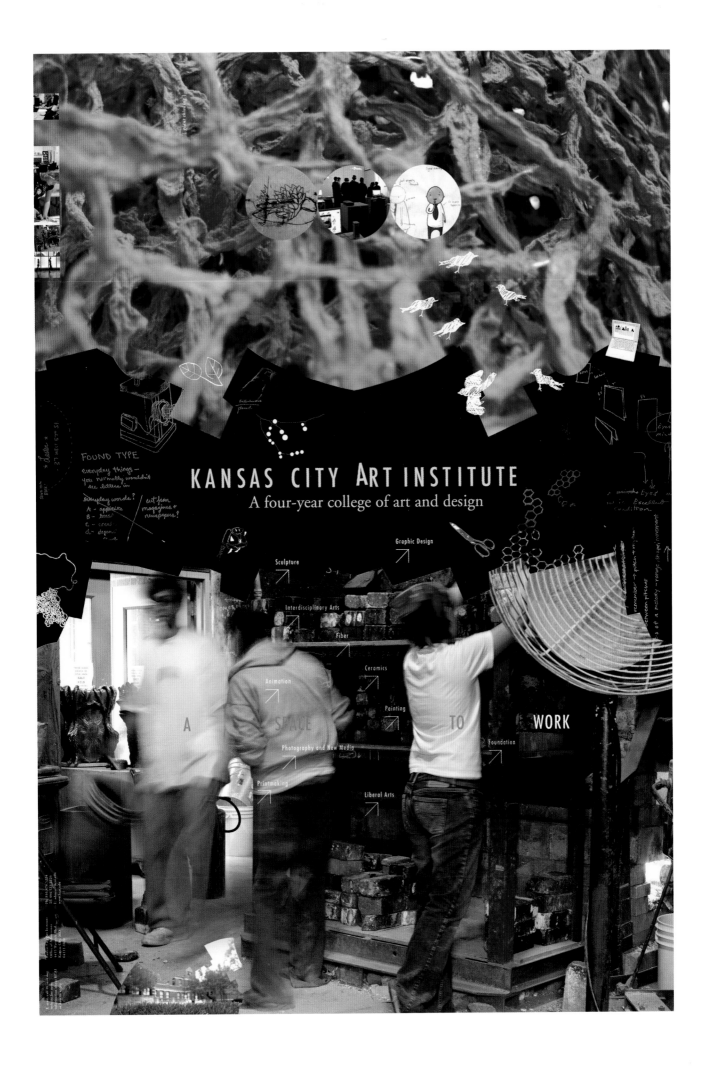

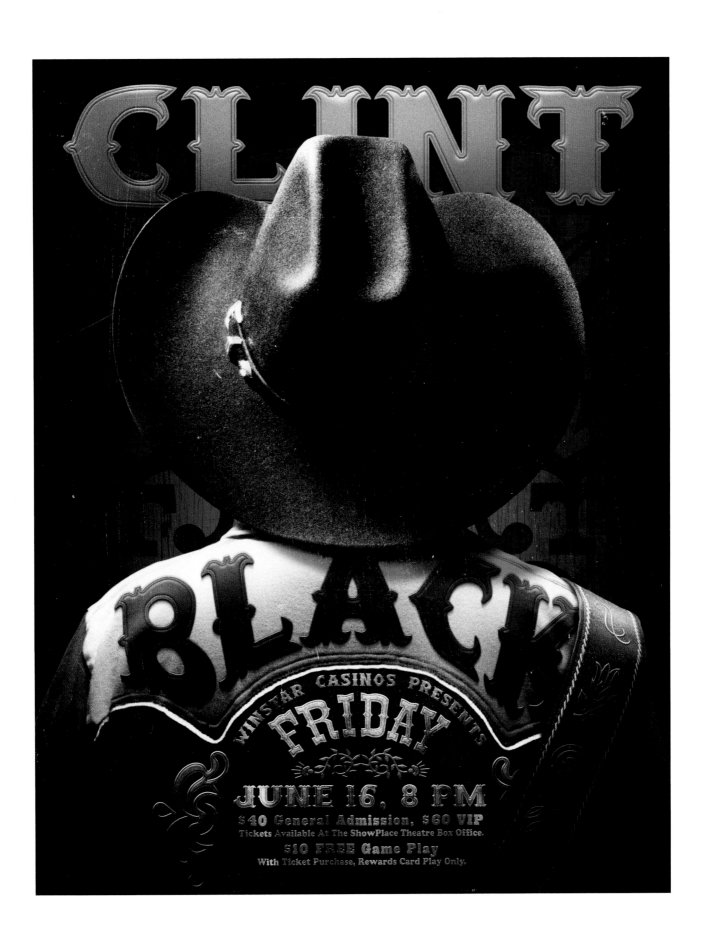

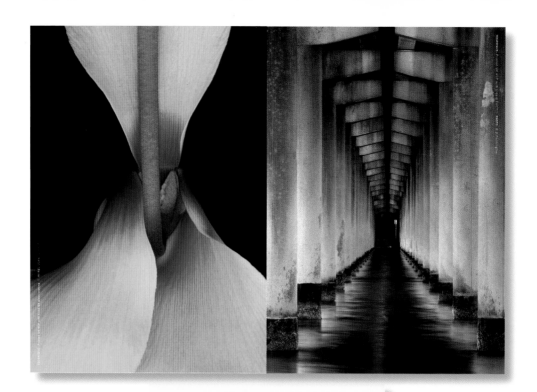

[visual side]

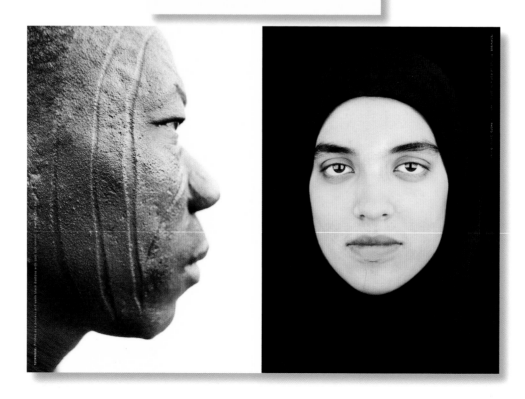

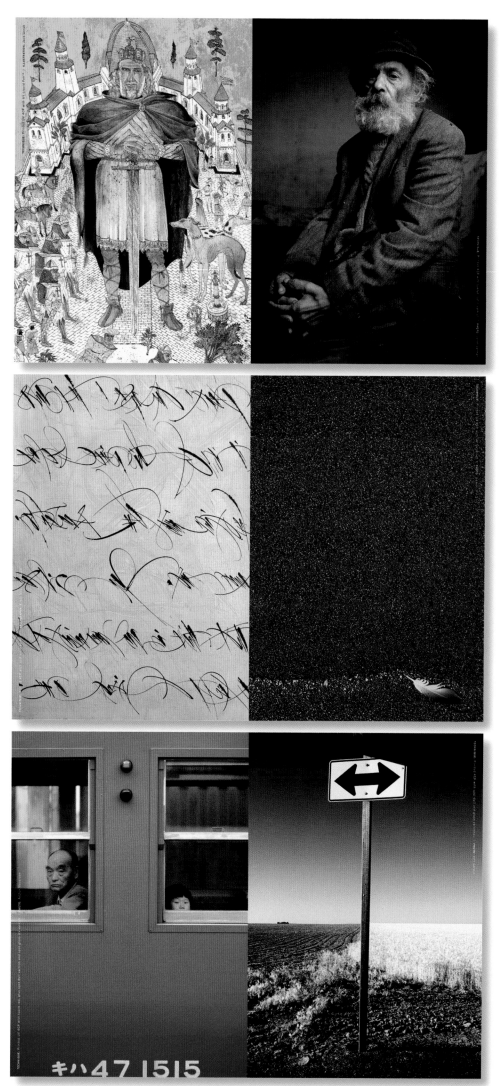

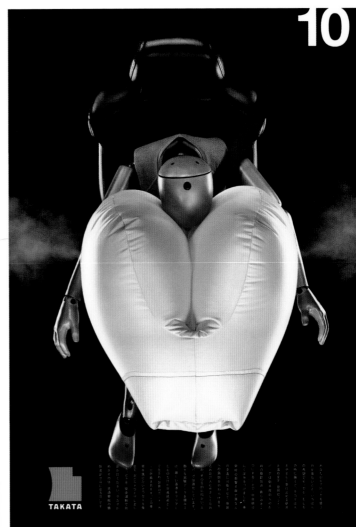

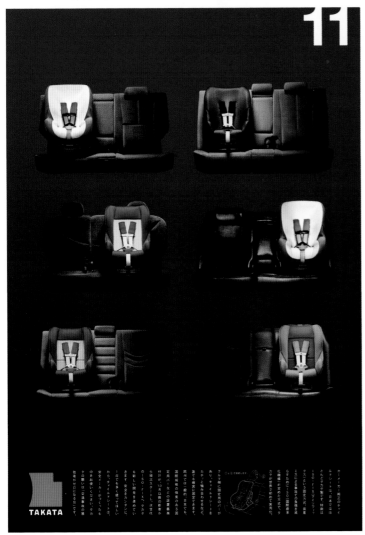

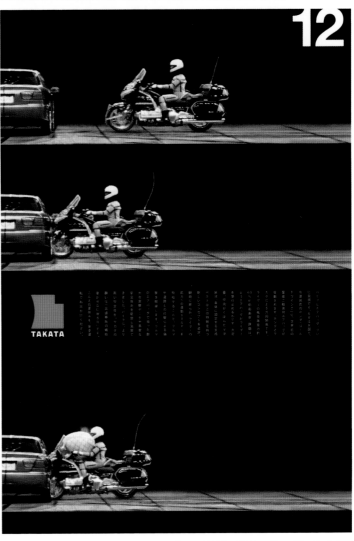

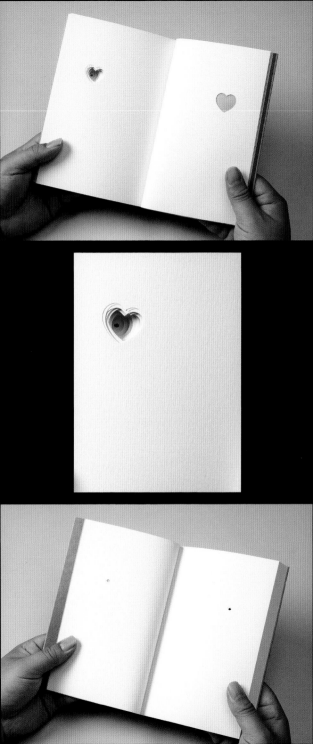

Look 23
Hasbro red i-Dog
$27.99

Look 26
Time to Play™ kitchen center
$79.99

Design Changes Everything: September 15, 10 am
How Passion and Imagination Shape the Future Feature Animation Theater
A talk by Brian Collins

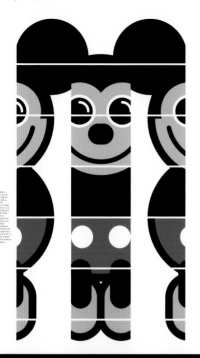

BRIAN COLLINS is Chief Creative Officer of the Brand Innovation Group at Ogilvy & Mather Worldwide. With a laboratory in New York, his team collaborates with clients to create new brands, products and experiences that stand at the intersection of entertainment, design and technology.

Design Changes Everything: September 15, 10 am
How Passion and Imagination Shape the Future Feature Animation Theater
A talk by Brian Collins

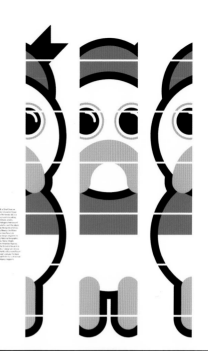

BRIAN COLLINS is Chief Creative Officer of the Brand Innovation Group at Ogilvy & Mather Worldwide. With a laboratory in New York, his team collaborates with clients to create new brands, products and experiences that stand at the intersection of entertainment, design and technology.

Design Changes Everything: September 15, 10 am
How Passion and Imagination Shape the Future Feature Animation Theater
A talk by Brian Collins

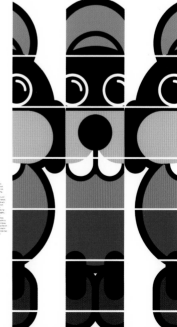

BRIAN COLLINS is Chief Creative Officer of the Brand Innovation Group at Ogilvy & Mather Worldwide. With a laboratory in New York, his team collaborates with clients to create new brands, products and experiences that stand at the intersection of entertainment, design and technology.

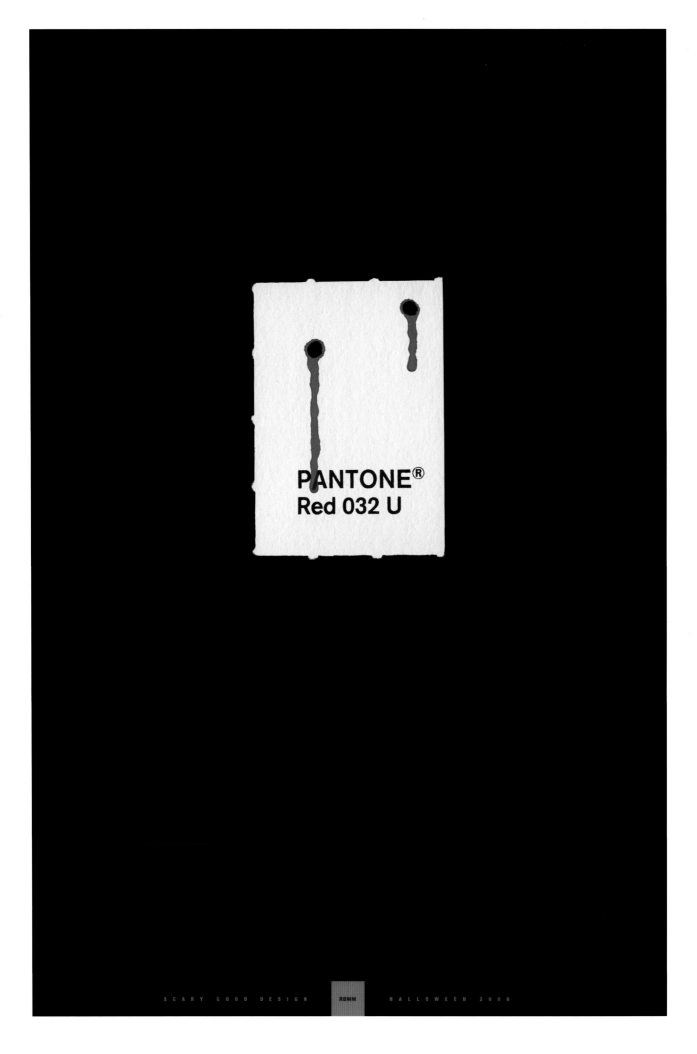

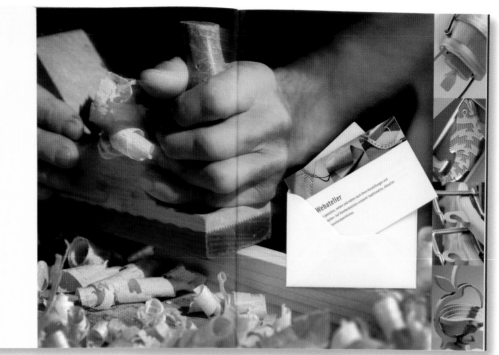

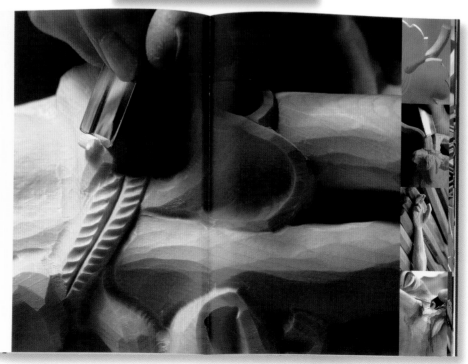

A decade in x-ray

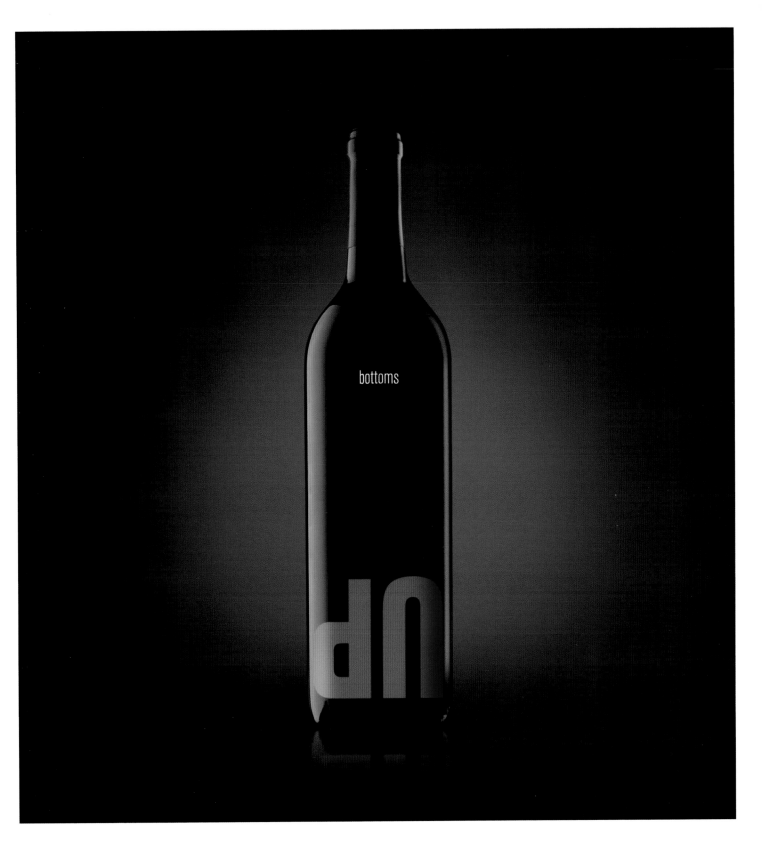

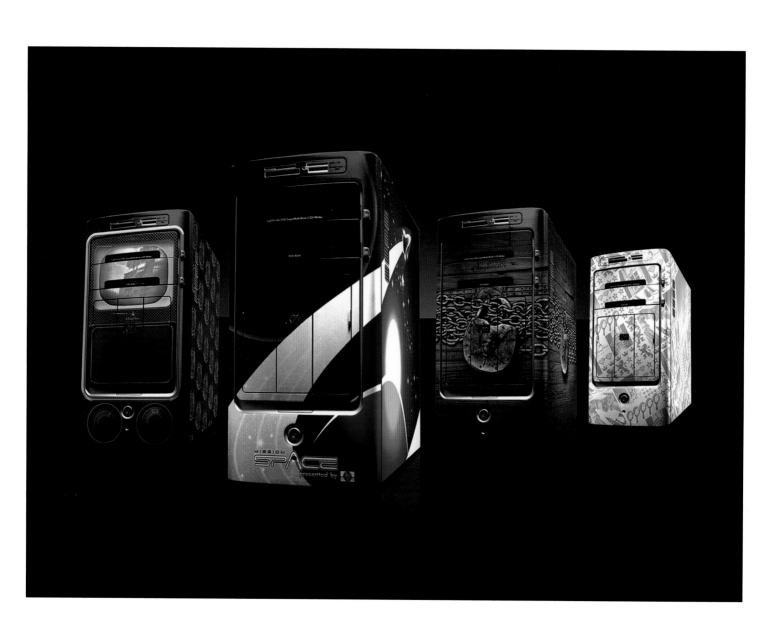

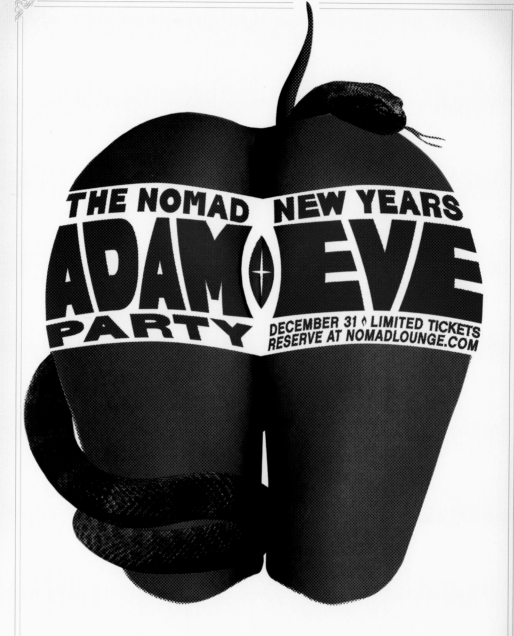

THE NOMAD NEW YEARS
ADAM ✦ EVE
PARTY DECEMBER 31 ✦ LIMITED TICKETS
RESERVE AT NOMADLOUNGE.COM

NOMAD LOUNGE

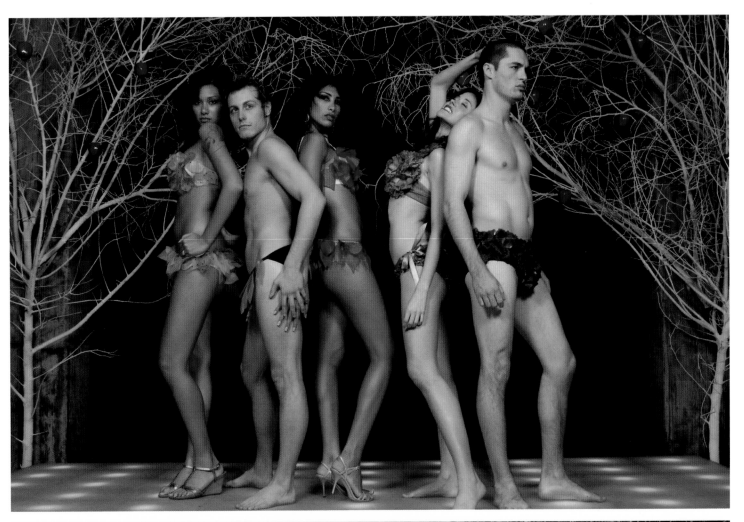

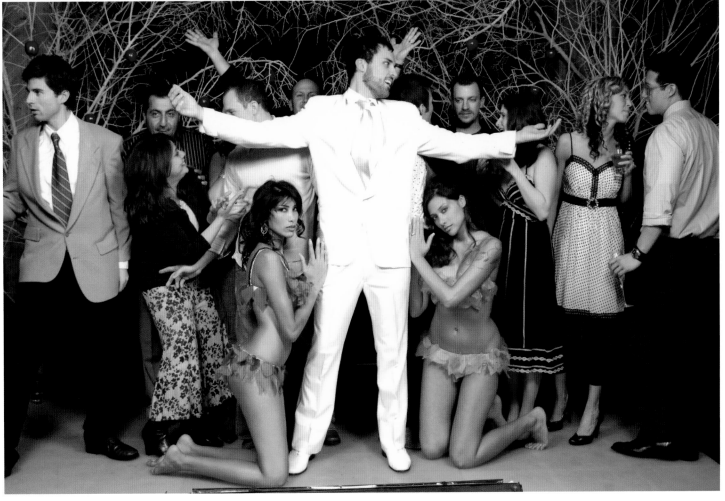

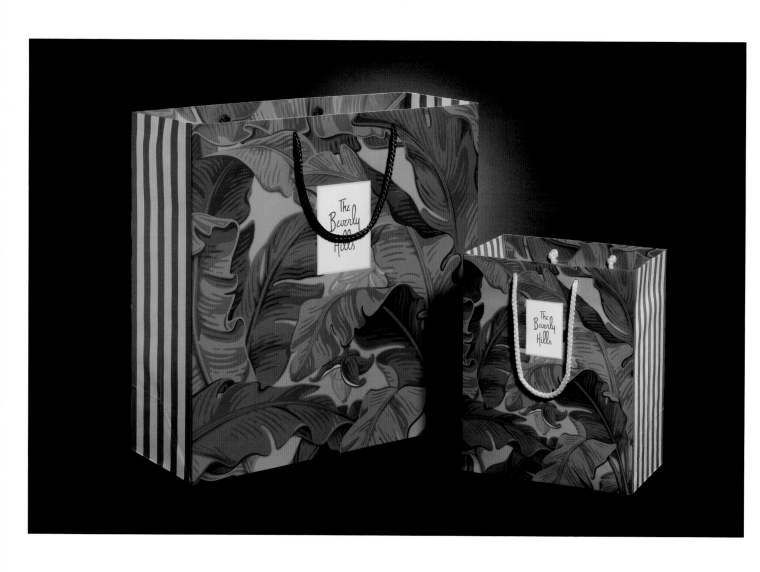

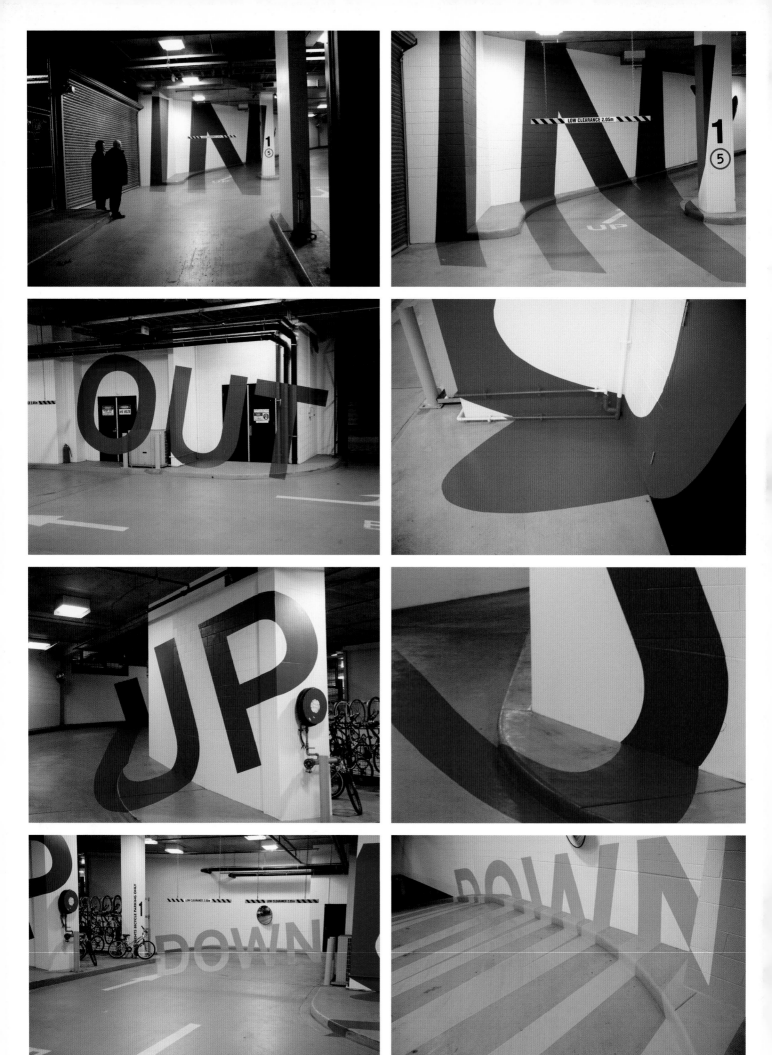

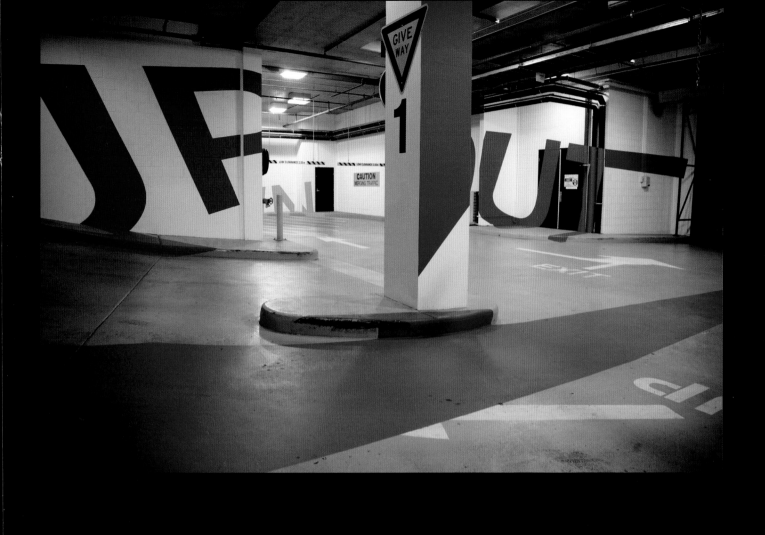

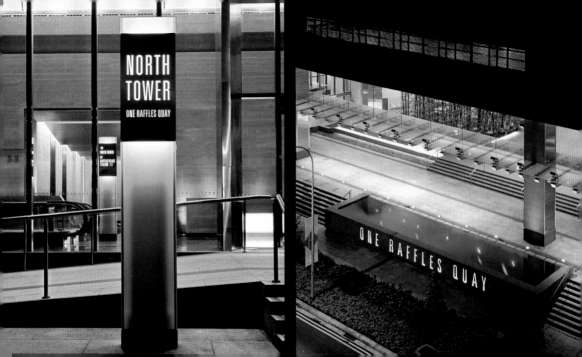

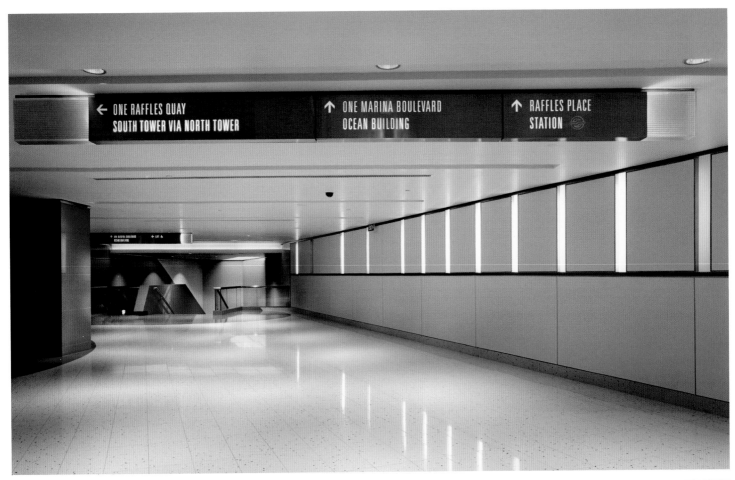

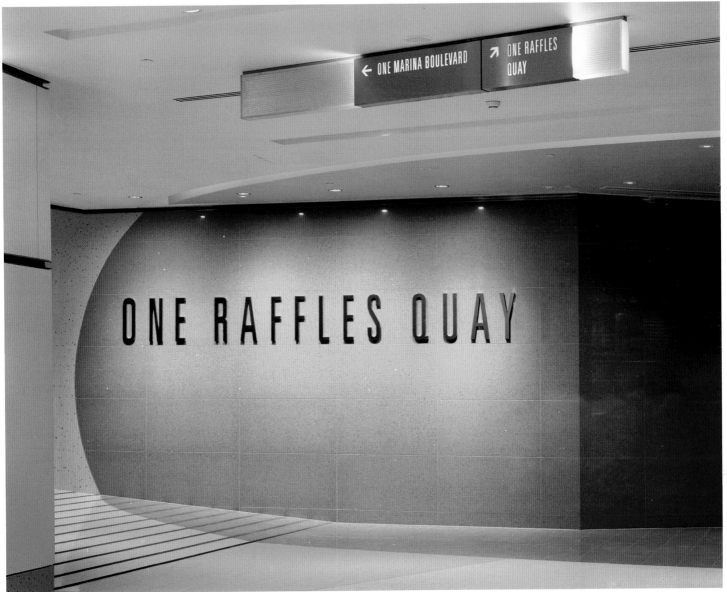

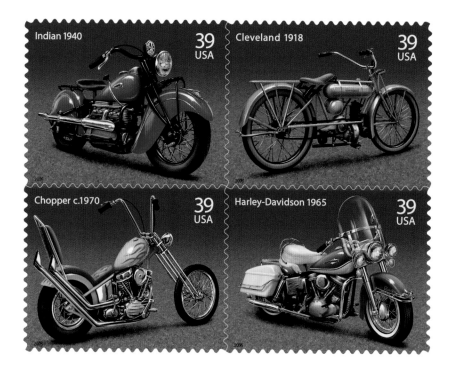

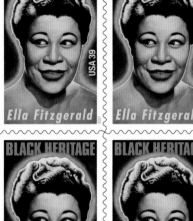

U aaaaaaaaa
aaaaaaaaa
aaaaaaaaaaaaaaaaa
aaaaaaaaaaaaaaaaa
aaaaaaaaaaaaaaaaa

The t-shirt reads:

SOUTHERN EXPOSURE'S NEW SHOW IS [NAME OF SHOW:] AND CAN BE VIEWED AT [SHOW LOCATION:] I WENT AND SAW THIS WITH [FRIEND/FAMILY/MATE:] & [FRIEND/FAMILY/MATE:] AND THOUGHT IT WAS [FEELINGS ABOUT THE SHOW:]

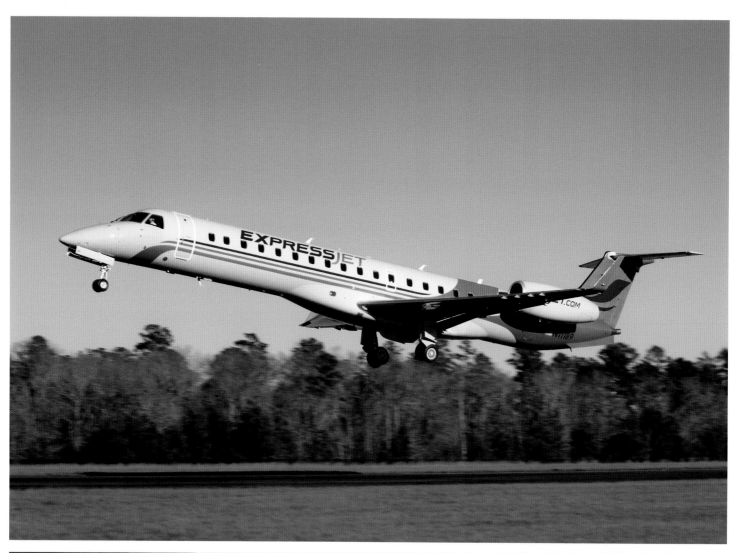

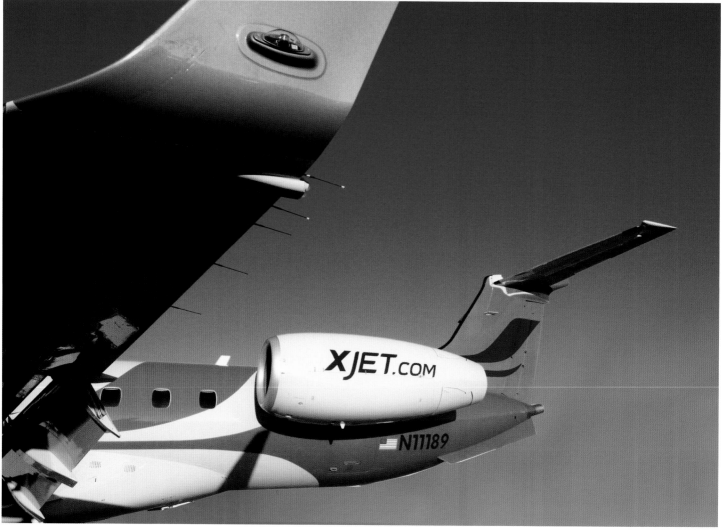

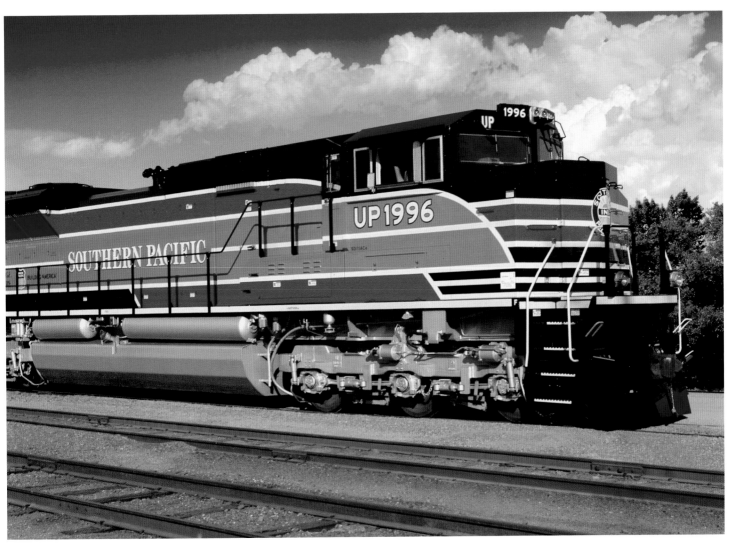

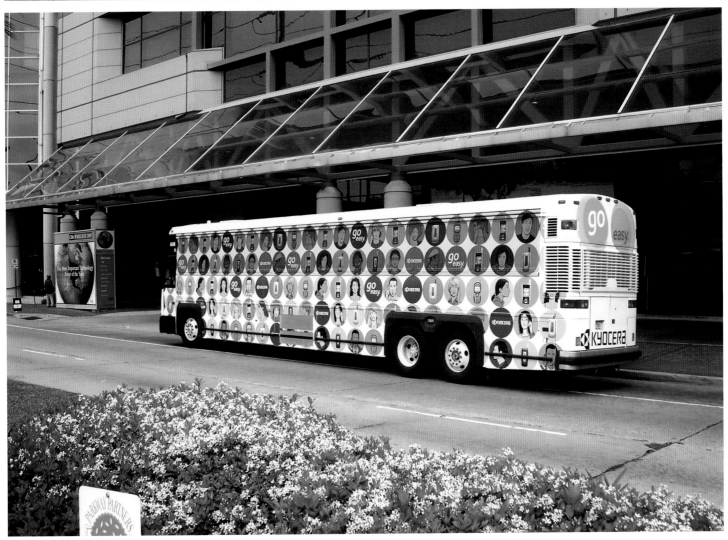

(top) **Bailey Lauerman** | Union Pacific | (bottom) **VITROROBERTSON** | Kyocera | TransportationDesign **229**

WAND FONT

A B C D E F G H I J K L M
N O P Q R S T U V W X Y Z
a b c d e f g h i j k l m
n o p q r s t u v w x y z

△ & I / . , ; : ' ! ? | #
() [] + − = ÷ / < > { }
$ ¢ % ∞ * ~ ÷ ø © @
" 1 2 3 4 5 6 7 8 9 0 "

HOWARD SCHATZ
With thanks to Matthew Carter

ABCDEFGHIJKLMNOPQRSTUVWXYZ

Aa Bb Cc Dd Ee Ff Gg Hh Ii Jj Kk Ll Mm Nn Oo Pp Qq Rr Ss Tt Uu Vv Ww Xx Yy Zz

abcdefghijklmnopqrstuvwxyz abcdefghijklmnopqrstuvwxyz

Аа Бб Вв Гг Дд Ее Жж Зз Ии Йй Кк Лл Мм Нн Оо Пп Рр Сс Тт Уу Фф Хх Цц Чч Шш Щщ Ъъ Ыы Ьь Ээ Юя

абвгдежзийклмнопрстуфхцчшщъыьэюя

абвгдежзийклмнопрстуфхцчшщъыьэюя

Аа Бб Вв Гг Дд Ее Жж Зз Ии Йй Кк Лл Мм Нн Оо Пп Рр Сс Тт Уу Фф Хх Цц Чч Шш Щщ Ъъ Ыы Ьь Ээ Юю Яя

αβγδεζηθικλμνξοπρστυφχψω αβγδεζηθικλμνξοπρστυφχψω

ΑαΒβΓγΔδΕεΖζΗηΘθΙιΚκΛλΜμΝνΞξΟοΠπΡρΣσΤτΥυΦφΧχΨψΩω

ΑαΒβΓγΔδΕεΖζΗηΘθΙιΚκΛλΜμΝνΞξΟοΠπΡρΣσΤτΥυΦφΧχΨψΩω

Credits

2 Collection of images for the SGAE/Fundación Autor Annual and Creator's Diary 07 | DesignFirm: Carrio Sanchez Lacasta, Madrid | ArtDirector: Carrio Sanchez Lacasta | Chief Creative Officer: Carrio Sanchez Lacasta | Creative Director: Carrio Sanchez Lacasta | Designer: Carrio Sanchez Lacasta | Illustrator: Pep Carrio | Photographer: Enrique Cotarelo | Client: SGAE/Fundación Autor

Every year SGAE gives the job of doing the illustrations for the diary and the annual. This year Pep Carrio conceived a series of 'thinker-heads' showing the creation moment.

4 Brand ID Photo Series | Design Firm: Hoyne Design Pty Ltd, St Kilda | Art Director: Andrew Hoyne | Designers: Andrew Hoyne, Pia Sabbadini | Photographer: Marcus Struzina | Client: Bolinda Audio

Brief: Create a brand campaign for Bolinda Audio that capitalizes on the Bolinda talking book icon and reinforces the Bolinda positioning of turning the everyday into a journey of discovery.
Solution: A photography series that takes the icon into situations and environments where one could genuinely listen to an audio book. Design the shots for multiple use: advertising, catalogue spreads, point of sale and web applications. Appeal to all Bolinda target groups: adult, young adult and children.
Result: A bank of images that place Bolinda audio books in everyday situations and invite the viewer to increase their repertoire of usage occasions. A further enhancement to the vibrant personality of the Bolinda brand.

6 See: The Potential of Place, Fifth Issue | Design Firm: Cahan & Associates, San Francisco | Art Directors: Bill Cahan, Steve Frykholm, Todd Richards | Creative Director: Bill Cahan | Designers: Todd Richards, Erik Adams | Illustrators: Artemio Rodriguez, Joseph Hart, Brian Carter | Photographers: Heimo Schmidt, Vivienne Flesher, Robert Schlatter, Catherine Ledner, Andy Sacks, Colin Faulkner, Brian Carter | Writers: Pamela Erbe, Nancy Ramsey, Debra Wierenga, Linton Weeks, Brian Carter | Client: Herman Miller

8 Graphis Platinum Award | Firm: Phil Marco Productions, New York | Photographer: Phil Marco | Client: Graphis Inc.

10 PLATINUM UC Student Recreation Center Archigraphic Murals | Design Firm: Rebeca Méndez Communication Design, Los Angeles | Art Director: Rebeca Méndez | Creative Director: Rebeca Méndez | Designer: Rebeca Méndez | Illustrators: Susanna Dadd, James Griffith | Photographer: Rebeca Méndez | Print Producer: Adam Eeuwens | Writers: Adam Eeuwens, Rebeca Méndez | Client: Morphosis Architects

Thom Mayne and his firm Morphosis designed a 353,000 sq.ft. student recreation center on the campus at the University of Cincinnati, which opened in May 2006. Rebeca Méndez was commissioned to create two permanent installations at the recreation center, one in the convenient store (c-store) and another at the food court.
For the c-store, the University imagined market scenes; Méndez had her own solution in mind. Hovering over the giant bags of Doritos and university paraphenalia, she composed 24 extreme panoramic landscapes. Ms. Méndez refers to them as 'ever sustaining landscapes. All products and nourishment have as their origin the extraction or harvest of the raw materials provided by the earth'. Méndez's interest is to give the viewer a glimpse of these raw materials in their integrity and beauty, as well as expose the distribution and processing of these goods before they are conveniently packaged for consumption at the c-store.
For the food court, Méndez was commissioned to create murals on four cone-like structures, two of them reaching over 50 feet high and piercing through the roof. The cone structures envelop the kitchens of the food court, and hide all the piping and machinery necessary for such enterprises. Méndez's investigations into how to create a visual dialogue between flora, the Architecture, and the site led her to select grass – specifically giant reed grass – for her artwork. Over many months and continents, Méndez photographed grass from various points of view and under the different weather conditions, allowing light and wind to create visual difference, and to reveal the patterns that one simple form – a blade of grass – produces through complex organization. Over a period of five weeks the muralists James Griffith and Susanna Dadd painted the compositions Méndez created onto the cones.
More information on this project appears on pages 10 and 11.

12 PLATINUM The Art of the Grid | Design Firm: Astrid Stavro, Barcelona | Art Director: Astrid Stavro | Chief Creative Officer: Astrid Stavro | Creative Director: Astrid Stavro | Designers: Astrid Stavro, Birgit Pfisterer | Client: The Royal College of Art

Backgroud info: Grids form an essential part of our lives. We may not always notice them, but their influence on what we see, hear and do is everywhere. By moving the grids from the background to the foreground, and divorcing them from their content, I pay homage as well as render the invisible visible. As Designers, understanding the advantages as well as the limitations of the grid helps us determine what place they should take in our own work. The grid, like any other instrument in the Design process, is not an absolute. Like computers, they are simple Design tools. It is the process of challenging or questioning these assumptions that is important, because in doing so we re-evaluate our perception of the environment and our role within it.
A Brief Note: Grid-it! Notepads have extended into The Art of the Grid products, which include shelving units and cutting mats.
The product, GRID-IT! Notepads: The Grid-it! Notepads series is based on the layout grids of famous publications. They are a selection of grids that played a historic role in the development of Design systems, covering a wide spectrum of classic and contemporary editorial Design.
More information on this project appears on pages 12 and 13.

14 Graphis Platinum Award | Firm: Phil Marco Productions, New York | Photographer: Phil Marco | Client: Graphis Inc.

AnnualReports

16 2006 Annual Report | Design Firm: Weymouth Design, Boston | Art Director: Robert Krivicich | Designers: Aaron Haesaert, Justin Gonyea, Gary Pikovsky | Photographers: Michael Weymouth, Tim Llewellyn | Print Producer: Kirkwood Printing | Writer: John Temple | Client: Courier Corporation

17 PLATINUM Radio New Zealand 2006 Annual Report | Design Firm: Clemenger BBDO, Wellington | Art Directors: Dianne Fuller, Bruce Hamilton | Creative Director: Bruce Hamilton | Designer: Dianne Fuller | Illustrators: Chris Chisnall, Geoff Francis, Steve Jaycock | Photographers: Dennis Hitchcock, Ian Robertson | Writer: Mark Di Somma | Client: Radio New Zealand

Background: Radio New Zealand is a public service broadcaster. Through their charter, Radio New Zealand has a direct responsibility for ensuring that New Zealand is free to speak its mind, to express itself and to enjoy the many sources of information and culture that affect and influence the nation. Radio New Zealand needed to maximize their value; going through a rebrand started this process. The overall objective for the rebrand was to revitalize the Radio New Zealand image and maximize the value of Radio New Zealand as a Public Service Broadcaster and a great New Zealand asset. The current image was clouding the product. They had to overcome perceptions that their listeners were old and wore cardigans. They also needed to minimize the confusion between the many business units that were currently not seen as part of the Radio New Zealand offering (Each business unit trademark was different, and there was no visual link back to Radio New Zealand).
The Annual Report: The idea was to reveal the voice of our culture. An Annual Report is always a great way to reflect on what has been happening in the year just past. Radio New Zealand had been doing a lot of reflecting on who they were and what they looked like through the process of rebranding. Because they are a public service broadcaster, they reflect and capture the many voices of New Zealand.
Proposition: Radio New Zealand gives our culture a voice.
Solution: Who we are as a broadcaster reflects who we are as a nation. The mirror on the cover was a creative way to express the idea that you and me are part of what makes Radio New Zealand unique. The large portrait images helped convey the many voices Radio New Zealand captures and reflects, their listeners, and also symbolized the personalities of their five business units. The portraits were dramatically split in half to continue the reflection theme, of what they would look like in sound. The five business units featured as part of the finale of the AR introduction clearly minimize the past confusion of what business units made up the great New Zealand's asset.

18 Maxygen 2005 Annual Report | Design Firm: Cahan & Associates, San Francisco | Art Director: Bill Cahan | Creative Director: Bill Cahan | Designer: Erik Adams | Writers: Erik Adams, Jeannine Medeiros | Client: Maxygen

Maxygen, a biotech company, will be entering a critical and exciting phase of transformation during the next year as their products complete the preclinical phase and enter clinical development. The metaphor of the caterpillar changing into a butterfly is used to illustrate the maturity of the company and their products. The metaphor is continued with the vertical typography, which is hung like a chrysalis. The 10-K wrap is covered in a dust-jacket that folds out into a 22 x 22 inch Poster, which then can be folded into a butterfly-using origami instructions included in the back of the 10-K.

19 Australians laugh outloud for Camp Quality | Design Firm: DesignworksEnterpriseIG, Sydney | Creative Director: Olivia Swinn | Designer: Adam Trunk | Client: Camp Quality

Camp Quality is a charitable organisation set up to support children with cancer and their families. Their purpose is to provide families with respite from what is often intense treatment programmes and they do so with a unique brand space of FUN THERAPY, which is underpinned by the strapline 'laughter is the best medicine' and an engaging character called Giggle. In this Annual Report, Giggle interacts with famous Australians making them laugh out loud for Camp Quality. Our intent was to pull together a series of well known and influential Australians so that not only could the series be used in the AR, but it could also become a travelling exhibition. We are still adding to the collection.

20 iStar Financial Corporate Identity | Design Firm: Addison, New York | Chief Creative Officer: Leslie Segal | Creative Director: Richard Colbourne | Designer: Christina Antonopoulos | Illustrator: dzarkdesign studio | Client: iStar Financial Inc.

iStar Financial, a publicly traded finance company focused on the commercial real estate industry, is another example of how Addison works with companies to develop their websites, all based on our solid knowledge of the company's business. The challenge was to create a vehicle for the new brand Addison created, reinforce the exclusive status of the company, demonstrate the long-term strategy of the company and to create differentiation, relevance and credibility among its key stakeholders. After strategizing the approach to creating iStar's new visual identity, Addison designed and developed a new corporate website that reflects meticulous attention to detail, brand accuracy, and messaging effectiveness. The strategy and purpose was to influence audience perceptions of the company and convey the brand character attributes consistently through graphic design. The new website applied the strategic messaging that Addison developed that spoke to their various stakeholders. iStar's new positioning established them as the premium provider in the REIT marketplace by embodying a simple, powerful, and functional visual identity that continues to grow and develop over the five years we have worked with them.

21 Boy Scouts of America Greater Pittsburgh Council 2005 Annual Report | Design Firm: Brady Communications, Pittsburgh | Production Specialist: John Moore | Art Director: Jenny Pearson | Chief Creative Officer: John Brady | Client: Boy Scouts of America Greater Pittsburgh Council

The 2005 Greater Pittsburgh Council Boy Scouts of America presented some unique challenges. Instead of one theme on which to focus, the Boy Scouts had a number of smaller events that added up to a great year for them. As a result, we designed the AR to have a look and feel of a scrapbook with intent to have the Annual look as if a Boy Scout had carried it in his backpack for a year. We distressed each page of the book by hand, using sandpaper to 'age' the paper and bending the corners to eliminate sharp points. The end result is an Annual Report that truly conveys a sense of something of record.

AwardAnnuals

22 Tangible/Intangible: Senior Library 2005 | Design Firm: School of Visual Arts, New York | Art Director: Paula Scher | Chief Creative Officers: Paula Scher, Richard Wilde | Creative Directors: Paula Scher, Richard Wilde | Designers: Paula Scher, Lenny Naar, Julia Hoffman | Writer: Alice Twenlow | Client: School of Visual Arts

A showcase of the best work of the graduating class of 2005 from the Advertising and Graphic Design Department at the School of Visual Arts. The intent of the book is to demonstrate the excellent work of seniors at SVA who are studying Advertising Design, Graphic Design, Three-Dimensional Design and Motion Graphics. Each year the book is edited and designed by a different Senior Portfolio instructor at SVA.

Books

23 Freestyle Book | Design Firm: Frost Design, Surry Hills | Art Director: Vince Frost | Chief Creative Officer: Vince Frost | Creative Director: Vince Frost | Designers: Vince Frost, Anthony Donovan, Ben Backhouse, Ray Parslow | Client: Object Gallery/Melbourne Museum

Freestyle is a ground-breaking exhibition and book of contemporary Australian Design for living. The challenge was two-fold: create a solution that is a strong statement about Design in its own right while also being able to effectively present the works of 40 other Designers without getting in the way aesthetically. Also key to the brief was incorporating the branding of sponsor Bombay Sapphire. Our idea was based on using a blue transparent perspex square as a framing device for the artist and their work (while also acting as a reference to the sponsor's brand and their iconic blue glass bottle). Each of the 40 Designers was photographed in their own environment, interacting with the blue frame in their own way. The square form was carried through to the Freestyle identity, which uses a modular geometric type, and using the squares as the structural grid for the book, website and other collateral.

24,25 PLATINUM Peter Beard Art Edition, No. 251-2500 | Design Firm: TASCHEN America, Los Angeles | Art Director: Ruth Ansel | Artist: Peter Beard | Editors: Nejma Beard, David Fahey | Authors: Owen Edwards, Steven M. L. Aronson | Client: Peter Beard

Photographer, collector, diarist, and writer of books, Peter Beard has fashioned his life into a work of art; the illustrated diaries he kept from a young age evolved into a serious career as an artist and earned him a central position in the international art world. He was painted by Francis Bacon, painted on by Salvador Dalí, and made diaries with Andy Warhol; he toured with Truman Capote and the Rolling Stones, created books with Jacqueline Onassis and Mick Jagger - all of whom are brought to life, literally and figuratively, in his work. As a fashion Photographer, he took Vogue stars like Veruschka to Africa and brought new ones - most notably Iman - back to the US with him. His love affair with natural history and wildlife, which informs most of his work, began when he was a teenager. He had read the books of Isak Dinesen (Karen Blixen), and after spending time in Kenya and befriending the author, bought a piece of land near hers. It was the early 1960s and the big game hunters led safaris, with all the colonial elements Beard had read about in Out of Africa characterizing the open life and landscape, but the times were changing. Beard witnessed the dawn of Kenya's population explosion, which challenged finite resources and stressed animal populations – including the starving elephants of Tsavo, dying by the tens of thousands in a wasteland of eaten trees. So he documented what he saw with diaries, photographs, and collages. He went against the wind in publishing unique and sometimes shocking books of these works. The corpses were laid bare; the facts were carefully written down, sometimes in type, often by hand, occasionally with blood. Spilling out over the pages of this massive tome, Beard's collages are reproduced as a group for the first time at the size they have always meant to be seen, some as foldouts. Hundreds of smaller-scale works and diaries fill the remaining spreads, magnified to show every detail, from Beard's meticulous handwriting and old-master-inspired drawings to stones and bones and bits of animals pasted to the page. Available in both Art and Collector's editions, this opulent and beautifully crafted limited edition – complete with wooden stand - is a work of art in itself.

Features: Comes with a specially fabricated wood book stand·XXL-Format: 34.5 x 50 cm·Main book: 200 pages of diaries and 294 pages of collages + 5 fold-outs·Original essay by photo critic Owen Edwards·Companion volume: PB2 image index with captions for all images from main book, personal photos and early work of the artist, interview with the artist by Steven M. L. Aronson, a facsimile reprint of Beard's 1993 handwritten essay from the sold-out first issue of Blind Spot magazine, extensive bibliography, and a list of exhibitions·All color illustrations are color-separated and reproduced in Pan4C, the finest reproduction technique available today, which provides

unequalled intensity and color range·Limited to 2,250 individually numbered copies, each signed by Peter Beard·Comes in a clamshell box

The Artist: Born in New York City, Peter Beard (born 1938) began keeping diaries and taking photographs as an adolescent. By the time he graduated from Yale, he had developed a keen interest in Africa; in the early 1960s he worked at Kenya's Tsavo National Park, during which time he photographed and documented the demise of over 35,000 elephants and published his first book, The End of the Game. His first show came in 1975 at the Blum Helman Gallery, and was followed in 1977 by the landmark installation of elephant carcasses, burned diaries, taxidermy, African artifacts, books and personal memorabilia at NY's International Center for Photography. He has also worked as a fashion Photographer and collaborated on projects with Andrew Wyeth, Richard Lindner, and Terry Southern. In 1996, shortly after Beard was trampled by an elephant, his first major retrospective opened at the Centre National de la Photographie in Paris, followed by others in Berlin, London, Toronto, Madrid, Milan, Tokyo, and Vienna. He lives in New York City, Long Island, and Kenya with his wife, Nejma, and daughter, Zara.

The Editors: Nejma Beard has been Peter Beard's agent and the director of the Peter Beard Studio since 2001. She has curated and co-curated shows in Paris, London, Milan, and LA, and assisted on the publication of Zara's Tales. David Fahey is co-owner of the Fahey/Klein Gallery, LA. During his 31-year career in the field, he has collaborated on over 45 fine art Photography books. He is the co-vice president of the Herb Ritts Foundation and serves on the Photography Advisory Council for the J. Paul Getty Museum.

The Art Director: Ruth Ansel is an award-winning Art Director at many of America's top fashion and cultural magazines since the 1960s. Ansel Design Studio (est. 1992) has produced international fashion campaigns and books with Photographers including Beard, Richard Avedon, and Annie Leibovitz.

The Authors: Owen Edwards has written about Photography for 30 years, for the American Photographer, New York Times Magazine, Smithsonian magazine, and many other publications. Steven M. L. Aronson, a former book publisher, is a writer and editor. He edited and published Beard's book Longing for Darkness. He is the author of HYPE and co-author of Savage Grace.

26 Dangerous Liaisons | Design Firm: Matsumoto Incorporated, New York | Art Director: Takaaki Matsumoto | Creative Director: Takaaki Matsumoto | Designer: Takaaki Matsumoto | Photographer: Joe Coscia, Oi-Cheong Lee | Writers: Harold Koda, Andrew Bolton | Client: Metropolitan Museum of Art

This is a catalogue for an exhibition at the Costume Institute of the Metropolitan Museum of Art. The exhibition took place in the French period rooms at the musem, with mannequins dressed in eighteenth century dress. The catalogue was published after the exhibition closed because all of the plates are photographs of the exhibition installation. Since the vignettes of the exhibition are so strong, the photographs are large and dramatic. There is very little type to detract from the arresting imagery.

27 AngloMania | Design Firm: Matsumoto Incorporated, New York | Art Director: Takaaki Matsumoto | Creative Director: Takaaki Matsumoto | Designer: Takaaki Matsumoto | Photographer: Joe Coscia | Writer: Andrew Bolton | Client: Metropolitan Museum of Art

This is an exhibition catalogue for the Costume Institute at the Metropolitan Museum of Art. The exhibition and catalogue are companions to the exhibition "Dangerous Liaisons." The exhibition took place in the English period rooms, and the mannequins were dressed in both eighteenth century and contemporary dress. Aside from the amazing clothing, all the mannequins had outrageous wigs or headpieces. Because the visual imagery of the exhibition was so dramatic, the photos of the exhibition take precedence, and there is very little type. To reinforce the theme, the cover was printed with a watercolor image of the Union Jack.

28 Joe | Design Firm: Matsumoto Incorporated, New York | Art Director: Takaaki Matsumoto | Creative Director: Takaaki Matsumoto | Designer: Takaaki Matsumoto | Photographer: Hiroshi Sugimoto | Writer: Jonathan Safran Foer | Client: Pulitzer Foundation for the Arts

This book was published to accompany an exhibition of Hiroshi Sugimoto's at the Pulitzer Foundation for the Arts, but is not an exhibition catalog. The photographs were taken by the artist at the Pulitzer Foundation and feature Richard Serra's sculpture "Joe." Rather than have the artwork accompanied by an interpretive or critical text, the artist asked novelist Jonathan Safran Foer to write a piece that would work with the artwork, but not describe it. The result is a collaboration between artwork and text. The large size accommodates the striking artwork. Only 3,000 copies were printed.

29 James Turrell, A Life In Light | Design Firm: Robert Romiti, London | Art Director: Robert Romiti | Chief Creative Officer: Louise T Blouin MacBain | Creative Director: Robert Romiti | Designer: Robert Romiti | Photographers: Florian Holzherr, James Dee, Richard Nicol, Antony Makinson | Print Producer: Somogy, Paris, France (Publishers) with ReBus srl, Italy (Printers) | Writers: Andrew Graham-Dixon, Michael Hue-Williams | Client: Louise T Blouin Foundation

I designed this book for the opening and first major exhibition of the Louise T Blouin Foundation in West London, called 'James Turrell, A Life In Light.' This is a not-for-profit philanthropic arts foundation founded by Louise T Blouin MacBain.

The book's purpose was to show a relationship with the natural light, materials, and unexpected realities that different light environments can create. Viewers are transfixed by Turrell's play with light, and how it changes dependant on time and the environments around us. It's fascinating how he uses a tech-

nique of shining a square or triangle of coloured light into a room's corner. From certain angles they produce a Platonic solid of a cube or tetrahedron that floats in space. He also uses a phenomenon of Ganzfeld, a form of snow blindness producing disorientation and the inability to distinguish between snow below and sky above.

I tried to make silent references to this way of looking at light, and how it can disorient us in different surroundings. For example, if one looks at the pages which have the double spread quotes outside in a sunny environment, one can be transfixed quite the same way the Ganzfeld phenomenon creates. You may notice subtle diffences a varnish can play upon metallic type. Also, the flurescent colour I used on the front cover, back cover and inside first/last page causes an effect on our perception, differently from the slit on FC and BC, and is almost blinding when revealed in whole. I used foil blocking on the titles, and created a sort of cathedral or biblical feeling with the graphics. The cover dye-cut through the heavy compressed board does not actually go all the way through -a sort of unexpected surprise. I also created an exact mirror image of the back cover to the front, where everything is reversed... referencing the feeling light can create, the way it can cut through things, the way it has cut through the book.The entire book uses a reverse french fold. The entire inside of the french fold has been printed in flourescent inks (a double hit). On white surroundings there is a subtle vibration on the surface around. Like Turrell's work, sometimes one has to take a second look.

This book was printed using the DINN colour system, which gives more exact colour matches when trying to produce the vivid, almost perfect hue tones commonly found in Turrell's work. The typeface used for the titles and quotes is called Quadraat, developed in the Netherlands in 2003. It felt perfect for the subject, almost biblical in feel, but more contemporary. I used Frutiger throughout most of the body copy.

As the first book, this is an example of the other books to come. Being a small arts foundation, I felt our books should feel almost home-made, so the use of natural and translucent materials felt right. We intend to use similar materials for future publications. 'James Turrell: A Life in Light' and all publications for the Louise T Blouin Foundation are published by Somogy – a French company specialising in producing over 100 art books and exhibition catalogues for leading museums and galleries in France, Belgium, Switzerland, the USA and Canada (http://www.ltbholding.com/products/somogy.html).

30,31 DOMUS 1928-1999, VOL. I-XII | Design Firm: TASCHEN America, Los Angeles | Editors: Charlotte J. Fiell, Peter M. Fiell | Client: domus

For over seventy-five years, domus has been hailed as the world's most influential Architecture and Design journal. Founded in 1928 by the great Milanese Architect Gio Ponti, the magazine's central agenda has always remained that of creating a privileged insight toward identifying the style of a particular age, from Art Deco, Modern Movement, Functionalism and Postwar to Pop, Post-Modernism and Late Modern. Beautifully designed and comprehensively documented, page after page domus presents some of the most exciting Design and Architecture projects from around the world. TASCHEN's twelve-volume reprint features selected highlights from the years 1928 to 1999. Reproducing the pages as they originally appeared, each volume is packed with articles that bring to light the incredible history of modern Design and Architecture. A truly comprehensive lexicon of styles and movements, the volumes are accompanied by specially commissioned introductory texts that not only outline the history of the magazine but also describe what was happening in Design and Architecture during each era covered. The volumes have also been thoroughly indexed, allowing the reader easy access to key articles - many of which have been translated into English for the first time. Hardcover, 12 vol.+ Index CD, 21.8 x 31.4 cm (8.6 x 12.4 in.), 6960 pages.

32 DUF | Design Firm: Ontwerphaven, Den Haag | Art Director: Suzanne Hertogs | Creative Director: Suzanne Hertogs | Designer: Suzanne Hertogs | Illustrators: Keiichi Bandou, Moni van Berkel, Wilma de Bok, Bob van Dijk, Sanne Duijf, Hederik van der Kolk, Bas de Koning, Heleen Engels, Paul Faassen, Nine Fluitsma, Floortje Bouwkamp, Hester van de Grift, Natascha Helmer, Janneke Hendriks, Suzanne Hertogs, Jeroen de Leijer, Leendert Masselink, Anne Miltenburg, Pepijn van den Nieuwendijk, Nozzman, Maartje Overmars, Ben Peters, Harriët van Reek, Joost Roozekrans, Alain Soetermans, Sally Targa,Jeannette Tepaske, Ben Tolman, Roel Venderbosch, Babette Wagenvoort, Jeroen Wilts | Photographers: Ilja Beudel, Naomi Buijse, Remko Delfgauw, Oliver Gruener, Sarah Mei Herman, Kun Istvan, Martijn Peters, Maaike Koning, Mieke Meesen, Margot Rood | Writers: Rani Azucar, Kitty Arends, Danielle Bakhuis, Moni van Berkel, Marc van Biezen, Frans Blok, Petra Boers, Cecile Bolwerk, Karin Brugman, Mirjam Bosgraaf, Frans Blok, Zlata Brouwer, Mia Claes, Morene Dekker, Leendert Douma, Marjolein van Eck, Yvonne Elburg, Sabine Feij, Sandra Gossink, Carel Helder, Suzanne Hertogs, Liesbeth Jansen, Rene Janssen,Jeroen Kleijne, Remco Koffijberg, Daan Kogelmans,Murat Kotan, Ronald van Lent, Hanne Marckmann, Carina Nijssen, Jaap Robben, Anne Roffel, Jochem Rutters, Hester Schaaf, Sparkle, Richard Thiel,Nicole Ros, Johan Slager, Elisa van Spronsen, Anton de Wit, Ivo van Woerden, Wonder, Marcel Zuijderland | Client: Independent Publication

This 'bookazine' was made for teenagers (12-17 years) to seduce them to read more. DUF is like the zapculture these youngsters move in. Different small worlds were created in words and images. DUF is an adventure, like reading is. DUF has small stories, prose, poetry, reportage and many other forms for reading pleasure. DUF was initiated by the Designer as an independent publication. You can buy DUF in Dutch bookshops. In the Netherlands their wasn't such a book available for teenagers before.

33 Blunt | Design Firm: Pentagram Design Ltd., Berlin | Art Director: Justus Oehler | Photographer: Nigel Parry | Client: Nigel Parry

Blunt is a unique book project by the American star Photographer Nigel Parry – a deluxe volume over 180 pages with 145 iconic images, each in Nigel Parry's signature style: intimate, honest and wholly original. His photographs feature the most powerful politicos and the most famous celebrities of our day, including Clint Eastwood, Susan Sarandon, JK Rowling, Brad Pitt, Cate Blanchett, Chuck Berry, Paul Wolfowitz, Condoleezza Rice, George W. Bush, Harvey Weinstein, Hillary Clinton, Dustin Hoffman, George Clooney, George Lucas, 50 Cent, Twyla Tharp and many others. Star Designer Tom Ford also wrote the introduction of Blunt, and its foreword was written by the famous American journalist Roger Rosenblatt.

Nigel Parry's in-your-face style and exacting precision yields portraits which are highly unique and unforgettable. Pentagram Partner Justus Oehler picks up the pure and direct character of Parry's photographs by arranging the photographs and quotes in a special way in order to create eye-catching double pages. The dominant colour is green, which adds a very fresh and striking contrast to the black and white pictures.

34,35 The Visual Constitution of Japan | Design Firm: Shin Matsunaga, Tokyo | Art Director: Shin Matsunaga | Creative Director: Shuji Shimamoto | Designer: Shinjiro Matsunaga | Writer: Shinzo Higurashi | Client: Shogakukan Inc.

36,37 Dirty Blonde: The Diaries of Courtney Love | Design Firm: Headcase Design, Philadelphia | Creative Directors: Abby Kagan, Paul Kepple, Susan Mitchell | Designers: Jude Buffum, Jessica Hische, Paul Kepple, Frances Soo Ping Chow | Writer: Courtney Love | Photographers: Various, including Mark Seliger, Stephane Sednaoui, Ellen Von Unwerth, Jean-Baptiste Mondino, Regan Cameron, Richard Avedon, Anton Corbijn, David LaChapelle, Steve Meisel, Herb Ritts, and Bruce Weber | Client: Farrar, Straus and Giroux

Designed to look like an actual diary/scrapbook, Dirty Blonde contains drawings, handwritten poems, photos, and other ephemera dating as far back as Courtney's childhood.

38,39 The Book on Vegas | Design Firm: Lloyd (+ co), New York | Art Director: Gustaf Torling | Creative Director: Douglas Lloyd | Client: Greybull Press

In celebration of Las Vegas's centennial, The Book on Vegas is the ultimate visual tribute to sin city. An exceptional collection of images of the city as seen through the eyes of many of the most important Photographers, Artists and Filmmakers of the past 50 years, it also includes classic archival images that capture the true essence of what makes Vegas the high/low pleasure capital of the world: its entertainers and celebrities, its winners and losers, the dealers, divas, players and dreamers.

40,41 Gucci by Gucci | Design Firm: Lloyd (+ co), New York | Art Director: Gustaf Torling | Creative Director: Douglas Lloyd | Account Director: Mia Forsgren | Client: Gucci

Gucci by Gucci allows, for the first time, the house archives to be viewed – in the form of bags, clothes, accessories, and a dazzling cache of documentary photographs – the history of the Florentine family-owned saddler that has imprinted its name on the fashion consciousness. Gucci by Gucci is for collectors of Fashion, Art, books and Photography. It also serves as a great reference of the changes throughout Gucci's 85 years.

A deluxe version of Gucci by Gucci is also offered, which comes with leather slipcase, with an embossed Gucci logo.

Gucci by Gucci is unique in that it is the first anthology of their 85 years in the luxury industry. Both a history of the company and a glorious visual exploration of its far-reaching influence, the book is a treat for the collector and the fan.

42,43 PVH Marketing | Design Firm: Calibre Design & Marketing Group, Toronto | Creative Director: Joe Drvaric | Designers: Damian Salter, Lori Wattie, Tim Fong | Writer: Tom Moffatt | Art Directors: Michael Kelly, Anthony Trama | Photographer: Troy Plota | Print Producer: Colour Innovations | Client: Phillips-Van Heusen Corporation

An image book created to present the essence and elements of the IZOD brand to licensees around the world.

Branding

44,45,46,47 Canyon | Design Firm: KMS Team GmbH, Munich | Art Director: Helena Frühauf | Chief Creative Officer: Knut Maierhofer | Creative Director: Christoph Rohrer | Designer: Grace Chou | Project Manager: Sandra Ehm | Print Producer: Melanie Sauer | Client: Canyon Bicycles GmbH

Canyon Bicycles commissioned us to redesign its corporate appearance. In the context of a holistic corporate identity process, we advise the manufacturer of exclusive sports bicycles in the areas of brand development, corporate Design and communication in space. The central element is the striking, left-tilted lettering.

48,49 Lovelace Health System Rebrand Launch | Design Firm: Kilmer&Kilmer Brand Consultants, Albuquerque | Art Directors: Richard Kilmer, Randall Marshall | Designers: Wayne Allen, Renee Innis | Photographer: Michael Barley | Client: Lovelace Health System

The 85-year-old Lovelace Health System brand was in need of an overhaul. We re-invented their brand by capitalizing on the word 'love' in their name. A powerful word that communicates care, passion, sensitivity and comfort. Our graphic solution features a versatile gerbera daisy with an aesthetic appeal, particularly to women, the primary decision makers in healthcare. We integrated this solution into a corporate identity system that now ties together a previously fragmented brand.

50,51 Cava Identity | Design Firm: Concrete Design Communications Inc., Toronto | Art Directors: Diti Katona, John Pylypczak | Designer: Agnes Wong | Illustrator: Agnes Wong | Client: Cava

Cava is acclaimed chef/owner Chris McDonald's interpretation of rustic, modern dining – a wine and tapas bar featuring eclectic flavours from Spain, Italy and France with occasional Mexican flourishes. Concrete designed an identity program featuring a series of whimsical illustrations that capture the

..
..

Credits

casual and playful dining experience as well as the restaurant's reputation for in-house cured meats.

52,53 FLIPP | Design Firm: Hoyne Design Pty Ltd, St Kilda | Creative Director: Dan Johnson | Designer: Dan Johnson | Photographer: Marcus Struzina | Print Producer: Hampton Press | Client: FLIPP

Brief: Create a brandmark and supporting promotional material for FLIPP, a new Sydney-based Photography agency and image library.

Solution: Design a contemporary wordmark, using the mirror image of the word FLIPP so that the name is quite literally flipped. Encourage client interaction by die-cutting the workmark from promotional material and reproducing photographs as mirror images.

Result: The interactive quality of the material made FLIPP memorable for their intellect and creativity, and gave the brand a significant point of difference.

54,55 PLATINUM Corporate ID | Design Firm: Landor Associates, San Francisco | Creative Director: Nicolas Aparicio | Designers: Anastasia Laksmi, JJ Ha, Brian Green | Client: Wolfgang Puck

Wolfgang Puck is an icon. Landor helped to make his brand iconic.

Wolfgang Puck, an indisputable icon in innovative California cuisine and the chef to the stars, wanted to gain back the control of his brand portfolio under one single vision and identity system. Mired in more than a decade of unmanaged license and franchise proliferation, Wolfgang Puck wanted to create a legacy he was proud of. Over the past years, Wolfgang had lost control over his brand due to an increasing number of licensing agreements that lacked any form of graphic and/or brand strategy guidelines. His name had been indiscriminately plastered on frozen pizza boxes, panini-making machines, cans of soup, airport restaurants, and other revenue-generating entities.

He hired Landor to help define the Wolfgang Puck brand strategy and to create an identity platform for the brand to live on well after he retires. Landor's work allowed Wolfgang Puck to examine the consumer holistically as a brand consumer, rather than a single category consumer, and leveraged cross-category offerings to maximize brand impact, and potentially revenues.

While the original task was simply to bring some consistency to the line, we identified the need to define a core idea for the brand and a brand architecture that would define a clear relationship between those business-to-consumer touch points like fine dining restaurants, casual dining and consumer products, and business-to-business touchpoints such as the catering business.

Informed by the brand idea, imagine, which reflects Wolfgang himself, always reinventing the future of food within a world of entertainment, we created a unified system we called a 'a peek into the world of Wolfgang.' The system is defined by a strong graphic panel on the top of any application, reserved for Wolfgang himself, where he is featured in an activity appropriate for the desired messaging. Product Photography is never staged. It is photographed as if it was in the process of being made within the context of a restaurant. The new identity built upon the idea that the brand's products and dining venues were personally created by Puck, not a corporate food-processing brand. He alone could bring such innovative, freshly prepared food to the consumer. The identity system was designed to be flexible enough to apply to 3-star fine dining venues, casual dining venues, consumer products (frozen pizzas, soups, coffees, kitchen appliances, etc.) and catering outlets like kiosks, uniforms and trucks. The system impacted decisions not only on graphics and imagery but also environmental and spatial relationships, packaging materials, display formats, livery design, signage, billboard advertisements, corporate communications, training/guidelines materials and other elements that defined the Wolfgang Puck experience.

Through the use of consistent Typography, color palette and Photographic style, we have unified the various touch points of the brand. Keeping in mind the customer journey, a consumer will be able to go to a Wolfgang Gourmet Express and get a take out pizza, or go to a supermarket to purchase some soup, or tune into the Home Shopping Network to buy a blender, and understand that all those products come from the same brand.

Landor's work unearthed areas of opportunity for future business growth, including new categories and potential markets for the client, such as a Wolfgang Puck signature line of consumer products. Additionally, the cleanliness and flexibility of the creative system enabled Wolfgang Puck to appropriately brand a plethora of elements in its portfolio to create a holistic brand experience.

The system is slowly being rolled out across the various channels. Employees now understand the premise behind the brand and speak with a unified purpose. It has served as a filter to identify not only what types of food and price range will be offered at every tier, but also as a vehicle to understand strategic alliances and channels of distribution that will enhance the overall brand. We provided a unified voice and visual language for the Wolfgang Puck brand. Now the brand represents a promise, an experience. Licensees and franchisees now have specific production guidelines. Terms for brand management and veto power are being included into contracts currently being negotiated. Each line of business now can examine areas of business opportunity in a new light. It also brought key tenets of the brand to life: the elemental art of cooking, the charisma of Puck himself, an emphasis on freshness (both of ingredients and ideas) and the social nexus of the shared meal. The simplicity of the new system contrasts starkly with the overt, often garish

and graphic standards of the commercial food industry. Defined by elegance and understated graphic elements, the system conveys an authority that resonates with consumers seeking a food experience that is both accessible and refined – a truly Wolfgang Puck experience.

Landor's team players worked with Wolfgang Puck for over a year to craft a complementary, cohesive and comprehensive brand. Landor's work for Wolfgang Puck was truly emblematic of helping the client think bigger and better - bigger than what the brand represents today, and better by being a strategic and creative partner in transforming the business through the brand.

About Landor: Landor believes in the power of ideas driven by consumer insight, and the need to align business strategy with marketing strategy to create brand-led business transformation. Wolfgang is a good example of ideas and creativity as our medium and our focus on impact, not input, as our purpose. Founded by Walter Landor in San Francisco in 1941, we are one company of 850 talented players, across 22 offices around the world.

Our work has been recognized by numerous organizations around the globe including: Communication Arts, AIGA, Graphis, Clio Awards, Print, Art Directors Club of San Francisco, and The Conference Board, among others.

56,57 Feng Brand Identity | Design Firm: Willoughby Design Group, Kansas City | Art Director: Zack Shubkagel | Creative Director: Ann Willoughby | Designer: Stephanie Lee | Photographers: Al Tutton, Issac Alongi | Writers: Megan Semrick, Janette Crawford | Client: Feng

Feng: wind, trend, style, of the moment. Drawing upon Feng's Asian influence, we created a rich color palette of dark chocolate brown, fiery orange and illuminating gold. Incorporating elements of Chinese culture such as a Bagua Map used in Feng Shui, and characters that translate into a poem written for Feng's website, the identity design expresses the bold but quiet exquisiteness of the boutique's atmosphere and merchandise. Elegant graphics are carried throughout the identity to represent its departments including: Butterfly for Fashion, Koi for Home, Fan for Antique, and Lotus Blossom for Tea.

The finished identity includes far more than typical identity basics. The Feng experience resonates in every detail, whether it be a personal note card, a beautifully gift-wrapped item, using a Feng packaged container to scoop a favorite loose tea, taking home a fabulous find in a custom shopping bag and being handed a cleverly designed receipt holder.

Brochures

58,59 PLATINUM VIE.W | Design Firm: E.Co.,Ltd, Tokyo | Art Director: Jun Tamukai | Creative Director: Tatsuo Ebina | Designer: Jun Tamukai | Writer: Kensaku Kamada | Client: E.Co.,Ltd

The problem: To create a brand new image for an ad agency that can be used as company information material.

Client directive: The work was for our own company so we had total freedom.

Solution: Distance between visual and copy ads, creative printing, color control, etc.

Creative and financial success: No problem financially because the work was for our own company. We consider it to be a great creative success.

Business history: 20 years since establishment. Mostly advertisement planning and creation.

of people in firm: 30

Award history: Tokyo ADC award, NY ADC Gold award, JAGDA novice award, TCC top award, and more. The complete list is available on the company website.

Published in: Japan, Tokyo ADC Annual, JAGDA Annual, Brainn (Magazine), Koukoku Hihyou (Advertizement Critic magazine), Commercial Photo magazine Overseas–NY ADC Annual, The One Show Annual, etc.

Design philosophy: Our company consist of Art Directors, Designers and Copy Writers. It allows us to work on the project in a comprehensive way, and allows us more creative expressions advantageous to both the clients and the viewers.

60,61 Brochure | Design Firm: Mirko Ilic Corp., New York | Art Director: Mirko Ilic | Chief Creative Officer: Mirko Ilic | Creative Director: Mirko Ilic | Designer: Mirko Ilic | Client: Tihany Design

62,63 Brochure | Six Short Stories and a Parable: Engineering and Why it Matters | Design Firm: Rigsby Hull, Houston | Art Director: Lana Rigsby | Creative Director: Thomas Hull | Designers: Lana Rigsby, Thomas Hull | Photographer: Terry Vine | Print Producer: Steve Woods Printing Company | Writer: JoAnn Stone | Client: Walter P Moore

How one of the nation's most respected engineering firms uses parables and stories to express a powerful perspective on why engineering matters. Measures 18.5 x 24".

64 BLUEFIN OCEAN CLUB BROCHURE | Design Firm: Corporate Grafix, Coral Gables | Creative Director: Bob Tonda | Client: Modus Vivendi Partners

65 Conference of Champions: CHOICES | Design Firm: Pentagram SF, San Francisco | Chief Creative Officer: Kit Hinrichs | Creative Director: Kit Hinrichs | Designers: Ashlie Benton, Kit Hinrichs | Photographers: Howard Holley, Barry Robinson, John Russell | Client: Safeco

Incentive piece for annual conference based on sales performance. Safeco is an insurance company.

66,67 The Private Residences at The Chase Park Plaza Sales Brochure | Design Firm: TOKY Branding+Design, St. Louis | Art Directors: Benjamin Franklin, Geoff Story, Karin Soukup | Creative Director: Eric Thoelke | Designers: Benjamin Franklin, Geoff Story, Karin Soukup | Photographers: Mark Katzman, Geoff Story | Writers: Jeff Insco, Cordell Jefferies, Eric Thoelke | Client: The Chase Park Plaza

68,69 Unbound 5 | Design Firm: Concrete Design Communications Inc., Toronto | Art Directors: Diti Katona, John Pylypczak | Designer: Andrew Cloutier | Photographer: Various | Client: Masterfile

Credits

Masterfile had an image problem. Despite building an archive that represents some of the most creative talent around, the largest remaining independent stock image agency was still perceived by its clients as being too conservative. To address this, Concrete produced a strategic campaign that included the development of a series of direct-mail pieces called 'Unbound' – a collection of images real and implied. Unbound uses the interpretation of imagery as a form of visual creative inspiration. While it uses many images from Masterfile's extensive library, just as many of the images have been modified, obscured or "implied."

70 View14 Brochure | Design Firm: HZDG, Rockville | Art Director: Jefferson Lui | Chief Creative Officer: Karen Zuckerman | Creative Director: Tamara Dowd | Designer: Jennifer Higgins | Illustrator: Spine 3D | Photographer: Cameron Davidson | Writers: Joey Tarbell, Chris Minesinger | Client: Level 2

View14 is a sleek, ultramodern luxury condominium located in a revitalized Washington, DC, neighborhood. The building's Architecture and Interior Design demanded a departure from traditional real estate marketing Design, which often consists of image after image of shiny, happy people in beautiful condos. We utilized a Zen-like organic minimalism and tech-y elements to form an enticing graphic experience, and to build upon the unconventional. The first task at hand was to persuade the client that the target audience, as well as the building, was too sophisticated for the standard treatment. With the client on board, we took inspiration from the cantilevered glass walls, koi pond, Zen garden, and other distinctive features of the building itself. We also drew on things that we felt complemented the building's aesthetic, like video games, South Beach, fashion, haiku, and rave flyers. The resulting website plays upon a tension between bold, futuristic elements and a calm simplicity to create a strong and memorable piece perfectly suited to its subject.

71 Element Brochure | Design Firm: Rubin Postaer & Associates, Santa Monica | Art Director: Joel Hanlin | Creative Director: David Tanimoto | Designer: Joel Hanlin | Photographers: Jeff Ludes, John Marian | Writer: Ryan Moore | Client: Honda

72 Lida Baday Fall 2006 Brochure | Design Firm: Concrete Design Communications Inc., Toronto | Art Directors: Diti Katona, John Pylypczak | Designer: Natalie Do | Photographer: Chris Nicholls | Client: Lida Baday

Each spring and fall Canadian Fashion Designer Lida Baday produces a promotional brochure that serves as the company's primary advertising vehicle. For this fall 2006, two brochures, instead of one, were produced to reflect two distinct styles of clothing encompassed in the one collection. Sensual photography is used to showcase the clothes.

73 Full-Service Printer and Fulfillment Company | Design Firm: Look, San Carlos | Art Director: Mary Schwedhelm | Chief Creative Officer: Mary Schwedhelm | Creative Director: Mary Schwedhelm | Designer: Monika Kegel | Photographer: Carter Dow | Print Producer: Lahlouh | Writer: Tyler Cartier | Client: Lahlouh

Calendars

74,75 A Toy Story Calendar Box | Design Firm: Riordon Design, Oakville | Art Director: Ric Riordon | Creative Director: Alan Krpan | Designer: Shirley Riordon | Photographer: Jason Grenci | Printer: Contact Creative Services | Custom Box: Quintessential Canada Inc. | Client: Riordon Design

We do not stop playing because we turn old, but we turn old because we stop playing. Toys are universally about Design, function, imagination and play. In our crazy, busy world, it seemed a good subject for connecting with our audience.

Each year we challenge ourselves to create a unique promotional piece that showcases our Design skills. This serves two intentions; one being our continuous effort to get our name out there in an interesting way, and two, it serves to inject a fun factor into the studio. Making time for these projects is a constant struggle. It takes an extreme amount of dedication to carve out a space for promotion, particularly a project of this size. With each year's promotional gift being a custom Design, the challenges are often as unique as the piece itself. The first is to determine the concept. Criteria: it must be completely different than anything we've done before. Secondly, it needs to be a keeper (something people won't easily discard).

Once we decided to create a piece around Ric's antique toy collection, we had to define the idea and its presentation. It seemed a good seasonal idea, given that we send our promo out at year-end. That led us to a self-contained package - a desk calendar, housing gift cards and a toy chocolate train.

Sourcing a manufacturer to create a custom toy box to house this was a challenge. Getting the antiquated finish and stamped pattern we wanted with a handmade feel to complement the enclosed elements required some major effort. This was the case for a few reasons: timing, costs, and frankly, we couldn't find anyone out there that had exactly what we were looking for. We chose a creative local manufacturer because we knew there was going to be a lot of back and forth, and we wanted to work closely on the most challenging component of the project.

Once we had our idea sorted out, we created a 3D paper mockup for our supplier to build to. This helped us flesh out the appropriate scale, function and graphical elements. It also provided a clear vision of what we were aiming for with the vendor. We partnered with a local chocolate manufacturer to select an appropriate treat for the package. They did all the work – we just had to design a label to tie in with the aesthetic, insert them in the boxes, and, of course, sample the odd train to make sure it met the Riordon standard. Partnering with local businesses on such projects can open up new relation-

ships as well. Photographer Jason Grenci created the images.

Each calendar card insert features an antique toy on one side and a personal favorite toy memory from childhood of one of our team members on the other. Memorabilia images and graphics accompany the story.

We're extremely pleased with the outcome, but more importantly, the feedback we've received from clients confirms the importance of this high profile piece for our company.

76,77 2007 Julius Blum & Co. Agenda Calendar | Design Firm: Emerson, Wajdowicz Studios, New York | Art Directors: Lisa LaRochelle, Jurek Wajdowicz | Creative Directors: Jurek Wajdowicz, Lisa LaRochelle | Designers: Lisa LaRochelle, Manny Mendez, Yoko Yoshida, Jurek Wajdowicz | Photographers: Jurek Wajdowicz, Manny Mendez | Client: Julius Blum & Co., Inc.

78 "Imagine" Rexroth presents–our fantastic world | Design Firm: WAJS, Hoechberg | Art Director: Joachim Schmeisser | Creative Director: Joachim Schmeisser | Designer: Joachim Schmeisser | Photographer: Joachim Schmeisser | Print Producer: Joachim Schmeisser

Objective: To design a high quality calendar suitable for series production which stood out and differed from conventional, technology-related calendars. Running under the campaign title "Imagine," a series of surreal pictures were developed that show our world in unusual, surprising dimensions. Bosch Rexroth has interpreted the subject of "our fantastic world" for 2007, depicting itself as an imaginative, emotional and visionary company.

79 Ray Gun Calendar | Design Firm: Webster Design Associates, Omaha | Creative Director: Dave Webster | Photographer: Scott Drickey | Writer: Bob Gardner | Designer: Nate Perry | Client: Barnhart Press

This is a printing promotion for Barnhart Press, an offset printer in Omaha, NE. They acquired a new printing system, Metal FX, and wanted a promotional item to pass out to Designers in the community to showcase the new technique.

Catalogues

80 Replogle catalog | Design Firm: Planet Propaganda, Madison | Creative Director: Dana Lytle | Designer: Curtis Jinkins | Client: Replogle Globes

Binder-and-looseleaf catalog system for globe manufacturer.

81 R-Zilla Product Binder | Design Firm: Howard, Merrell & Partners, Raleigh | Art Director: Joe Ivey | Creative Director: Billy Barnes | Designer: Joe Ivey | Print Producer: Sharon Fred | Writer: Billy Barnes | Client: Central Garden & Pet/R-Zilla

R-Zilla, a maker of premium reptile products for reptile owners, needed a sales binder to be used on sales calls with retailers. It needed to be edgy (to match and feel a part of the Advertising campaign), and it had to be done inexpensively. When you buy a reptile at a pet store, you take it home in a cardboard box that has air holes punched in the side. We turned that idea into the idea for the binder. Creating the feeling of peaking in, we had holes punched in cardboard, then had the rest hand assembled. Divider pages with tabs for every section each feature a different reptile in a dramatic way – the first being visible through the holes on the front cover. Reaction has been fantastic. Retailers have been blown away by the binder's uniqueness, and most have asked for their own copies, which the client is very happy to provide.

82 Edmiston Yacht Charter 2007 | Design Firm: Steven Taylor & Associates, London | Creative Director: Steven Taylor | Print Producer: The Colourhouse | Writers: Sue Bryant, Steven Taylor | Client: Edmiston

Luxury Yacht charter directory showing over 100 of the world's finest yachts with up to date listings of the world's best restaurants and destinations.

83 Admissions Catalog | Design Firm: Matsumoto Incorporated, New York | Art Director: Takaaki Matsumoto | Creative Director: Takaaki Matsumoto | Designer: Takaaki Matsumoto | Photographers: Steven Heller, Vahe Alaverdian | Writers: Karen Tonnis, Amy Wilkins | Client: Art Center College of Design

The admissions catalog for this Art and Design college in Pasadena had to make a strong statement about the forward-thinking character of the institution. The white cover is die-cut with small holes, revealing a subtle array of colors. When the book is opened, the viewer is surprised by a vivid array of bright colors. Most of the pages are dedicated to large reproductions of student work to highlight the school's talented student body. Auxiliary photographs of students at work bolster the portfolio sections.

84 catalog | Design Firm: mono, Minneapolis | Art Director: Chris Lange | Creative Directors: Chris Lange, Michael Hart | Designer: Dawn Selg | Photographers: Chris Lange, Chris Sheehan | Art Buyer: Erika Schumacher | Writer: Michael Hart | Client: Blu Dot

Blu Dot, a Designer and manufacturer of modern furniture, has always held a slightly more inclusive view of what constitutes good Design. Everything we've created for Blu Dot, from the catalog to the ads to the short film series, is designed to reflect their innovative and unique voice in the Design world. Their work is both elegant and a bit unexpected, and we've always felt their communications should be as well.

85 CCA Glass Show Catalog | Design Firm: Michael Osborne Design, San Francisco | Creative Director: Michael Osborne | Designer: Sheri Kuniyuki | Client: San Francisco Museum of Craft and Design

Documents the SFMC+D Exhibit, CCA: A Legacy in Studio Glass.

86 Davide Cenci fall/winter collection 2006/2007 | Design Firm: Tangram Strategic Design, Novara | Art Director: Alberto Baccari | Creative Director: Enrico Sempi | Designer: Anna Grimaldi | Photographer: Arcangelo Argento | Client: Davide Cenci

DesignerPromotions

87 Sweet Memories | Design Firm: Watts Design, South Melbourne | Creative Directors: Peter Watts, Helen Watts | Designer: Peter Watts | Client: Watts Design

Client gift of chocolate, featuring 9 individual Designs.

88,89 PLATINUM The Art of the Grid | Design Firm: Astrid Stavro, Barcelona | Art Director: Astrid Stavro | Chief Creative Officer: Astrid Stavro | Creative Director: Astrid Stavro | Designers: Astrid Stavro, Birgit Pfisterer | Client: The Royal College of Art

Backgroud info: Grids form an essential part of our lives. We may not always notice them, but their influence on what we see, hear and do is everywhere. By moving the grids from the background to the foreground, and divorcing them from their content, I pay homage as well as render the invisible visible. As Designers, understanding the advantages as well as the limitations of the grid helps us determine what place they should take in our own work. The grid, like any other instrument in the design process, is not an absolute. Like computers, they are simple Design tools. It is the process of challenging or questioning these assumptions that is important, because in doing so we re-evaluate our perception of the environment and our role within it.

The product, GRID-IT! Notepads: The Grid-it! Notepads series is based on the layout grids of famous publications. They are a selection of grids that played a historic role in the development of Design systems, covering a wide spectrum of classic and contemporary editorial Design.

More information on this project appears on pages 11 and 12.

90 Dreaming of Marrakech | Design Firm: Inaria, London | Creative Directors: Andrew Thomas, Debora Berardi | Designers: Andrew Thomas, Anna Leaver | Client: Inaria

The first in a series of Inaria self promotional cards inspired by the aspirational destinations featured in much of our work. The solution for Marrakech was the creation of a Moorish style pattern capturing the elegant and elaborate fretwork and dramatic play on light found throughout this city of extreme contrasts. Due to the intricacy of the pattern, the execution of choice was laser cutting - and in doing so, has demonstrated the amazing possibilities of this medium.

91 Webster the Duck | Design Firm: Webster Design Associates, Omaha | Creative Director: Dave Webster | Designers: Karen Koch, Loucinda Hamling | Writer: Bob Gardner | Client: Webster Design Associates

This is a holiday promotion we mailed to friends and clients.

Editorial

92,93,94,95 See: The Potential of Place, Fifth Issue | Design Firm: Cahan & Associates, San Francisco | Art Directors: Bill Cahan, Steve Frykholm, Todd Richards | Creative Director: Bill Cahan | Designers: Todd Richards, Erik Adams | Illustrators: Artemio Rodriguez, Joseph Hart, Brian Carter | Photographers: Heimo Schmidt, Vivienne Flesher, Robert Schlatter, Catherine Ledner, Andy Sacks, Colin Faulkner, Brian Carter | Writers: Pamela Erbe, Nancy Ramsey, Debra Wierenga, Linton Weeks, Brian Carter | Client: Herman Miller

96,97 PLATINUM Stretch special issue | Design Firm: Frost Design, Surry Hills | Art Director: Vince Frost | Chief Creative Officer: Vince Frost | Creative Director: Vince Frost | Designers: Vince Frost, Anthony Donovan | Client: POL Oxygen

POL Oxygen approached Frost Design to do a special edition of the magazine with Vince Frost as guest Art Director. In the initial briefing, it was discussed that it would be all about people who move effortlessly between creative fields. Creatives like Catherine Martin, Gotan Project, Marc Quinn, Floria Sigismondi, Graft, Jun Takahashi, 2X4, Viggo Mortensen, Kenny Schachter and John Pawson. We came up with the notion of Stretch and set about stretching the boundaries of magazine Design.

The magazine itself is stretched. At 550mm, Stretch is double the height of a standard POL Oxygen magazine, with a horizontal split down the middle so it folds to fit on a library shelf. The split changes the way the reader interacts with the magazine, breaking conventional ways of reading. The bronzed skeleton sculpture by Marc Quinn used on the front cover, again reinforced the stretch theme. It unfolds to reveal a midget – a stretch on reality that is only revealed once you open the cover.

How successful was the solution- both creatively and financially?

It's been an incredibly successful magazine and has since been nominated for best front cover and entire issue in the SPD awards in New York, and won the best overall magazine and best front cover in the Asia Media Awards.

Philosophy and approach?

Frost Design is an independent creative studio of 30+. We understand Design. We understand business. But most importantly we understand the business of good Design. Founded in London and now based in Sydney, we are an interdisciplinary creative studio working seamlessly across a variety of media for a diverse range of international clients. Design for Design's sake does not concern us. Making a difference does. Solving problems is what we do best - listening, getting to the heart of a problem and developing effective solutions that surprise and excite in equal measure. We also understand the value and power of the Big Idea - and the difference it can make to a business, large or small, when correctly executed. From small art projects to multinational brand identities, each and every project is treated individually and afforded the same care and attention. We have the ideas and the experience to make a difference.

About Vince Frost, Creative Director and CEO: A member of CSD, D&AD, ISTD, AGDA and AGI, Vince plays an active role in the world Design community, lecturing at colleges and conferences. A few pointers to his potential emerged in the early 90s, when he became Pentagram London's youngest Associate Director. After five years at the Design industry's best finishing school, he set up Frost Design in 1994. Since then, many awards have come his way, including D&AD silvers, golds from the New York Society of Publication Designers and gongs from the New York and Tokyo Art Directors' Clubs. In 2004 he made the move to Sydney, Australia, from where Frost continues to work for global clients – including New York-based Rizzoli Books, Deutsche Bank Asia and Seoul International Finance Centre – and win international accolades.

98,99 Ampersand | Design Firm: Frost Design, Surry Hills | Art Director: Vince Frost | Chief Creative Officer: Vince Frost | Creative Director: Vince Frost | Designers: Vince Frost, Anthony Donovan, Ben Backhouse | Writer: Lakshmi Bhaskaran | Client: D&AD

D&AD (British Design & Advertising) is an educational charity with a purpose to set creative standards, educate, inspire and promote good Design and Advertising. Ampersand is D&AD's members' magazine. Content includes latest news and views, industry related features and profiles celebrating the world's most inspiring creatives. In a nutshell, Ampersand is a magazine obsessed by ideas. The Ampersand name came about for a number of reasons. First, it was at the heart of the D&AD logo. Second, it expressed connection - the glue that could hold an infinite diversity of content together. Lastly, within a masthead, the ampersand could portray the home of all great ideas - the thought bubble. Printed on 100% recycled paper and using vegetable inks, Ampersand lives up to D&AD's goal of environmental best practice.

100 Noi.se | Design Firm: Nuts About Design, Balmain NSW | Art Director: Jason Smith | Creative Director: Mark Stapleton | Designer: Martine Wilson | Hair: Antoine Ifergan | Makeup: Vanessa Evelyn | Model: Sveta Utkina | Photographer: Gray Scott | Photographer's Assistant: Audrey Crewe | Set Designer & Props: Rachael Mayfield | Stylist: Michel Onofrio | Location: Raw Space, New York | Client: Highlights Publications

Special thanks to Oscar & Tony Moschini

101 Dot Magazine 14 | Design Firm: Matsumoto Incorporated, New York | Art Director: Takaaki Matsumoto | Creative Director: Takaaki Matsumoto | Designers: Takaaki Matsumoto, Hisami Aoki | Photographer: Vahe Alaverdian | Writer: Various | Client: Art Center College of Design

This sem-annual institutional publication is distributed to a wide audience: students, alumni, donors and corporate sponsors, among others. The cover needs to have visual impact and say something about the institution. All the covers feature a detail of a student work, as the college prides itself on the high-caliber of its students. Every issue features a portfolio of student work, which is given the most pages of any section. Feature stories are each designed differently to create visual interest, but maintain a sense of playfulness and sophistication.

102 Dot Magazine 13 | Design Firm: Matsumoto Incorporated, New York | Art Director: Takaaki Matsumoto | Creative Director: Takaaki Matsumoto | Designers: Takaaki Matsumoto, Hisami Aoki | Photographer: Vahe Alaverdian | Writer: Various | Client: Art Center College of Design

Please see the description above for page 101.

103 Flaunt No. 79 | Design Firm: Flaunt, Los Angeles | Art Director: Lee Corbin | Artist: Christopher Chin | Creative Director: Jim Turner | Client: Flaunt

The Bronze Age: Eighth Anniversary Issue

104 DeNiro | Design Firm: GQ Magazine, New York | Design Director: Fred Woodward | Designer: Anton Ioukhnovets | Client: GQ Magazine

104 Queen Christina | Design Firm: GQ Magazine, New York | Design Director: Fred Woodward | Designer: Anton Ioukhnovets | Client: GQ Magazine

105 She's Not There | Design Firm: GQ Magazine, New York | Design Director: Fred Woodward | Designer: Drue Wagner | Client: GQ Magazine

105 Troy Story | Designer Firm: GQ Magazine, New York | Art Director: Ken DeLago | Design Director: Fred Woodward | Client: GQ Magazine

106 The Great Divider | Design Firm: GQ Magazine, New York | Design Director: Fred Woodward | Designer: Thomas Alberty | Client: GQ Magazine

106 Young Love | Design Firm: GQ Magazine, New York | Design Director: Fred Woodward | Designer: Thomas Alberty | Client: GQ Magazine

106 Alec Baldwin | Design Firm: GQ Magazine, New York | Design Director: Fred Woodward | Designer: Drue Wagner | Client: GQ Magazine

107 Unsung Heroes | Design Firm: GQ Magazine, New York | Design Director: Fred Woodward | Designer: Thomas Alberty | Client: GQ Magazine

107 Josh Hartnett | Design Firm: GQ Magazine, New York | Art Director: Ken DeLago | Design Director: Fred Woodward | Client: GQ Magazine

107 Dwayne's World | Design Firm: GQ Magazine, New York | Art Director: Ken DeLago | Design Director: Fred Woodward | Client: GQ Magazine

108 Ashes and Snow | Design Firm: American Airlines Publishing, Fort Worth | Art Director: Marco Rosales | Designer: Marco Rosales | Photographer: Gregory Colbert | Writer: Ana Cristina Reymundo | Client: American Airlines

Pictorial essay of the book "Ashes and Snow" by Photographer Gregory Colbert.

108 Maria Celeste, in search of new horizons | Design Firm: American Airlines Publishing, Fort Worth | Art Director: Marco Rosales | Designer: Marco Rosales | Writer: Keyla Medina-Rosa | Client: American Airlines

Candid conversation with Mexican journalist Maria Celeste Arraras.

109 Cielo, Tierra, Tequila. A trek to the heart of Mexico | Design Firm: American Airlines Publishing, Fort Worth | Art Director: Marco Rosales | Designer: Marco Rosales | Photographer: Douglas Menuez | Writer: Ana Cristina Reymundo | Client: American Airlines

Story on the production of Tequila in the heart of Mexico.

109 Germany in 12 steps | Design Firm: American Airlines Publishing, Fort Worth | Art Director: Marco Rosales | Designer: Marco Rosales | Photographer: John Hicks | Writer: Oscar Gonzales | Client: American Airlines

A brief overview of the 12 German cities where the 2006 World Cup took place.

109 Let go of the Bull! | Design Firm: American Airlines Publishing, Fort Worth | Art Director: Marco Rosales | Designer: Marco Rosales | Photographer: Patrick Price | Writer: Antonio Sepulveda | Client: American Airlines

Exciting account of the rodeo cowboy.

Environmental

110,111,112,113 PLATINUM UC Student Recreation Center Archigraphic Murals | Design Firm: Rebeca Méndez Communication Design, Los Angeles | Art Director: Rebeca Méndez | Creative Director: Rebeca Méndez | Designer: Rebeca Méndez | Illustrators: Susanna Dadd, James Griffith | Photographer: Rebeca Méndez | Print Producer: Adam Eeuwens | Writers: Adam Eeuwens, Rebeca Méndez | Client: Morphosis Architects

Credits

Thom Mayne and his firm Morphosis designed a 353,000 sq. ft. student recreation center on the campus at the University of Cincinnati, which opened in May 2006. Rebeca Méndez was commissioned to create two permanent installations at the recreation center, one in the convenient store (c-store) and another at the food court. For the c-store, the university imagined market scenes; Méndez had her own solution in mind. She composed 24 extreme panoramic landscapes, and refers to them as 'ever sustaining landscapes. All products and nourishment have as their origin the extraction or harvest of the raw materials provided by the earth'. Méndez's interest is to give the viewer a glimpse of these raw materials in their integrity and beauty, as well as expose the distribution and processing of these goods before they are conveniently packaged for consumption at the c-store.

For the food court, Méndez was commissioned to create murals on four cone-like structures, two of them reaching over 50 feet high and piercing through the roof. The cone structures envelop the kitchens of the food court, and hide all the piping and machinery necessary for such enterprises. Méndez's investigations into how to create a visual dialogue between flora, the Architecture, and the site led her to select grass – specifically giant reed grass – for her artwork. Over many months and continents, Méndez photographed grass from various points of view and under the different weather conditions, allowing light and wind to create visual difference, and to reveal the patterns that one simple form – a blade of grass – produces through complex organization. Over a period of five weeks the muralists James Griffith and Susanna Dadd painted the compositions Méndez created onto the cones. More information on this project appears on pages 10 and 11.

114 Clothing | Design Firm: BVK, Milwaukee | Art Director: Laure Arthur | Creative Director: Jeff Ericksen | Photographer: Cory Haggen | Writer: Jeff Ericksen | Client: Eisner Museum

Printed Posters shaped as various pieces of clothing were placed on hangers and hung in the changing rooms of high end fashion boutiques. A mock price tag attached to the pieces informed viewers about details of the upcoming event. The price tags were also created as tear off cards to act as invites to the fashion show.

115 Street Advertising | Design Firm: BVK, Milwaukee | Art Director: Laure Arthur | Creative Director: Jeff Ericksen | Photographer: Cory Haggen | Writer: Jeff Ericksen | Client: Eisner Museum

116,117 Brand ID Photo Series | Design Firm: Hoyne Design Pty Ltd, St Kilda | Art Director: Andrew Hoyne | Designers: Andrew Hoyne, Pia Sabbadini | Photographer: Marcus Struzina | Client: Bolinda Audio

Brief: Create a brand campaign for Bolinda Audio that capitalizes on the Bolinda talking book icon and reinforces the Bolinda positioning of turning the everyday into a journey of discovery.

Solution: A Photography series that takes the icon into situations and environments where one could genuinely listen to an audio book. Design the shots for multiple use: advertising, catalogue spreads, point of sale and web applications. Appeal to all Bolinda target groups: adult, young adult and children.

Result: A bank of images that place Bolinda audio books in everyday situations and invite the viewer to increase their repertoire of usage occasions. A further enhancement to the vibrant personality of the Bolinda brand.

118,119 dcb | Design Firm: love the life, Taito-Ku | Designers: Akemi Katsuno, Takashi Yagi | Photographer: Shinichi Sato | Clients: Shinichi Sakuraoka, Susumu Koyata

"dcb" is a bar composed of minimum elements. It is in the sub-basement in a small building. Only one small staircase reaches it. We had to devise a method to produce a unified counter top of 5 meters in length by low cost. Therefore, artificial marble was used to be able to weld on the site. White color was given to the main elements, and all the remaining space was painted over in dark blue. The modest lighting and the reflection let only white aspects rise like moonlight, and the impression is emphasized by a stainless steel pipe which curves gently.

120,121 MEC Environmental Graphics | Design Firm: Karacters Design Group / DDB Canada, Vancouver | Creative Director: James Bateman | Designers: Kara Lawler, Dan O'Leary | Client: Mountain Equipment Co-op

Better Insight: MEC have a long history of delivering quality gear and their staff has real expertise in all aspects of outdoor recreation. However, research showed that the majority of members were only associating with MEC's ability to deliver excellent gear at reasonable prices, without truly understanding the co-op's incredible commitment to social and environmental responsibility, or connecting to their greater sense of community. The foundation of our recommended strategic positioning centered on rebalancing and articulating the brand's four pillars of gear, expertise, belief and belonging, whilst communicating the different way MEC and its members connect with the outdoors.

Better Idea: The overarching concept of the creative platform is the members' journeys and their experiences, brought to life through the voice of the experience, a series of first person quotes describing their passions for these activities. Real member images depict genuine participation, as well as illustrate a strong social interaction. These elements are drawn together by the use of a path graphic, symbolic of each member's unique journey. The brand pillars of expertise, belief and belonging have been given their own visual language and tone so they are clearly communicated to the member both in print and throughout the in-store experience.

Better Results: The new MEC brand is currently rolling out through all marketing touchpoints, from a bilingual website relaunch in 2006 to catalogue design and print collateral. The retail concept was recently unveiled at the Victoria store opening to incredible response, with line-ups at the door prior to official publication of the opening. Overall results show that combined sales are already up 6% over the previous year (on a same-store basis).

122,123 Trade Show Booth | Design Firm: Pentagram SF, San Francisco | Chief Creative Officer: Lorenzo Apicella | Creative Director: Lorenzo Apicella | Designers: Lorenzo Apicella, Matthew Clare, Jason McCombs, Rob Duncan | Photographer: Jamie Padgett | Client: Sonance

This exhibit marked the launch of Sonance's new graphic identity, as well as the first of a range of new architectural in-wall and ceiling speakers. Both the identity and the new products were also designed by this firm. The form of the exhibit sought to three-dimensionally embody the spirit and language of these designs. It also had to anticipate the functional needs of a number of future, smaller exhibit locations, and therefore had to be scalable.

124 Nativity | Design Firm: emerystudio, Southbank | Creative Director: Garry Emery | Designer: Mark Janetzki | Client: City of Melbourne

For the City of Melbourne, emerystudio designed temporary street decorations for the 2006/2007 festive season. A wall in a central city location was given over for the installation of a nativity scene as proposed by the City of Melbourne in collaboration with representatives of the Christian Church. emerystudio redirected the brief away from the traditional nativity scene towards a preferred Design approach centred around the specific nativity text from the Bible, a scripture that the studio interpreted as a decorative monumental inscription expressed in a naïve calligraphic style. The lettering was digitised and cut from sheet metal, fixed to a frame and back-lit from below to establish a compelling night time presence and a successful public attraction.

125 BestShop | Design Firm: Landor Associates, San Francisco | Art Director: Cameron Imani | Chief Creative Officer: Nicolas Aparicio | Creative Director: Christopher Lehmann | Designers: Gaston Yagmourian, Tony Rastatter, Noriko Ohori, John Ledwith, Jo Clarke, Cee Architects | Client: LG Electronics

LG Electronics (LGE) operates 800 retail stores in South Korea, selling the complete line-up of LG products – from refrigerators and washing machines to mobile phones and computers. In the past few years, LGE stores' sales have declined mostly because of the success of the mixed channel approach, where customers have the opportunity to compare products from the country's most prominent brands, LG and Samsung. To revive the exclusive brand channel, LGE turned to Landor SF to develop a new store design.

The existing LGE store was clean, well-lit and organized, but completely undifferentiated. Samsung stores and LGE stores, mass merchandise and other electronics stores all looked very similar. The existing store environment resembled a high-end warehouse, creating sterility and lacking human dimension. Items were tightly merchandised in undifferentiated categories, with little or no connection between products and customers. Redundant communications surrounded the products, creating visual confusion. Store uniforms looked dated and unprofessional. Existing LGE research showed the store experience was somewhat stressful and undesirable to customers. The wide-open layout of the store did not provide them with the opportunity to explore on their own. Large, expensive products were featured too prominently, creating purchase pressure in the minds of customers. LGE research also showed that the electronics customer was most likely to be female, between the ages of 29-45, and married with children. They focused their energy on raising children and family happiness, and derived pride and empowerment from their electronics and home appliances.

Landor conducted a retail level set evaluation, comparing LG with furniture stores like IKEA and Crate&Barrel. The evaluation revealed that creating a unique and customer-focused electronics experience was a unique and ownable idea in the category, and aligned with customers' needs. It would help to combat previous mixed channel strategies by enhancing customer loyalty, attracting new customers and encouraging more frequent visits. The new store also needed to simultaneously leverage and build the LG brand, which had diminished in Korea ever since the company's spin-off of its convenience store businesses (now branded GS). The colors, materials and imagery used in the LG BestShop store (named by LG) create a comfortable and lively experience that reflects customers' daily life. LG brand equities, including technology for humans, friendliness and approachability, were built upon. Visual equities, including the LG future face shape and red color, heavily influenced the identity system. Product presentation, fixtures, communications and imagery were based on customer needs and end benefits, providing them with a truly personal experience. The new store differentiates itself and provides relevance by presenting products in a home-like context, enabling customers to easily envision how they fit into life. The sectioned store layout creates perceptual zones with flooring, lighting and partitions to allow complete immersion in categories. Small and large items are featured equally to attract customers to a wider range of products and maintain relationships with vendors. Based on an information hierarchy, the communications system provides the right information at the right time, making comparison and decision making easier. New and premium products are featured more consistently, so customers learn where to find and interact with the latest LG products.

Exhibits

126,127 Hospitality Design Show 2006 | Design Firm: Kuhlmann Leavitt, Inc, St. Louis | Art Director: Deanna Kuhlmann-Leavitt | Chief Creative Officer: Deanna Kuhlmann-Leavitt | Creative Director: Deanna Kuhlmann-Leavitt | Designers: Deanna Kuhlmann-Leavitt, Monica Goldsbury | Client: Formica Corporation

128,129 The Art of Gaman | Design Firm: Pentagram SF, San Francisco | Chief Creative Officer: Kit Hinrichs | Creative Director: Kit Hinrichs | Designer: Myrna Newcomb | Photographer: Tom Tracy | Writer: Delphine Hirasuna | Client: Museum of Craft and Folk Art

Illustration

130 Circuit Board | Design Firm: Peter Kramer, Dusseldorf | Designer: Peter Kramer | Illustrator: Peter Kramer | Client: Peter Kramer

Holiday card 2007: Originally, this 3D illustration was created for a large Glicée-Print (140x180 cm).

131 Ink Refill Tattoo Campaign | Design Firm: DDB Chicago, Chicago | Art Directors: Pete Taylor, D.J. Webb | Creative Director: Vinny Warren | Illustrator: Todd Holloway | Photographer: Daniella Federici | Print Producer: Peggy Atkins | Writers: Vinny Warren, Shane Colton | Client: OfficeMax

132 fred "the king" woodward | Design Firm: Anita Kunz, Toronto | Art Director: Hudd Byard | Illustrator: Anita Kunz | Client: Memphis Magazine

I was asked to paint a portrait of Designer extraordinaire Fred Woodward.

133 Product Range Illustrations | Design Firm: oakwood dc, Bristol | Art Director: Jess Britton | Chief Creative Officer: Phil Michaelis (Castrol) | Creative Director: Neil Sims | Designer: Jess Britton | Illustrator: Jim Meston | Print Producer: Castrol | Writer: Castrol | Client: Castrol PGO

Interactive

134 monoface | Design Firm: mono, Mpls | Art Director: mono | Chief Creative Officer: mono | Creative Director: mono | Designer: mono | Photographer: Stephanie Rau | Writer: mono | Programmer: Jim Park | Client: mono

monoface is a simple flash site that allows viewers to seamlessly create over 750,000 different faces made up from the facial features of mono employees. *The message:* Happy New Year from all of us.

135 www.paulelledge.com | Design Firm: LOWERCASE Inc., Chicago | Designers: Tim Bruce, Kurt Saberi | Illustrator: Paul Elledge | Photographer: Paul Elledge | Client: Paul Elledge Photography

136 Duffy & Partners Website www.duffy.com | Design Firm: Duffy & Partners, Minneapolis | Creative Directors: Joe Duffy, Dan Olson | Designers: Brad Surcey, Chad Hancock | Programmer: Andy LeMay | Client: Duffy & Partners

Duffy.com is easy to use while being a comprehensive, new website that includes our work, a place to meet our people, and a way to learn our philosophy about the strategic importance of great Design and the ability to watch a new video profiling the D&P team and the way we do business.

137 Dargroup.com website | Design Firm: Dar Al-Handasah (Shair and Partners), London | Art Director: Renata Tomko (Dar) | Designer: Lloyd Colling (Rife) | Executive Creative Strategist: Julian Davies (Sears Davies) | Programmer: Ian Fusco-Fagg (Dijit) | Client: Dar Al-Handasah (Shair and Partners)

A website for one of the world's largest Engineering and Architecture consultancies in the world. Based in the Middle East, Dar is a 50 year old, global Design firm with comprehensive in-house services. Working in wide areas of activity, their work ranges from designing airports to dams, planning cities, providing infrastructure works in developing countries to project management. Known for designing unique, elegant, cost-effective engineering solutions for their clients, they sought the same from their online presence.

Brief: Show the firm's wide areas of activities in a cohesive way·Showcase the company's "product " images of their designs/work·Allow the firm flexibility in presentation·Reflect the firm's reputation for engineering excellence by delivering a clean, elegant website, which features technically-challenging behind-the-scenes solutions tailored to the clients' exact needs.

Solution: To show the vast amount of projects and areas in as clear and simple a presentation so as not to detract from the beauty and complexity of the featured images, a sleek and fluid interface has been designed, which is driven by an extensive database.

The site's uniqueness comes from the immense flexibility it affords its client. A ColdFusion built administration system allows the client to add, amend and delete pages in an easy-to-use web-based interface that anyone can be trained on in less than 30 minutes. Because there are no preset limits, the client site can feature 200 or 2,000 project pages. A potentially endless amount of completely new sections can also be easily created.

Within any page in the admin system, incredible flexibility has been built-in: the background color, text color and link color can be controlled with an online color picker. Headings can be positioned over the images by way of coordinates system to suit the image, and clients can upload any supporting documentation via a pdf or word document. Since between 5-8% of the website visitors did not have flash, a fall-mirrored HTML site was created.

This seamless simplicity is made possible by using a number of technologies. The database is managed by a custom-built ColdFusion administration system. The design team used their bespoke custom tags to build the XML needed to drive the Flash based front-end and the fall-over mirrored HTML site for those who do not have Flash. Lateral movement and load graphic are used to disguise any load time for the amount of large images throughout the site.

138 Phi Website www.phicollection.com | Design Firm: Sibley/Peteet Design, Austin | Art Director: David Guillory | Designers: David Guillory, Matt Wetzler | Client: Phi

139 artcenter.edu/gpk | Design Firm: Vrontikis Design Office, Los Angeles | Chief Creative Officer: Nik Hafermaas | Creative Director: Brian Boyl | Designer: Carolina Trigo | Web Developers: Josh Moore,Peter Chang | Client: Art Center College of Design, Graphic Design Department

Comprehensive website featuring students, faculty, leadership, and Design projects from the Graphic Design Department at Art Center College of Design.

Letterhead

140 Ratchet Stationery System | Design Firm: Duffy & Partners, Minneapolis | Creative Director: Alan Leusink | Designer: Ken Sakurai | Client: Ratchet

After Duffy & Partners recommended a company name change from the very inside the technology category Mysis Corporation to Ratchet, we needed to create a stationery system to help the re-named company be as visually interesting as their new name. The stationery system included business cards, letterhead, envelopes, presentation materials and other elements to help Ratchet communicate to clients and prospects.

The Ratchet stationery system was engineered to be flexible and unique. A metal clip bearing the brand identity is utilized as a badge on the business card and as a binding device for other elements of the system. Bold graphics and colors communicate Ratchet's proposition of creating hard working technology tools for its clients. Unique substrates further differentiate Ratchet's brand presentation from those of a typical company.

141 Art Real Stationary System | Design Firm: Templin Brink Design, San Francisco | Creative Directors: Joel Templin, Gaby Brink | Designer: Katie Fishback | Client: Art Real

Identity System for Screen Printer

142 Work Labs | Design Firm: Work Labs, Richmond | Art Director: Cabell Harris | Chief Creative Officer: Cabell Harris | Designer: Paul Howalt | Client: Work Labs

143 Impossible to Ignore | Design Firm: The Republik, Durham | Art Director: Brady Bone | Creative Director: David Smith | Client: Rubberneck

144 Logo and Stationary for Advertising Club of Los Angeles, The Los Angeles Advertising Agencies Association and Magazines Representatives Association | Design Firm: TBWA\Chiat\Day, Los Angeles | Chief Creative Officer: Lee Clow | Creative Director: Erik Miller | Designers: Bory Chung, Jason Fryerc | Executive Creative Director: Rob Schwartz | Client: thinkLA

After the mergence of the Los Angeles Ad Club, The Los Angeles Advertising Agencies Association and the Magazine Representatives Association, this new non-profit organization needed a look that could cater to its collective audience. At the same time, the brand needed to attract fresh minds to actively participate in this revamped ad community.

We gave thinkLA a personality and a sense of humor. From using friendly lowercases as part of its communication, to having bright orange as their trademark color, to a logo that merges a thought bubble and a brain – thinkLA became fun, approachable, quirky and smart.

145 Printing Today Identity System | Design Firm: Sandstrom Design, Portland | Creative Director: Steve Sandstrom | Designers: David Creech, Steve Sandstrom | Print Producer: Kirsten Cassidy | Client: Printing Today

Identity for a high quality commercial printer with a name that suggest low quality. The business had been successful for a number of years with many on-going client relationships. The owner believed in the equity of the name, but agreed it had connotations of a small quick print shop. The concept reflects multi-color and technical capabilities and helps to 'offset' the regretful name.

Logos

146 Identity/Logo | Design Firm: Wall-to-Wall Studios, Inc., Pittsburgh | Art Director: Larkin Werner | Chief Creative Officer: James Nesbitt | Creative Director: Larkin Werner | Designer: Larkin Werner | Client: Pittsburgh Arts & Lectures

A new logo and identity system for Pittsburgh Arts & Lectures, the region's premier literary organization.

146 OK | Design Firm: McCann Erickson Russia, Moscow | Art Director: Oleg Pudov | Creative Director: Alexander Alexeev | Designer: Oleg Pudov | Client: fund of SOCIAL COMMUNICATIONS

146 Home on the Range | Design Firm: 601 Design, Inc., Steamboat Springs | Art Director: Bruce Holdeman | Designer: Bruce Holdeman | Illustrator: Bruce Holdeman | Client: Lynne Bier/Interior Designer

Western/cowboy home furnishing store logo located in Steamboat Springs, Colorado.

146 Square One Films logo | Design Firm: Ó!, Reykjavik | Art Director: Einar Gylfason | Designer: Einar Gylfason | Client: Square One Films

146 Trademark for ArkOpen Ltd. | Design Firm: Hahmo Design Ltd., Helsinki | Art Director: Antti Raudaskoski | Designers: Antti Raudaskoski, Paco Aguayo | Client: ArkOpen Ltd.

ArkOpen is the leading Architecture bureau in Finland when it comes to open Architecture, where inhabitants themselves can choose, for example, the plan and the materials of their apartments.

147 NUTRITION BRAND | Design Firm: BRAND PLANT, Duesseldorf | Creative Director: Alexander Sakhel | Designer: Alexander Sakhel | Photographer: Andreas Bednareck | Client: Bianca Schmidt

Bianca Schmidt is a nutritionist offering nutrition consultation. The logo supplies a positive representation of food, and the observer feels he is offered healthy food in an appetizing manner. The pear stands for healthy/light/digestible/sweet/appetite and the pleasant anticipation of biting into it. The white color helps support the clean, hygienic aspect, which play a major role in nutrition. Observers now have a positive feeling towards food.

148 Fox Atomic Logo | Design Firm: Intralink Film Graphic Design, Los Angeles | Art Director: Michael Golob | Chief Creative Officer: Anthony Goldschmidt | Creative Director: Mark Crawford | Designer: Michael Golob | Client: Fox Atomic / Karen Crawford

Logo for theatrical movie studio (a division of Fox Filmed Entertainment) which produces theatrical films, comics, and digital content targeting the 17-24 year old demographic. The logo needed to be adaptable to various style treatments in the same way the MTV logo is. It also makes a slight nod to the spotlight logo of its parent company.

149 Cinch Logo | Design Firm: Turner Duckworth, San Francisco | Chief Creative Officers: David Turner, Bruce Duckworth | Creative Directors: David Turner, Bruce Duckworth | Designers: David Turner,Shawn Rosenberger | Photographer: Richard Eskite | Client: Shaklee

Credits

Shaklee, a wellness company, created a new weight management program to combat the rollercoaster of weight loss and gain experienced by so many people attempting to diet. 'Cinch, Inch loss program' focuses on the shape of the user, not just weight. The identity and packaging emphasize the inches lost and the simplicity of the plan. Mouth-watering photography contained in carefully measured panels is used to give the products appetite appeal.

149 Pato Zazo Logo | Design Firm: Sibley / Peteet Design, Austin | Art Director: Rex Peteet | Creative Director: Rex Peteet | Designers: Rex Peteet, David Kampa | Client: El Pato Fresh Mexican Food

Pato, "duck" in Spanish, is the mascot and symbol for this fresh food Mexican restaurant. "Pato," a term of endearment coined by the childhood friends of the owner, stuck with him. The mark and logotype are inspired by the Mola art of South America.

149 Bar | Design Firm: VIVA DESIGN! studio, Kiev | Art Director: Sergiy Minyuk | Designer: Sergiy Minyuk | Client: Pool Bar

The challenge was to create a logo for a bar titled PoolBar, part of the Crimean Riviera Hotel Complex, emphasizing the atmosphere typical of a bar by a pool. The result was an active, dare-devil logo inviting everyone to join the reckless leisure with spirits. The black square, unstable in its standing, reinforces the vivid colors of the logo's letters. The informality of the solution is accentuated with the O's substituted by the bar-glass bottom prints and the inverted A, encapsulating a contour of a glass.

149 Cherry Street Logo | Design Firm: David Clark Design, Tulsa | Art Director: David Clark | Designer: Becky Gelder | Client: Cherry Street Association

Created for a street in Tulsa lined with shops and restaurants. They wanted a new, more modern identity to appeal to tourists and a younger demographic.

149 Identity | Design Firm: Young & Laramore, Indianapolis | Art Director: Pamela Schiff | Creative Director: Carolyn Hadlock | Client: Tamarindo

150 Code Breakers logo | Design Firm: RBMM, Dallas | Designer: Brian McAdams | Client: CodeBreakers

150 Silent Auction Identity | Design Firm: MBA, Austin | Designer: Mark Brinkman | Client: St. Mark's Episcopal Day School

Identity for a silent auction for St. Mark's Episcopal Day School.

150 logo | Design Firm: Pentagram SF, San Francisco | Chief Creative Officer: Kit Hinrichs | Designer: Erik Schmitt | Client: Fuego North America

150 Zia Music Production Logo | Design Firm: Ventress Design Group, Franklin | Designer: Tom Ventress | Client: Zia Music Production

150 Askja logo | Design Firm: Ó!, Reykjavik | Art Director: Einar Gylfason | Designer: Einar Gylfason | Client: Askja

The logo is a combination of a circle and the capital letter A, which symbolizes the steering wheel that is a reference to the cars that ASKJA is agent for. At the same time, the letter A stands for the road and line in the wheel of the horizon that indicate that ASKJA is a car sales agency driving well into the future. Askja is the authorized Mercedes-Benz dealer in Iceland.

151 Logotype Design | Design Firm: Pentagram Design Ltd. Berlin, Berlin | Art Director: Justus Oehler | Designers: Norman Palm, Josephine Rank, Uta Tjaden, Christiane Weismueller | Client: Regione Autonoma della Sardegna

Pentagram Berlin was commissioned to develop a new visual identity for the Italian region of Sardegna. The logotype is based on the typeface Eurostile (designed in 1962 by Aldo Novarese). It has been carefully modified.

The colours in the letters are those used in the richly embroidered Sardinian costumes. The modern shapes of the letters combined with the patchwork of warm colours reflect the two sides of Sardinia: history and tradition on one hand, and modernity and openness on the other. Pentagram partner Justus Oehler: "We wanted to create a symbol which would not depict sun and sea - like most of the other Mediterranean countries' identities do, but which would look grown-up and confident, yet at the same time playful and warm."

152 V.I.O. Identity | Design Firm: Duffy & Partners, Minneapolis | Creative Director: Alan Leusink | Designer: Joseph Duffy | Client: V.I.O.

V.I.O. Video. In and Out is a pioneering new company introducing portable and wearable video camera technology to enthusiast sports participants (skiers, mountain bikers, surfers) and tactical (military, police, fire) customers. The technology allows you to record digital video with hands free operation by attaching the camera lens head to a helmet, bike handles, firearm or any other device in motion. The charge was to communicate that V.I.O. was something new and unique. The new brand identity translates a corporate name – V.I.O. Inc.– into a statement about the brand and the benefit of their products.

The letters in the name V.I.O. are combined in a unique form to suggest an eye and a camera lens. The strategic underpinning of the final identity design is that V.I.O. allows you to record digital video from your personal perspective so others can see exactly what you have seen. The identity is just one component of an entire brand language which will inform product badging, packaging, the technology interface, the website and marketing communications materials.

152 Montgomery Farm Gardens Logo | Design Firm: Sibley/Peteet Design, Dallas | Creative Director: Don Sibley | Designer: Geoff German | Illustrator: Geoff German | Client: Montgomery Farm

152 Nomacorc logo | Design Firm: RBMM, Dallas | Designer: Christy Gray | Illustrator: Christy Gray | Client: Nomacorc

152 Gajba | Design Firm: Brandoctor, Zagreb | Art Director: Igor Manasteriotti | Creative Director: Moe Minkara | Designer: Igor Manasteriotti | Illustrator: Davor Rukovanjski | Client: Gajba

Gajba means "crate of beer" in Croatian. This is a logo for a small pub in the center of Zagreb.

152 Logo Design | Design Firm: Synergy Graphix, New York | Art Director: Remo Strada | Client: Piranha Extreme Sports

153 The Austonian | Design Firm: Les Kerr Creative, Carrollton | Art Director: Les Kerr | Creative Director: Danny Nguyen | Designer: Les Kerr | Client: Levenson & Hill

Logo for a luxury high-rise condominium in downtown Austin, Texas.

154 Sundance Preserve | Design Firm: Michael Schwab, San Anselmo | Art Director: Jamie Redford | Chief Creative Officer: Julie Mack | Creative Director: Michael Schwab | Designer: Michael Schwab | Illustrator: Michael Schwab | Client: Sundance Preserve

Logo designed for the Sundance Preserve, a nonprofit organization founded by Robert Redford, dedicated to environmental stewardship and developing creative strategies for social and cultural change. Set in the splendor of its own protected lands, the Preserve seeks to promote positive and powerful action by cultivating the exchange of innovative ideas among artists, scholars, scientists, and other leaders.

154 Osuna Nursery Logo | Design Firm: 3, Albuquerque | Creative Director: Sam Maclay | Designer: Tim McGrath | Client: Osuna Nursery

Osuna Nursery prides itself on providing healthy plants and a nurturing environment for its products.

154 MoveStar logo | Design Firm: RBMM, Dallas | Art Director: Steve Gibbs | Designer: Brian McAdams | Client: MoveStar

154 Logo for Handy Horse | Design Firm: Zync Communications Inc., Toronto | Art Director: Mike Kasperski | Creative Director: Marko Zonta | Designer: Mike Kasperski | Client: Weston Forest Group

Product logo for Weston Forest Group's Handy Horse Sawhorse.

154 reThink logo | Design Firm: FiveStone, Buford | Creative Director: Jason Locy | Designer: Patricio Juarez | Client: reThink

155 Acquire New York Logotype | Design Firm: Poulin + Morris Inc., New York | Designers: Douglas Morris, Brian Brindisi, AJ Mapes | Client: Acquire New York

Acquire New York commissioned Poulin+Morris to develope a comprehensive graphic identity and branding program for a unique new real estate resource. This includes a contemporary graphic identity as well as a website, brochures, and stationery. The coordinated materials function as effective sales and marketing tools for Acquire New York as they work to consistently expand their client list in the highly competitive field of New York real estate.

MusicCDs

156 Talking Jazz box set | Design Firm: Planet Propaganda, Madison | Creative Director: Kevin Wade | Designer: Travis Cain | Client: Unlimited Media Ltd.

Boxed set of 24 CDs and a booklet featuring 60 recorded conversations with jazz luminaries, condensing decades of jazz history into a consumer-sized package.

157 Vessels Album Artwork | Design Firm: Mash, Adelaide | Art Directors: James Brown, Andy Irwin | Chief Creative Officers: James Brown, Andy Irwin | Creative Directors: James Brown, Andy Irwin | Designers: James Brown, Andy Irwin | Illustrator: Peta Kruger | Photographer: Daniel Noone | Print Producer: CCS Packaging | Client: Wolf & Cub

Wolf & Cub: A unique blend of genre smarts and isolation-inspired innovation. For their debut long player, Vessels, the band embraced virtuosity as their new yardstick. Taking psych-rock as their cue, Wolf & Cub create a world in stereo, displacing the listener, mastering the epic and practicing conciseness simultaneously. It's a combination that's rarely achieved in any derivation of rock, and never with this much elegance. For once, a record worthy of the hype and something that needs a suiting cover. The pyschadelic set was constructed in an old warehouse over 5 days. The idea was to create artwork to depict that some of us are real, and some of us are fake. Some parts of us are real; some parts of us aren't. Some of us don't see it; some of us do. Some of us don't care; some of us wish we didn't...We're all just Vessels. Vessels for information. The idea was to have the band inconspicuously in a room of people (vessels), people that had no particular reason for being there. The overall result leaves you a little puzzled and has since gone on to win best Australian album cover artwork of 2006 with a handful of magazines. The application is a matte finish with gold foiling which gives the intended feeling of an old physc rock cover from back in the day!

157 Swan Dive | Design Firm: Carrio Sanchez Lacasta, Madrid | Art Director: Carrio Sanchez Lacasta | Chief Creative Officer: Carrio Sanchez Lacasta | Creative Director: Carrio Sanchez Lacasta | Designer: Carrio Sanchez Lacasta | Illustrator: Paco Lacasta | Client: Siesta

Design of the pack-CD Swan Dive. Pop music for an Autumn afternoon.

Outdoor

158 Art & Architecture | Design Firm: The Integer Group, Lakewood | Art Director: Scott Lary | Creative Director: Jane Brody | Writer: Natalie Boykin | Client: Denver Art Museum

The first billboard in series was visual only - giving the viewer a glimpse of something emerging, breaking through the basic billboard space - extensions were used on both the first and second boards. The second billboard showed the full image and messaging–revealing the new Denver Art Museum building–the intersection of Art & Architecture - and announcing its grand opening.

159 Forum Vini | Design Firm: Heye & Partner GmbH, Unterhaching | Art Director: Andi Stenzel | Creative Directors: Ralph Taubenberger, Wolf Bruns | Photographer: Felix Holzer | Print Producers: Carsten Horn, Matthias Remmling | Client: Albrecht-Gesellschaft fuer Fachausstellungen u Kongresse mbH

Albrecht - Association for trade exhibitions and congresses - Forum Vini is an international wine trade fair in Munich. As the Advertising budget is limited, they were looking for an exceptional idea to become the talk of the town. Wine bottle corks have similar proportions to German Advertising pillars.

So we created giant corks, branded (similar to real corks of premium wines) with "Forum Vini." So suddenly there stood giant corks in the middle of crowded places in downtown Munich. After three days of public puzzling, extra Posters on top of the corks added the information about the trade fair. The fair had more visitors than ever, despite lower Advertising spending.

Packaging

160 The Cost Vineyard Wine Bottles | Design Firm: Sandstrom Design, Portland | Art Director: Steve Sandstrom | Creative Director: Steve Sandstrom | Designers: Starlee Matz, Steve Sandstrom | Print Producer: Prue Searles | Writer: Lane Foard | Client: The Cost Vineyard

Packaging for a new, small Oregon winery with a limited production capacity for a high quality Pinot.

160 Pheasant Farm | Design Firm: IKD Design Solutions, Dulwich | Art Director: Ian Kidd | Designer: Jason Spencer | Illustrator: Dan Tomkins | Client: Colin Beer

Wine Label

161 Killibinbin Wine Packaging | Design Firm: Mash, Adelaide | Art Directors: James Brown, Dominic Roberts | Chief Creative Officer: Dominic Roberts | Creative Directors: James Brown, Dominic Roberts | Designers: James Brown, Dominic Roberts, Peta Kruger | Illustrators: John Englehart, Peta Kruger | Print Producer: Clear Image (AQ) | Writer: Dave Kalucy | Client: Killibinbin Wines

Take one form & turn it into something greater, something with passionate purpose; in the rare trade underworld the shining killibinbin is something to die for, a killer.

Killibinbin was connected to the main distributor of the product; he was always saying the wines were 'killer,' so we decided to take that idea, and using old horror movies we created horror – killer like images. They capture the viewer's eye with an almost shockful fright. Overall this approach has been received really well as an exciting change from the regular script and picturesque rolling hills so typical on wine packaging these days. The print finish is on a bulky uncoated stock to give the feeling of an old horror Poster.

162 St. Germain | Design Firm: Sandstrom Design, Portland | Creative Director: Steve Sandstrom | Designer: Steve Sandstrom | Illustrator: Antar Dayal | Print Producer: Prue Searles | Client: Maison 6ème

An artisanal elder flower Liqueur from France. Every bottle is individually numbered for that year's vintage.

163 VODAVODA | Design Firm: nonobject Inc., Menlo Park | Chief Creative Officers: Suncica Lukic, Branko Lukic | Creative Director: Suncica Lukic | Designer: Branko Lukic | Photographer: Nicholas Zurchendorfer | Writer: Branko Lukic | Client: VODAVODA / SI&SI Group

The VODAVODA Premium Water Brand: Our inspiration came from the outstanding quality of VODAVODA water. This water was composed and designed by nature long before life began. Filtered naturally through layers of limestone at a depth of 273 meters without a need for additional filtration or chemical processes, it is bottled at the source and is served with immaculate purity. Voda means water in the Serbian language. We call it VODAVODA because we were inspired by the water.

The Vessel Design: Water can momentarily take any shape of any vessel in an instant. We wanted to create a vessel that would become a connector between nature and oneself, while also balancing the rational and pragmatic aspects of the package design. We developed a square PET bottle that can fit more bottles per given volume than a common round bottle. This meant more bottles delivered to people for less money and energy.

164 Brand Management | Design Firm: Delikatessen Agentur für Marken und Design GmbH, Hamburg | Creative Director: Robert Neumann | Designer: Karsten Kummer | Client: Frank Busch

Design relaunch of the super premium German beer "Hövels." The design reflects the style of the Dortmund beer tradition during the art nouveau heyday.

165 Boris Limited Edition | Design Firm: Bob, Montreal | Art Director: Patrick Fleury | Creative Director: Patrick Fleury | Designers: Cindy Goulet, Patrick Fleury | Illustrators: Patrick Fleury, Neil Armstrong | Writer: David Charron | Client: Saverne

For the summer season, Karlsbräu Canada launched a series of limited edition collectable labels. This series of six labels visually displaying the provocative and social spirit of Boris was created by Bob Communications. Boris is an imported Alsatian beer marketed in Quebec, France and the United States since May 2003, for which Bob designed the brand identity and logo for the full line of beers: Boris, Boris Cool and Boris Bold.

166 Scottie | Design Firm: Shin Matsunaga, Tokyo | Art Director: Shin Matsunaga | Designer: Shin Matsunaga | Client: NIPPON PAPER CRECIA CO., LTD.

167 Black Orchid | Design Firm: Lloyd (+ co), New York | Art Director: Peter Poopat | Creative Director: Douglas Lloyd | Designer: Kate Zimmer | Client: Tom Ford

168 Seeds of Change Organic Chocolate Packaging | Design Firm: Sandstrom Design, Portland | Art Directors: Marc Cozza, Chris Gardiner | Creative Directors: Marc Cozza, Mark Waggoner | Designer: Chris Gardiner | Illustrators: Howell Golson, Steve Noble | Print Producer: Jim Morris | Writer: Mark Waggoner | Client: Seeds of Change

Seeds of Change created a line of five organic chocolate bars that featured authentic recipes from a variety of chocolate-centric areas of the world. The packaging was inspired by beautiful bank notes and stamps from these cultures, and the intricate artwork features ingredients and icons of each region. Each product was given a name that represented the region or the recipe's origin, and the cacao content was cleverly included looking like a bank note denomination.

169 CHIAVALION | Design Firm: Bruketa&Zinic, Zagreb | Art Directors: Davor Bruketa, Nikola Zinic | Chief Creative Officer: Mirna Grzelj | Creative Directors: Davor Bruketa, Nikola Zinic | Designer: Ruth Hoffmann | Illustrator: Ruth Hoffmann | Print Producer: Vesna Durasin | Client: CHIAVALION

This is an olive oil packaging.

170 Packaging | Design Firm: Landor Associates, San Francisco | Creative Director: Nicolas Aparicio | Designer: Anastasia Laksmi, JJ Ha, Brian Green | Client: Wolfgang Puck

Wolfgang Puck is an undisputable icon, and Landor helped to make his brand iconic. Mired in more than a decade of unmanaged license and franchise proliferation, Wolfgang Puck wanted to create a brand legacy he could be proud of. Landor's work allowed Wolfgang Puck to examine the consumer holistically as a brand consumer, rather than a single business category consumer. This enabled him to leverage cross-category offerings to maximize brand impact. The new identity was built upon the idea that the brand's products and dining venues were personally created by Puck, not by a corporate food-processing brand.

170 Alto | Design Firm: Stephanie Martin Design, Chatswood | Art Director: Stephanie Martin | Creative Director: Stephanie Martin | Designer: Stephanie Martin | Writer: Jane Adams | Client: Alto Olives

Brand name Alto (from Latin, altus: high) refers to olives sourced from high altitude olive groves for this premium quality extra virgin olive oil. An Australian product for the export market, the simple name and design are acceptable and appropriate for various language marketplaces.

171 Green Tea Packaging | Design Firm: Duffy & Partners, Minneapolis | Creative Director: Dan Olson | Designer: Ken Sakurai | Writer: Lisa Pemrick | Client: Thymes

Charged with revitalizing a current Thymes brand of bath and body products, the new Green Tea packaging delivers the Japanese sensibilities of Design: the craft of presentation, brilliantly calculated use of color for punctuation, a precise picture of the art of gift-wrapping, all enveloping a Thymes product line made from green tea, and designed to give its users all the benefits great tea has been proven to offer.

172 MOTOKRZR | Design Firm: Turner Duckworth, San Francisco | Chief Creative Officers: David Turner, Bruce Duckworth | Creative Directors: David Turner, Bruce Duckworth | Designers: Shawn Rosenberger, Ann Jordan, Josh Michaels, Rebecca Williams, Brittany Hull, Radu Ranga | Illustrator: Terry Dudley | Client: Motorola

Part of a global packaging system for Motorola consumer products. We created individualized backgrounds and used innovative packaging engineering to surprise the consumer. The MOTOKRZR phones feature a highly reflective jewel-like finish. This inspired the gemstone background.

173 PLATINUM MOTOROKR | Design Firm: Turner Duckworth, San Francisco | Chief Creative Officers: David Turner, Bruce Duckworth | Creative Directors: David Turner, Bruce Duckworth | Designers: Shawn Rosenberger, Ann Jordan, Josh Michaels, Rebecca Williams, Brittany Hull | Illustrator: Michael Brunsfeld | Photographer: Lloyd Hryciw | Client: Motorola

The MOTOROKR Design was part of Turner Duckworth's comprehensive global redesign of all Motorola packaging. Typically, the stemized approach to creating global packaging becomes obsolete quickly, especially in the fast-moving world of wireless communications where technology and products evolve at a breakneck pace. So, rather than a rigid, static system, we set out to create a more flexible Design solution that allows every Motorola phone to express its own personality. The overarching idea is to use individualized backgrounds and textures that express a unique aspect of each product and use innovative packaging engineering to surprise and delight the consumer. Our design enables the phones to be the heroes, rather than showcasing the lifestyles they fit into or the people that use them.

For MOTOROKR, which is both a phone and an MP3 player, the challenge was to generate excitement and communicate clearly across borders and languages that the MOTOROKR is all about music. Working with the slider box mechanism patented by BurgoPak, we designed the slider box as a stereo speaker. The front of the box was laser cut to achieve the look and feel of a speaker's protective cover. Slide the box mechanism in one direction and the speakers extend out to expose the woofers and tweeters. Slide the box in the opposite direction and the phone is presented while the speakers remain inside, visible behind the laser cut protective cover. The Design requires no words but the message is simple, clear and compelling: If you love music, the MOTOROKR is the phone for you.

Additional Information:

How successful was the solution?
The client absolutely loved the solution, and it's garnered quite a bit of attention and kudos in the Design community.

How long has the firm been in the Design business?
Turner Duckworth was founded in 1992.

How many employees in firm? 30

What other awards have you received?
13 Clios, The One Show, New York Art Directors, D&AD, Design Effectiveness Awards, and European Art Directors

174,175 American Eagle Denim | Design Firm: 160over90, Philadelphia | Client: American Eagle Outfitters |

176 Optimo & Strukto | Design Firm: TRIDVAJEDAN market communication ltd., Zagreb | Art Director: Izvorka Juric | Creative Director: Izvorka Juric | Designers: Izvorka Juric, Matej Korlaet | Client: CEMEX - Dalmacijacement

Task: Optimo & Strukto are cements produced by CEMEX-Dalmacijacement. The brands are new on the market, so a different and strong visual identity was needed. It had to clearly communicate the different characteristics of each product, and those characteristics had to be visible in all additional materials.

Solution: Optimo & Strukto logotypes are designed by an intervention in Typography. Colors follow the visual standards of the company. As an additional graphic element two illustrations are used. Illustrations present building ele-

ments (house and tunnel) that clearly communicate the purpose of each product, also making the products different and visible amongst the competitors.

176 Payback Bag | Design Firm: Colle + McVoy, Minneapolis | Creative Director: Ed Bennett | Designer: Ryan Carlson | Writer: Annette Bertelson | Client: CHS

177 Aura Cans | Design Firm: Carmichael Lynch Thorburn, Minneapolis | Creative Director: Bill Thorburn | Designers: Ben Levitz, David Schwen | Photographer: Mark Laita | Client: Benjamin Moore

The packaging was derived from positioning of the product as not merely a paint, but a product that dramatically enhances life when applied. Its color evokes emotion, changes moods and seeps into the memory. Color that comes from life. Flowers expressing paint became the metaphor for the rich, provocative and enticing quality of this new paint line.

PaperCompanies
178,179 Touch Me Baby | Design Firm: Carmichael Lynch Thorburn, Minneapolis | Creative Director: Bill Thorburn | Designer: David Schrimpf | Photographer: William Clark | Writer: Jonathan Graham | Client: Appleton Coated

The brochure was used to launch a new product for Appleton Coated Paper. We used fashion to express the seductive and alluring qualities of the new paper. There is a union between the texture and photography of the brochure that invites you to touch and feel with your eyes and fingers.

180 Lettra Swatchbook | Design Firm: Michael Osborne Design, San Francisco | Creative Director: Michael Osborne | Designers: Cody Dingle, Michael Osborne | Writer: Alyson Kuhn | Client: Crane & Co.

Crane and Co.'s Lettra brand paper was developed specifically for use in letterpress printing. The sample swatchbook was designed to both describe the product and provide some guidance as to its application.

181 Elevate identity folder | Design Firm: Design Guys, Minneapolis | Creative Director: Steve Sikora | Designer: Barry Townsend | Photographers: Zachary Scott (Sharp + Associates), Getty Images | Print Producer: Fey Publishing | Writer: Jeff Mueller | Client: Neenah Paper, Inc.

Other than being award-winning, the letterhead systems in this collection culled from the Neenah Paperworks Awards have one other thing in common - Neenah's Classic Crest premium papers have helped elevate each of the designs above the competition. That fact provided the theme for the folder.

182 Spicers Paper Snowcard Promotion | Design Firm: Watts Design, South Melbourne | Creative Director: Peter Watts | Designer: Peter Watts | Client: Spicers Paper

183 2006 Printers of the Year North American Awards Catalog | Design Firm: Weymouth Design, San Francisco | Art Director: Bob Kellerman | Creative Director: Bob Kellerman | Designer: Arvi Raquel-Santos | Photographer: Rob Villanueva | Writer: Jean Gogolin | Client: Sappi Fine Paper

Posters
184,185 Welcome to Japan | Design Firm: E.Co.,Ltd, Tokyo | Art Director: Tatsuo Ebina | Designer: Mika Niitsu | Photographer: Tadashi Tomono | Client: AGI

Poster for exhibition.

186 E&E Paper Promotion | Design Firm: ken-tsai lee design studio, Taipei | Art Director: Ken-tsai Lee | Creative Director: Ken-tsai Lee | Illustrator: Ken-tsai Lee | Designer: Ken-tsai Lee | Client: Fonso Interprise Co., Ltd.

187 Transformation Renewal | Design Firm: AMEBA DESIGN LTD., Hong Kong | Creative Director: Gideon Lai | Designer: Gideon Lai, Kenji | Writer: Gideon Lai | Client: Soul environmental protection

188 Archive '06 Call for Entries | Design Firm: Hartford Design, Chicago | Art Director: Tim Hartford | Designers: Tim Hartford, Ron Alikpala, Andrea Bettinardi, Brad Neal | Illustrator: Nimrod Systems | Photographer: Kipling Swehla | Writers: Wayne Stuetzer, Cheri Gearhart, Tim Hartford, Brad Neal | Client: The Society of Typographic Arts

The Society of Typographic Arts wanted a Call for Entries Poster that would memorably convey the message that by entering the juried competition, a Designer stood the chance of being positioned in perpetuity alongside the Design legends of Chicago on the STA's Web Archive. It uses images of Design tools throughout history, shrink-wrapped and preserved for eternity. The theme copy "Live On" supports the visual message.

189 2D Buddha | Design Firm: AMGD / Anders Malmstromer Graphic Design, Stockholm | Art Director: Anders Malmstromer | Chief Creative Officer: Anders Malmstromer | Creative Director: Anders Malmstromer | Designer: Anders Malmstr"mer | Illustrator: Anders Malmstr"mer | Client: AMGD / Anders Malmstromer Graphic Design

A self promotional, give-away Poster to celebrate that our Studio opened a branch in Shanghai in 2006. A 2-dimensional Buddha figure that is big, radiant and quite friendly...

190 Stars & Stripes | Design Firm: Pentagram SF, San Francisco | Chief Creative Officer: Kit Hinrichs | Creative Director: Kit Hinrichs | Designer: Kit Hinrichs | Client: Four Corners Gallery

191 Design Matters | Design Firm: GCF, Baltimore | Art Director: Domenica Genovese | Designer: Domenica Genovese | Photographer: Jody Zamirowski | Print Producer: Alpha Graphics | Writer: Brenda Foster | Client: UCDA Foundation

The Poster was designed to raise awareness and funds for the UCDA Foundation.

192 Fillmore Jazz | Design Firm: Michael Schwab, San Anselmo | Art Director: Sarah Myers | Creative Director: Thomas Reynolds | Designer: Michael Schwab | Illustrator: Michael Schwab | Client: Hartmann Studios

Poster celebrating the romantic, urban history of San Francisco's Fillmore Street and its annual festival.

193 Fine Arts Poster | Design Firm: Muller + Company, Kansas City | Art Director: Jeff Miller | Creative Director: John Muller | Designer: Jeff Miller | Illustrator: KCAI Students | Client: Kansas City Art Institute

194 Director's Cut | Design Firm: Frost Design, Surry Hills | Art Director: Vince Frost | Chief Creative Officer: Vince Frost | Creative Director: Vince Frost | Designer: Vince Frost, Caroline Cox | Photographer: Stephen Ward | Client: Sydney Dance Company

The Director's Cut was a suite of three different performances to celebrate Graeme Murphy's 30 years with Sydney Dance Company. It was also a chance to promote the Company's new logo, which we had also designed. When we

started working on the project, the choreography and music had yet to be decided, so the title was our main clue. With the campaign identity, we used the idea of 'Cut' very theatrically–with dancers hanging off the letter C and blood running down their arms. This sets up an interesting interaction between the Typography and the Photography, and was an opportunity to take an element directly from the new logo and incorporate it into the Design. With the huge red C and bleeding dancer, the Poster was extremely striking visually, and placed on bus shelters all around Sydney, was instantly recognisable and remembered.

195 Clint Black Poster | Design Firm: Ackerman McQueen, Irving | Designer: Sergio Moctezuma | Writer: Jeff Brightwell | Client: Winstar Casinos

Printers
196,197 Williamson Printing Corporation Annual Report | Design Firm: RBMM, Dallas | Art Director: Brian Owens | Designer: Brian Owens | Illustrator: Various | Photographer: Various | Print Producer: Erika Dorsey | Writer: Mike Renfro | Client: Williamson Printing Corporation

Products
198,199 MacBook | Design Firm: Graphic Design, Apple Computer, Cupertino | Client: Apple

The slim package mirrors the thinness of the product and saves space.

200 Clipeez Linking Bag Clips | Design Firm: Stuart Karten Design, Marina Del Rey | Designers: Stuart Karten, Eric Olson, Simon Sollberger | Client: Zyliss

The simply straightforward Clipeez Linking Bag Clips introduce a Design solution that improves on the basic bag clip by addressing an unmet need. They clip together with an inner 'tongue' for storage to keep tidy in the junk drawer or store together on the fridge. Clipeez vaguely anthropomorphic form is sculptural and satisfying to hold. The curves and size allow users to grip clips with the thumb or the palm, benefiting those with reduced dexterity or strength.

201 Takata Brand Series | Design Firm: Wieden + Kennedy Tokyo, Minato-ku | Art Director: Eiki Hidaka | Creative Directors: Sumiko Sato, Hiroshi Yonemura | Designer: Shunichi Aita | Photographer: Hatsuhiko Okada | Writer: Yuhei Nayuki | Client: Takata Corp.

202 iPod nano | Design Firm: Graphic Design, Apple Computer, Cupertino | Client: Apple

The iPod nano packaging was designed and engineered to take full advantage of the new product shape, material, and colors, giving it great presence in retail while still providing a rewarding customer experience.

203 nano Holiday Ad | Design Firm: Graphic Design, Apple Computer, Cupertino | Client: Apple

Promotions
204,205 Joey's Corner Wrapping Paper | Design Firm: Michael Osborne Design, San Francisco | Creative Director: Michael Osborne | Designer: Michael Osborne | Client: Joey's Corner

This wrapping paper is produced annually for sale by Joey's Corner. All proceeds go to Joey's Corner, a non-profit Design studio dedicated to providing pro-bono services to non-profit groups focusing on health care, children's and social well-being issues.

206, 207 2007 Notebook | Design Firm: ken-tsai lee design studio, Taipei | Art Director: Ken-tsai Lee | Creative Director: Ken-tsai Lee | Designers: Ken-tsai Lee, Yao-Feng Chou | Illustrator: Ken-tsai Lee | Writer: Ken-tsai Lee | Client: Fonso Paper

208 Holiday 2006 Press Kit | Design Firm: Target Corporation, Minneapolis | Art Director: Kirstin Stahl | Chief Creative Officer: Eric Erickson | Creative Director: Holly Robbins | Writers: Melissa Champine, Travis Robertson | Print Producer: Amy Lauer | Client: Target

Developing a cohesive holiday campaign press kit with exceptional creative that expresses the magic and wonder of the season for the guest distinguishes Target from other retailers, and supports all the Target businesses. Through the use of an exclusive art pattern and unique forms created by internationally acclaimed Designer Tord Boontje, Target presents key holiday products and the exclusive Studio Tord Boontje line.
Target partnered with Boontje to develop Design vocabulary that is fresh, richly ornate and ethereal. The envelope and book are covered in Boontje's exclusive holiday pattern. The book is then wrapped in a delicate laser-cut white panel of Boontje's art, which can be removed from the book and hung up as a holiday decoration. The book opens to panels filled with enchanting woodland scenes by Boontje. The Studio Tord Boontje exclusive product line section features a spread of Boontje's sketches and photos of his team and studio. The kit went out to more than 1000 members of the media. The response was overwhelmingly positive. US holiday media impressions totaled around 160 million, with more than 63 million consumer impressions for Studio Tord Boontje product.

209 Design Changes Everything: Mickey (top left), Design Changes Everything: Donald (top right), Design Changes Everything: Goofy(bottom) | Design Firm: BIG/Ogilvy & Mather, New York | Executive Creative Director: Brian Collins | Creative Director: Allen Hori | Designer: Apirat Infahsaeng | Writer: Tonice Sgrignoli | Client: The Walt Disney Company

How Passion and Imagination Shape the Future: A Talk with Brian Collins

210 2006 Halloween Poster | Design Firm: RBMM, Dallas | Designer: Kenny Duggan | Illustrator: Kenny Duggan | Print Producer: Erika Dorsey | Client: RBMM

211 Atelier Manus | Design Firm: visucom, Brig | Art Director: Frank Lynch | Photographer: Thomas Andenmatten | Writer: Erich Heynen | Client: Atelier Manus

Atelier Manus is a workplace for handicapped people. We wanted to present the people who work there and the products they produce. We did so using black & white and colour Photography. We wanted to integrate the client into the production process - therefore the embossing, binding, colating, dye-cutting, etc. was done by Atelier Manus themselves. The end product has no text, except for the contents of the envelope at the back of the brochure. This gave the client the flexibility to send different copy for different customers. The cd-rom contains an internet/flash presentation.

212 A Decade in X-Ray | Design Firm: Nick Veasey, Maidstone | Designer: Zoe Scutts | Photographer: Nick Veasey | Client: Nick Veasey

A miniature book in a bespoke miniature replica of Nick Veasey's actual portfolio case. It celebrates the beauty and diversity of this unique collection of imagery.

213 Bottoms Up | Design Firm: Wallace Church, Inc., New York | Art Director: Stan Church | Creative Director: Stan Church | Designer: Stan Church | Client: Wallace Church, Inc.

Each year Wallace Church designs a Thanksgiving wine bottle as a gift for clients and friends. This playful take on the traditional toast celebrates Thanksgiving 2006.

213 Termini Business Cards | Design Firm: Asprey Creative, Melbourne | Creative Director: Peter Asprey | Designer: Peter Asprey | Client: Mauro Marcucci

214 HP Disney Skins | Design Firm: The Integer Group, Lakewood | Art Director: David Jones | Chief Creative Officer: John Marquis | Creative Director: James Pelz | Illustrators: Aaron Finkelstein, Ian McKee | Client: Hewlett-Packard

Four Disney Parks-themed skins were designed to serve as adhesive wraps to personalize one's laptop and/or CPU units.

215 Holiday Calendar | Design Firm: Squires & Company, Dallas | Creative Director: Brandon Murphy | Designers: Jerome Marshall, Brandon Murphy | Print Producer: The Graphics Group, Dallas, Texas | Writer: Brandon Murphy | Client: Squires & Company

A 24 x 36 Holiday promotional (gift) Calendar/Poster sent out to clients, vendors, friends and family.

216, 217 Nomad Lounge New Year's Adam and Eve Party Campaign | Design Firm: Archrival, Lincoln | Creative Director: Charles Hull | Designers: Joel Kreutzer, Clint Runge | Illustrators: Carey Goddard, Cassidy Kovanda | Client: Nomad Lounge

ShoppingBags
218 Shopping Bag | Design Firm: Regina Rubino / IMAGE: Global Vision, Santa Monica | Creative Director: Regina Rubino | Designers: Javier Leguizamo, Claudia Pandji, Regina Rubino | Illustrator: Tracy Sabin | Print Producer: Armour Packaging | Client: The Beverly Hills Hotel

219 Audrey bloom | Design Firm: TrueBlue, Seoul | Art Director: Eui - Hwan Chang | Creative Director: Eui - Hwan Chang | Client: Audrey bloom

The brand logo of Audrey bloom, based upon neo-classical styling, is in thin and slim type style giving out minimal and elegant feeling. The flowery symbol, located above the logotype, is connected with the "Y," the central letter of Audrey bloom, to visualize an image of beautifully decorated flowers.

Signage
220, 221 Eureka Tower carpark | Design Firm: emerystudio, Southbank | Creative Director: Garry Emery | Designers: David Crampton, Axel Peemoeller, Job van Dort | Client: Eureka Tower

The Eureka Tower is a 90 story residential building with one car park solely dedicated to residents. The car park is a typically robust and utilitarian environment experienced in motion. An opportunity was initiated by the project Architect to exploit the potential of the vertical and horizontal surfaces of the entry, as a sequence of monumental messages that enhance the experience of arrival and departure through bold graphic illusions. Ambiguous and literal information is realized through false perspectives that are concurrently both two and three-dimensional. From different view points the super-sized letterforms are perceived as either abstract distortions or literal directional information. When viewed in motion, the distorted words In, Out, Up and Down snap into alignment to convey information at key decision making points along the journey. The reference point for this work is French artist Felice Varini.

222, 223 Owner | Design Firm: Calori & Vanden-Eynden, New York | Art Director: David Vanden-Eynden | Chief Creative Officer: David Vanden-Eynden | Creative Director: David Vanden-Eynden | Designers: Chris Calori, Denise Funaro | Photographer: Tim Nolan | Client: Keppel Land Limited, Singapore

At two-million square feet, One Raffles Quay (pronounced One Raffles Key) is Singapore's newest and largest office tower complex. The complex is comprised of two towers, a car park, retail spaces, below-grade connections to the subway, and connections to the pedestrian bridge system. Within a complex of this magnitude and complexity, a clear and concise messaging system was key to the success of the EGD program.
The goal was to create a graphics program that reinforced ORQ's gateway location, technical innovations, and outstanding architectural detailing. The resulting solution includes sculptural glass identity signs, glass-skinned totem signs, overhead signs with dramatic lighting, and core and shell signs that reinforce the Grade A aspects of ORQ, provide easy navigation, and fulfill the building's operational requirements. The program made use of the latest sign manufacturing technology and old-world artisan skills.
After extended experimentation, trial and error and commitment, the end product is expressive, impressive, and beautiful. The cast glass letters are a delightful counterpoint to the mechanical perfection of the building and their handcrafted quality helps humanize the experience of the city.

Stamps
224 CASCAIS 2007 (top) | Design Firm: João Machado, Porto | Art Director: João Machado | Chief Creative Officer: João Machado | Creative Director: João Machado | Designer: João Machado | Illustrator: João Machado | Client: CTT Correios de Portugal

Cascais 2007 Campeonato Mundial de Classes Olímpicas de Vela
Cascais 2007 Sailing World Championship
This stamp series was created to promote the Sailing World Championship that is going to take place this year in Cascais (Portugal).

224 American Motorcycles(bottom) | Design Firm: USPS | Art Director: Richard Sheaff | Artist: Steven Buchanan | Designer: Richard Sheaff | Typographer: Richard Sheaff | Client: USPS

The stamp art represents four different approaches, spanning more than fifty years, of top styling and design by US bike manufacturers. In the designs, we wanted to show the distinctive features of each bike – the fenders, the handlebars, the colors – so we decided to go with the three-quarter view. We created a background reminiscent of asphalt to suggest the open road, which is so much a part of the spirit of these popular bikes.

225 Black Heritage: Ella Fitzgerald | Design Firm: USPS | Art Director: Ethel Kessler | Artist: Paul Davis | Designer: Ethel Kessler | Typographer: Ethel Kessler | Client: USPS

People think that postage stamps are mini-posters. They're not. They look like miniaturizations, but the space is very different. If a poster needs to be read in three seconds, a stamp needs to read in one-tenth of that. And how, when you're trying to communicate the likeness of a great artist such as Ella Fitzgerald, can you do any better than a literal interpretation? Paul Davis did more. He captured her personality, playfulness, and the glowing essence of this First Lady of Song.

T-shirts
226 Uaaaaaaaaaaaa/T-shirt | Design Firm: STUDIO INTERNATIONAL, Zagreb | Art Director: Boris Ljubicic | Chief Creative Officer: Boris Ljubicic | Creative Director: Boris Ljubicic | Designer: Boris Ljubicic | Illustrator: Boris Ljubicic | Print Producer: Igor Ljubicic | Writer: Boris Ljubicic | Client: STUDIO INTERNATIONAL

This T-shirt is a political opinion of USA politics in the world today. Letter U and many letters aaaaaaaaaaaa make a beautiful US flag in black and white.

227 Southern Exposure "off-site" promotional t-shirt | Design Firm: Volume Design, Inc., San Francisco | Creative Directors: Eric Heiman, Adam Brodsley | Designer: Eric Heiman | Client: Southern Exposure

Southern Exposure (SOEX), a progressive art gallery in San Francisco, recently had to vacate its main exhibition space due to seismic retrofitting. SOEX has weathered this storm by hosting site-specific art projects that are spread across various Bay Area locations. Many of these projects occur in public spaces and demand active participation of the community.
This t-shirt embodies SOEX's current exhibition paradigm threefold: 1) The shirt's empty shell content reflects SOEX's need – in lieu of a fixed space – for public interaction, assistance, and attendance. 2) The shirt's interactive nature asks the public, whether longtime SOEX devotees or neophytes, to voice their own thoughts about the exhibitions publicly. It becomes a way, especially at these off-site openings, to encourage interaction and discussion between patrons. 3) Along with stickers and buttons, this is one of the main vehicles that identifies and promotes the space-less SOEX at openings and events. The shirt also provides mobile promotion for SOEX through the people who end up wearing the completed shirt out in public.

TransportationDesign
228 ExpressJet Fleet Graphics | Design Firm: Origin, Houston | Art Directors: Jennifer Gabiola, Saima Malik | Chief Creative Officer: Jim Mousner | Creative Director: Jim Mousner | Designer: Saima Malik | Client: ExpressJet

229 Southern Pacific Heritage Locomotive (top) Design Firm:Bailey Lauerman, Omaha | Chief Creative Officer:Carter Weitz | Creative Director:Marty Amsler | Designer:Cathy Solarana | Client: Union Pacific

The Union Pacific Heritage Series of locomotives honor the people and the railroads that have made the company what it is today. Each locomotive features a unique paint scheme, incorporating elements of one of the six major railroads that have merged with Union Pacific.

229 2005 CTIA Bus Wraps (bottom) | Design Firm: VITROROBERTSON, San Diego | Art Director: Mike Brower | Chief Creative Officer: John Vitro | Creative Director: Mike Brower | Client: Kyocera

The bus wraps were designed to build awareness and understanding for the Kyocera brand among the trade. In an environment cluttered with people and advertising we needed the design to stand out and get across our message - simplicity. Kyoceraís focus at the time was providing full-featured phones with a user-friendly experience.

Typography
230 The Wand Font Poster | Design Firm: Schatz/Ornstein Studio, New York | Art Director: Howard Schatz | Creative Director: Howard Schatz | Photographer: Howard Schatz | Client: Personal Project

231 Arno Pro | Design Firm: Adobe Systems, Inc., San Jose | Designer: Robert Slimbach | Client: Adobe Systems, Inc.

Named after the Florentine river which runs through the heart of the Italian Renaissance, Arno draws on the warmth and readability of early humanist types of the 15th and 16th centuries. While inspired by the past, Arno is distinctly contemporary in both appearance and function. Designed by Adobe Principal Designer Robert Slimbach, Arno is a meticulously-crafted face in the tradition of early Venetian and Aldine book typefaces. Embodying themes Slimbach has explored in typefaces such as Minion and Brioso, Arno represents a distillation of his Design ideals and a refinement of his craft. As a multi-featured OpenType family, with the most extensive Latin-based glyph complement Adobe has yet offered, Arno offers extensive pan-European language support, including Cyrillic and polytonic Greek. The family also offers such typographic niceties as five optical size ranges, extensive swash italic sets, and small capitals for all covered languages. Arno will be available in the next version of Adobe Creative Suite software in Spring 2007.

232 Hitofude-font | Design Firm: Graphic Communication Laboratory Japan | Art Director: Noriyuki Kasai | Creative Director: Noriyuki Kasai | Designer: Noriyuki Kasai | Client: Noriyuki Kasai

DesignersDirectory

160over90 www.160over90.com
One South Broad St. 10th Floor, Philadelphia, Pennsylvania, United States, 19107
Tel 215 732 3200 | Fax 215 732 1664

3 www.whois3.com
8220 La Mirada NE, Suite 500, Albuquerque, New Mexico, United States, 87109
Tel 505 293 2333 | Fax 505 293 1198

601 Design, Inc. www.601design.com
P.O. Box 771202 Steamboat Springs, Colorado, United States, 80477
Tel 970 871 8005 | Fax 970 871 8007

Ackerman McQueen www.am.com
545 E. John Carpenter Frwy, Suite 1700 Irving, Texas, United States, 75062 | Tel 972 444 9000

Addison www.addison.com
20 Exchange Place 18th Floor, New York, New York, United States, 10005
Tel 212 229 5000 | Fax 212 929 3010

Adobe Systems, Inc.
345 Park Ave. San Jose, California, United States, 95110 | Tel 408 536 6000

AMEBA DESIGN LTD. www.AmebaDesign.com
Unit 402, China Aerospace Centre, 143 Hoi Bun Road, Kwun Tong, Hong Kong, China
Tel (852) 2389 6981 | Fax (852) 2763 9800

American Airlines Publishing
4333 Amon Carter Blvd. MD5374 Fort Worth, Texas, United States, 76155 | Tel 817 963 5378

AMGD / Anders Malmströmer Graphic Design www.malmstromer.se
Skeppargatan 18 Stockholm, Sweden, se-11452 | Tel +46707726401 | Fax +4683113 77

Anita Kunz
218 Ontario St. Toronto, Canada, M5A2V5 | Tel 416 364 3846

Archrival www.archrival.com
720 O Street, Suite A, Lincoln, Nebraska, United States, 68512
Tel 402 435 2525 | Fax 402 435 8937

Asprey Creative www.aspreycreative.com.au
1 Chapel Street, Fitzroy, Melbourne, Victoria, Australia, 3054
Tel 9416 3077 | Fax 9416 1857

Astrid Stavro www.artofthegrid.com / www.astridstavro.com
Arc De Sant Agusti, 7 Principal Primera Barcelona, Spain, 08001 | Tel 0034 620550515

Bailey Lauerman www.baileylauerman.com
1299 Farnam Street, Suite 930 Omaha, Nebraska, United States, 68102-1157
Tel 402.514.9400 | Fax 402.514.9401

BIG / Ogilvy & Mather www.ogilvy.com
309 West 49th Street, New York, New York, United States, 10019 | Tel 212 237 6621 | Fax 212 237 4106

Bob www.bob.ca
4200 Saint-Laurent, Montréal, Québec, Canada, H2W 2R2 | Tel 514 842 4262 | Fax 514 842 7262

Brady Communications www.bradycommunications.com
16th Floor Four Gateway Center, Pittsburgh, Pennsylvania, United States, 15222
Tel 412 288 9300

BRAND PLANT
Pionierstraße 31 Duesseldorf NRW, Germany, 40215
Tel +49 (0) 211 34 02 99 | Fax +49 (0) 211 15 93 380

Brandoctor www.brandoctor.com
Zavrtnica 17 Zagreb, Croatia (local Name: Hrvatska), 10000
Tel +385 1 6192 597 | Fax +385 1 6192 597

Bruketa & Zinic www.bruketa-zinic.com
Zavrtnica 17 Zagreb, Croatia (local Name: Hrvatska), 10000
Tel +385 1 6064 000 | Fax +385 1 6064 001

BVK www.bvk.com
250 West Coventry Court Suite 300, Milwaukee, Wisconsin, United States, 53217
Tel 414 228 1990

Cahan & Associates www.cahanassociates.com
171 Second Street, 5th Floor, San Francisco, California, United States, 94105 | Tel 415 621 0915

Calibre Design & Marketing Group www.calibredesign.com
19 Duncan street Suite 503, Toronto, Ontario, Canada, M5H 3H1
Tel 416 703 1062 | Fax 416 703 6235

Calori & Vanden-Eynden www.cvedesign.com
130 West 25th Street, 12th floor, New York, New York, United States, 10001
Tel 212 929 6302 | Fax 212 675 2867

Carmichael Lynch Thorburn
800 Hennepin Avenue, Minneapolis, Minnesota, United States, 55403 | Tel 612 334 6000

Carrió Sánchez Lacasta www.carriosanchezlacasta.com
Jose Ortega y Gasset, 59 Madrid, Spain, 28006 | Tel 91 401 68 55

Clemenger BBDO
PO Box 9440 Wellington, New Zealand | Tel +64 4 802 3333 | Fax +64 4 802 3322

Colle + McVoy www.collemcvoy.com
400 First Ave N, Suite 700, Minneapolis, Minnesota, United States, 55401 | Tel 612 305 6169

Concrete Design Communications Inc. www.concrete.ca
2 Silver Avenue, Toronto, Ontario, Canada, M6R 3A2 | Tel 416 534 9960 | Fax 416 534 2184

Corporate Grafix www.corporategrafix.com
4040 Aurora Street, Coral Gables, Florida, United States, 33146
Tel 305 447 9820 | Fax 305 447 9860

Dar Al-Handasah (Shair and Partners) www.dargroup.com
101 Wigmore Street, 1st Floor, London, United Kingdom, W1U 1QU49 49 | Tel +44 (0) 20 7962 1333

David Clark Design www.davidclarkdesign.com
1305 E. 15th Street, Suite 202, Tulsa, Oklahoma, United States, 74120
Tel 918 295 0044 | Fax 918 295 0055

DDB Chicago www.ddbchi.com
200 East Randolph Street, Chicago, Illinois, United States, 60601
Tel 312 552 6000 | Fax 612 337 0054

Delikatessen Agentur für Marken und Design GmbH www.delikatessen-hamburg.com
Große Brunnenstr. 63a Hamburg, Germany, 22763
Tel + 49 (0) 40/35 08 06 14 | Fax + 49 (0) 40/35 08 06 10

Design Guys www.designguys.com
119 North 4th Street, Suite 400, Minneapolis, Minnesota, United States, 55401 | Tel 612 338 4462

DesignworksEnterpriseIG www.designworkseig.com
1 Barrack Street, Level 1, Sydney NSW, Australia, 2000 | Tel 02 9299 8966 | Fax 02 9262 6806

Duffy & Partners www.duffy.com
710 2nd Street South, Suite 602, Minneapolis, Minnesota, United States, 55401
Tel 612 548 2333 | Fax 612 548 2334

E.Co.,Ltd www.e-ltd.co.jp/
LK Bldg.,1-10-4, Hiroo, Shibuya-ku Tokyo, Japan, 150-0012 | Tel +81 3 3446 4791 | Fax +81 3 3444 9282

Emerson, Wajdowicz Studios designEWS.com
1123 Broadway, Suite 1106, New York, New York, United States, 10010
Tel 212 807 0414 | Fax 212 675 0414

emerystudio www.emerystudio.com
80 Market Street, Southbank, Victoria, Australia, 3006 | Tel 61 3 9699 3822 | Fax 61 3 9690 7371

FiveStone www.fivestone.com
554 West Main Street, Tannery Row, Building B, Suite 200 Buford, Georgia, United States, 30518
Tel 678 730 0686 x223

Flaunt www.flaunt.com
1422 North Highland Avenue, Los Angeles, California, United States, 90028
Tel 323 836 1000 | Fax 323 856 5839

Frost Design www.frostdesign.com.au
Level 1, 15 Foster Street, Surry Hills NSW, Australia, 2010 | Tel +61 2 9280 4233 | Fax +61 2 9280 4266

GCF www.GCFonline.com
3000 Chestnut Avenue, Suite 400, Baltimore, Maryland, United States, 21211
Tel 410 467 4672 | Fax 410.467 4306

GQ Magazine
4 Times Square, New York, New York, United States, 10036 | Tel 212 286 7523 | Fax 212 286 8515

Graphic communication laboratory
311, 417-325, Makuhari-cho, hanamigawa-ku Chiba, Japan, 2620032
Tel +81 43 351 5033 | Fax +81 043 351 5033

Graphic Design, Apple Computer www.apple.com
1 Infinite Loop MS 83-PPS, Cupertino, California, United States, 95014
Tel 408 974 5286 | Fax 408 9649

Hahmo Design Ltd. www.hahmo.fi
Unioninkatu 3 C, Helsinki, Finland, FI-00130 | Tel +358 9 681 8210 | Fax +358 9 6818 2121

Hartford Design www.hartfordesign.com
954 W. Washington, 4th Floor, Chicago, Illinois, United States, 60607
Tel 312 563 5600 | Fax 312 563 5603

Headcase Design www.headcasedesign.com
428 N 13th Street, 5F Philadelphia, Pennsylvania, United States, 19123
Tel 215 922 5393 | Fax 215 922 5398

Heye & Partner GmbH
Ottobrunner Str. 28 Unterhaching, Bavaria, Germany, 82008
Tel + (0) 89/665 32 13 40 | Fax +49 (0) 89/665 32 13 80

Howard, Merrell & Partners www.merrellgroup.com
8521 Six Forks Road Raleigh, North Carolina 27615, United States | Tel 919 848 2400 | Fax 911 845 9845

Hoyne Design Pty Ltd www.hoyne.com.au
Level 1, 77a Acland Street, St Kilda, Victoria, Australia, 3182 | Tel 61 3 9537 1822 | Fax 61 3 9537 1833

HZDG www.hzdg.com
725 Rockville Pike Studio 3, Rockville, Maryland, United States, 20852
Tel 301 294 6302 | Fax 301 294 6305

IKD Design Solutions www.ikdesign.com.au
173 Fullarton Road, Dulwich SA, Australia, 5065 | Tel 61 8 8332 0000 | Fax 61 8 8364 0726

Inaria www.inaria-design.com
10 Plato Place 72-74 St, Dionis Road, London, United Kingdom, SW6 4TU
Tel 020 7384 0905 | Fax 020 7751 0305

Intralink Film Graphic Design www.intralinkfilm.com/site.html
155 North La Peer Drive, Los Angeles, California, United States, 90048 | Tel 310 271 5671

João Machado www.joaomachado.com
Rua Padre Xavier Coutinho, 125. 4150-751 Porto Porto, Portugal, 4150-751
Tel +351226103778 | Fax +351226103773

Karacters Design Group / DDB Canada www.karacters.com
1600-777 Hornby Street, Vancouver, BC, Canada, V6Z 2T3 | Tel 604 640 4327 | Fax 604 608 4452

ken-tsai lee design studio
17# 31 Lane 49 Alley Chung Cheng st, Peitou Taipei, Taiwan, Province Of China, 112
Tel 886 2 28935236 | Fax 886 2 87803659

Kilmer & Kilmer Brand Consultants www.kilmer2.com
125 Truman NE. Albuquerque, New Mexico, United States, 8710849
Tel 505 260 1175 | Fax 505 260 1155

KMS Team GmbH www.kms-team.de
Deroystr. 3-5 Munich, Bavaria, Germany, 80335 | Tel ++49(0)89 490411-0 | Fax ++49(0)89 490411-49

Kuhlmann Leavitt, Inc www.kuhlmannleavitt.com
7810 Forsyth Blvd., 2W St. Louis, Missouri, United States, 63105 | Tel 314 725 6616 | Fax 314 725 6618

Landor Associates www.landor.com
1001 Front Street, San Francisco, California, United States, 94111 | Tel 415 365 1700 | Fax 415 365 3190

Les Kerr Creative www.leskerr.net
3315 Willow Ridge Circle, Carrollton, Texas, United States, 75007 | Tel 972 236 3599

Lloyd (+ co)
180 Varick Street, Suite 1018, New York, New York, United States, 10014
Tel 212 414 3100 | Fax 212 414 3113

Look www.lookdesign.com
1594 Laurel Street, San Carlos, CA, United States, 94070 | Tel 650 595 8089 | Fax 650 595 1408

love the life www.lovethelife.org
3-12-10-803 Moto-Asakusa, Taito-Ku, Tokyo, Japan, 111-0041
Tel +81 3 5806 3888 | Fax +81 3 5806 3889

LOWERCASE Inc. www.lowercaseinc.com
213 West Institute Place, Suite 311, Chicago, Illinois, United States, 60610
Tel 312 274 0652 | Fax 312 274 0659

Mash http://www.mashdesign.com.au
249A Morphett Street, Adelaide, South Australia, 5000
Tel +61 (0) 8 8410 0191 | Fax +61 (0) 8 8410 0713

Matsumoto Incorporated www.matsumotoinc.com
127 West 26th Street, 9th Floor, New York, New York, United States, 10001
Tel 212 807 0248 | Fax 212 807 1527

MBA www.your-mba.com
823 Congress, Suite 525 Austin, Texas, United States, 78701 | Tel 512 971 7820

McCann Erickson Russia
11, Bolshoi Karetnyi Pereulok, Moscow, Russian Federation, 127051
Tel + 7 495 933 05 00 | Fax + 7 495 933 05 01

Michael Osborne Design www.michaelschwab.com
444 De Haro Street, Suite 207, San Francisco, California, United States, 94107 | Tel 415 255 0125

Michael Schwab
108 Tamalpais Avenue, San Anselmo, California, United States, 94960
Tel 415 257 5792 | Fax 415 257 5793

Mirko Ilic Corp.
207 East 32nd Street, New York, New York, United States, 10016 | Tel 212 481 9737

mono www.mono-1.com
2902 Garfield Ave. S. Minneapolis, Minnesota, United States, 55408
Tel 612 822 4135 | Fax 612 822 4136

Muller+Company mullerco.com
4739 Belleview, Kansas City, Missouri, United States, 64112
Tel 816 531 1992 | Fax 816 531 6692

Nick Veasey www.nickveasey.com
Radar Studio, Coldblow Lane Thurnham Maidstone, Kent, United Kingdom, ME14 3LR
Tel +44 1622 737722 | Fax +44 1622 738644

nonobject Inc.
1031 Menlo Oaks Drive Menlo Park, California, United States, 94025
Tel 650 245 6382 | Fax 650 323 8253

Nuts About Design www.highlightsmag.com
79 Beattie Street, Balmain NSW, Australia | Tel 61 2 9555 2520

Ó! www.oid.is
Armuli 11 Reykjavik, Iceland, 108 | Tel +354 562 3300

oakwood dc www.oakwood-dc.com
7 Park Street Bristol, United Kingdom, BS1 5NF | Tel 00 44 117 983 6789 | Fax 00 44 117 983 7323

Ontwerphaven www.duf.nu
Van Bylandtstraat 21 Den Haag, Netherlands, 2562 GH
Tel +31 (70) 4450373 | Fax +31 (84) 7174750

Origin www.origindesign.com
20 East Greenway Plaza, Suite 310, Houston, Texas, United States, 77046 | Tel 713 520 9544

Pentagram Design Ltd. Berlin www.pentagram.com
Leibnizstrasse 60, Berlin, Germany, 10629 | Tel +49 30 2787610 | Fax +49 30 27876110

Pentagram SF www.pentagram.com
387 Tehama Street, San Francisco, California United States, 94103
Tel 415 896 0499 | Fax 415 541 9106

Peter Krämer www.peterkraemer-web.de
Lindemannstr. 31 40237, Dusseldorf, Germany | Tel +49 211 2108087 | Fax +49 211 228541

Planet Propaganda www.planetpropaganda.com
605 Williamson Street, Madison, Wisconsin, United States, 53703 | Tel 608 256 0000

Poulin + Morris Inc. www.poulinmorris.com
286 Spring Street, Sixth Floor, New York, New York, United States, 10013
Tel 212 675 1332 | Fax 212 675 3027

RBMM www.rbmm.com
7007 Twin Hills, Suite 200, Dallas, Texas, United States, 75231 | Tel 214 987 6500 | Fax 214 987 3662

R. Dana Sheaff & Company
9330 North 96th Place, Scottsdale, Arizona, United States, 85258 | Tel 480 451 0788

KesslerDesignGroup Ltd. www.kesslerdesigngroup.com
6931 Arlington Road, Suite 301, Bethesda, Maryland, United States, 20814
Tel 301 907 3233 | Fax 301 907 6690

Rebeca Méndez Communication Design www.rebecamendez.com
11009 1/2 Strathmore Drive, Los Angeles, California, United States, 90024
Tel 310 985 0621 | Fax 888 843 6497

Regina Rubino / IMAGE: Global Vision www.imageglobalvision.com
2525 Main Street, Suite 204, Santa Monica, California, United States, 90405
Tel 310 998 8898 | Fax 310 396 1686

Rigsby Hull www.rigsbyhull.com
2309 University Boulevard, Houston, Texas 77005-2641, United States | Tel 713 660 6057

Riordon Design www.riordondesign.com
131 George Street, Oakville, Ontario, Canada, L6J 3B9 | Tel 905 339 0750 | Fax 905 339 0753

Robert Romiti www.ltbfoundation.org
Louise T Blouin Foundation, 3 Olaf Street, London, United Kingdom, W11 4BE
Tel +44 20 7985 9674 | Fax +44 20 7985 9679

Rubin Postaer & Associates www.rpa.com
2525 Colorado Avenue, Santa Monica, California, United States, 90404
Tel 310 633 6224 | Fax 310.633.6917

Sandstrom Design www.sandstromdesign.com
808 SW 3rd Avenue, Ste 610 Portland, Oregon, United States, 97204
Tel 503 248 9466 | Fax 503 227 5035

Schatz/Ornstein Studio www.howardschatz.com
435 W. Broadway #2, New York, New York, United States, 10027 | Tel 212 334 6667

School of Visual Arts www.schoolofvisualarts.edu
Adv/GD Dept, 209 East 23rd Street, New York, New York, United States, 10010
Tel 212 592 2166 | Fax 212 592 2014

Shin Matsunaga
98-4, Yarai-cho, Shinjuku-ku, Tokyo, Japan, 162-0805
Tel +81 3 5225 0777 | Fax +81 3 3266 5600

Sibley/Peteet Design(Austin) www.spdaustin.com
522 East 6th Street, Austin, Texas, United States, 78701 | Tel 512 473 2333

Sibley/Peteet Design(Dallas) www.spddallas.com
3232 McKinney Avenue, Suite 1200, Dallas, Texas, United States, 75204
Tel 214 969 1050 | Fax 214 969 7585

Squires & Company www.squirescompany.com
2913 Canton Street, Dallas, Texas, United States, 75226 | Tel 214 939 9194 | Fax 214 939 3464

Stephanie Martin Design
34 Bellevue Street, Chatswood NSW, Australia, 2067 | Tel 02 9419 6762

Steven Taylor & Associates www.steventaylorassociates.com
The Plaza, Unit 3.17 535 Kings Road, London, SW10 0SZ, United Kingdom | Tel 00 44 (20) 73512345

Stuart Karten Design www.kartendesign.com
4204 Glencoe Avenue, Marina Del Rey, California, United States, 90292
Tel 310 827 8722 | Fax 310 821 4492

STUDIO INTERNATIONAL www.studio-international.com
Buconjiceva 43, Zagreb, Croatia (local Name: Hrvatska), 10000 Tel +385 1 3760171 | Fax +385 1 3760172

Synergy Graphix www.synergygraphix.com
183 Madison Avenue, Suite 415, New York, New York, United States, 10016 | Tel 212 968 7567

Tangram Strategic Design www.tangramsd.it
Viale Michelangelo Buonarroti 10/C, Novara, Italy, 28100
Tel +39 032 135 662 | Fax +39 0321 392 232

Target Corporation www.target.com
1000 Nicollet Mall, Minneapolis, Minnesota, United States, 55403
Tel 612 696 8679 | Fax 612 696 3988

TASCHEN America www.taschen.com
6671 Sunset Blvd. Suite 1508, Los Angeles, California, United States, 90028
Tel 323 463 4441 | Fax 323 463 4442

TBWA\Chiat\Day www.tbwachiat.com/
5353 Grosvenor Blvd. Los Angeles, California, United States, 90060 | Tel 310 305 5000

Templin Brink Design templinbrinkdesign.com
720 Tehama Street, San Francisco, California, United States, 94103
Tel 415 255 9295 | Fax 415 255 9296

The Integer Group www.integer.com
7245 West Alaska Drive, Lakewood, Colorado, United States, 80226 | Tel 303 393 3000

The Republik www.therepublik.net
313 West Main Street, Durham, North Carolina, United States, 27701 | Tel 919 956 9400

TOKY Branding+Design www.toky.com
3139 Olive Street St. Louis, Missouri, United States, 63103 | Tel 314 534 2000 | Fax 314 534 2001

TRIDVAJEDAN market communication ltd. www.tridvajedan.hr
Ilica 204 Zagreb, Croatia (local Name: Hrvatska), 10000
Tel +385 1 3707020 | Fax +385 1 3707050

TrueBlue www.tbcom.co.kr
Ahsung Bldg, 32-7, Pil-dong, Jung-gu, Seoul, Republic Of Korea, 100-866
Tel 822 2273 8565 | Fax 822 2273 8564

Turner Duckworth www.turnerduckwoth.com
831 Montgomery Street, San Francisco, California, United States, 94133
Tel 415 675 7777 | Fax 415 675 7778

Ventress Design Group ventress.com
3310 Aspen Grove Drive, Suite 303, Franklin, Tennessee, United States, 37067
Tel 615 727 0155 | Fax 615 727 0159

visucom www.visucom.com
Winkelgasse 2 Brig VS, Switzerland, 3900 | Tel +41279221640 | Fax +41279221641

VITROROBERTSON www.vitrorobertson.com
625 Broadway, Fourth Floor, San Diego, California, United States, 92101
Tel 619 234 0408 | Fax 619 234 4015

VIVA DESIGN! studio www.viva-design.com
Apt. 7, 15/2 Vanda Vasylevskaya str. Kiev, Ukraine, 04116 | Tel +38044 489 19 54 | Fax +38044 489 19 54

Volume Design, Inc. www.volumesf.com
2130-B Harrison Street, San Francisco, California, United States, 94110
Tel 415 503 0800 | Fax 415 503 0800

Vrontikis Design Office www.35k.com
2707 Westwwod Blvd. Los Angeles, California, United States, 90064 | Tel 310 446 5446

WAJS www.wajs.de
Otto-Hahn-Str.13, Hoechberg, Bavaria 97204, Germany
Tel 0049 (0) 931 304990 | Fax 0049 (0) 931 30499 20

Wall-to-Wall Studios, Inc. www.walltowall.com
40 24th Street, 2nd Floor, Pittsburgh, Pennsylvania, United States, 15222
Tel 412.232.0880 | Fax 412.232.0906

Wallace Church, Inc. wallacechurch.com
330 East 48 Street, New York, New York, United States, 10017 | Tel 212 755 2903 | Fax 212 355 6872

Watts Design www.wattsdesign.com.au
66 Albert Road, 2nd Floor, South Melbourne, Victoria, Australia, 3205
Tel 61 3 9696 4116 | Fax 61 3 9696 4006

Webster Design Associates www.websterdesign.com
5060 Dodge Street, Suite 2000, Omaha, Nebraska, United States, 68132
Tel 402 551 0503 | Fax 402 551 1410

Weymouth Design (CA) www.weymouthdesign.com
600 Townsend Street, Suite 320, East San Francisco, California, United States, 94103
Tel 415 487 7900 | Fax 415 431 7200

Weymouth Design (MA) www.weymouthdesign.com
332 Congress Street, Boston, Massachusetts, United States, 02210
Tel 617 542 2647 | Fax 617 451 6233

Wieden+Kennedy Tokyo
7-5-6 Roppongi Minato-ku, Tokyo, Japan, 106-0032 | Tel 03 5771 2900

Willoughby Design Group www.willoughbydesign.com
602 Westport Road, Kansas City, Missouri, United States, 64111
Tel 816 561 4189 | Fax 816 561 5052

Work Labs www.worklabs.com
2019 Monument Avenue, Richmond, Virginia, United States, 23220
Tel 804 358 9372 | Fax 804 358 9372

Young & Laramore www.yandl.com
407 N. Fulton Street, Indianapolis, Indiana, United States, 46202 | Tel 317 264 8000

Zync Communications Inc. www.zync.ca
282 Richmond St. East, Suite 200, Toronto, Ontario, Canada, M5A 1P4 | Tel 416 322 2865

Designers

ArtDirectors

CreativeDirectors

DesignDirectors

DesignFirms

ChiefCreativeOfficers

Illustrators

Photographers

PrintProducers

Writers

Clients

AdditionalCreativeContributors

Graphis Standing Orders (50% off):

Get 50% off the list price on new Graphis books when you sign up for a Standing Order on any of our periodical books (annuals or bi-annuals).

A Standing Order is a subscription to Graphis books with a 2 year commitment. Secure your copy of the latest Graphis titles, with our best deal, today online at *www.graphis.com*.

Click on Annuals, and add your selections to your Standing Order list, and save 50%.

Graphis Titles

DesignAnnual2008

GraphisDesignAnnual2008

Spring 2007
Hardcover: 256 pages
300 plus color illustrations

Trim: 8.5 x 11.75"
ISBN: 1-932026-43-6
US $70

GraphisDesignAnnual2008 is the definitive Design exhibition, featuring the year's most outstanding work in a variety of disciplines. Featured categories include Books, Brochures, Corporate Identity, Interactive, Letterhead, Signage, Stamps, Typography and more! All winners have earned the new Graphis Gold and/or Platinum Awards for excellence. Case studies of Platinum winning artists and their work complete the book.

Brochures6

GraphisBrochures6

Fall 2007
Hardcover: 256 pages
300 plus color illustrations

Trim: 8.5 x 11.75"
ISBN: 1-932026-48-7
US $70

GraphisBrochures6 demonstrates the potency of the brochure medium with close ups, reproductions of covers and inside spreads from the award winners. Each of these outstanding brochures has earned a Graphis Gold and/or Platinum Award for excellence. Case studies of a few, carefully selected Platinum winning artists and their work complete the book. The sixth volume of this popular series also features an index of firms, creative contributors and clients.

AdvertisingAnnual2008

GraphisAdvertisingAnnual2008

Fall 2007
Hardcover: 256 pages
300 plus color illustrations

Trim: 8.5 x 11.75"
ISBN: 1-932026-44-4
US $70

GraphisAdvertisingAnnual2008 showcases over 300 single ads and campaigns, from trade categories as varied as Automotive, Film, Financial Services, Music, Software and Travel. All have earned the new Graphis Gold Award for excellence, and some outstanding entries have earned the Graphis Platinum Award. This year's edition also includes case studies of a few Platinum-winning Advertisements. This is a must-have for anyone in the industry.

PosterAnnual2007

GraphisPosterAnnual2007

Summer 2007
Hardcover: 256 pages
200 plus color illustrations

Trim: 8.5 x 11.75"
ISBN: 1-932026-40-1
US $70

GraphisPosterAnnual2007 features the finest Poster designs of the last year, selected from thousands of international entries. These award winning Posters, produced for a variety of corporate and social causes, illustrate the power and potential of this forceful visual medium. This year's edition includes interviews with famed Japanese Designer **Shin Matsunaga, Marksteen Adamson** of Britain's ASHA and Swiss Poster Curator **Felix Studinka**.

PhotographyAnnual2007

Winter 2006
Hardcover: 240 pages
200 plus color illustrations

Trim: 8.5 x 11.75"
ISBN: 1-932026-39-8
US $70

GraphisPhotographyAnnual2007 is a moving collection of the year's best photographs. Shot by some of the world's most respected artists, these beautiful images are organized by category for easy referencing. This book includes interviews with **Albert Watson** on his latest work, "Shot in Vegas," **Joel Meyerowitz** on the dramatic September 11th recovery series, *Aftermath*, and **Paolo Ventura** on his recently released and haunting *War Souvenir* series.

AnnualReports2006

GraphisAnnualReports2006

Spring 2006
Hardcover: 224 pages
200 plus color illustrations

Trim: 8.5 x 11.75"
ISBN: 1-932026-24-X
US $70

GraphisAnnualReports2006 presents 34 outstanding reports, selected for excellence in Design and clear expression of the client's message. Insightful essays by Designers and judges **Steve Frykholm, Delphine Hirasuna, John Klotnia, Douglas Oliver** and **Gilmar Wendt** on the role of AR Design in the current corporate climate make this a must have for anyone involved in this demanding medium. Detailed credits and indices complete this annual.

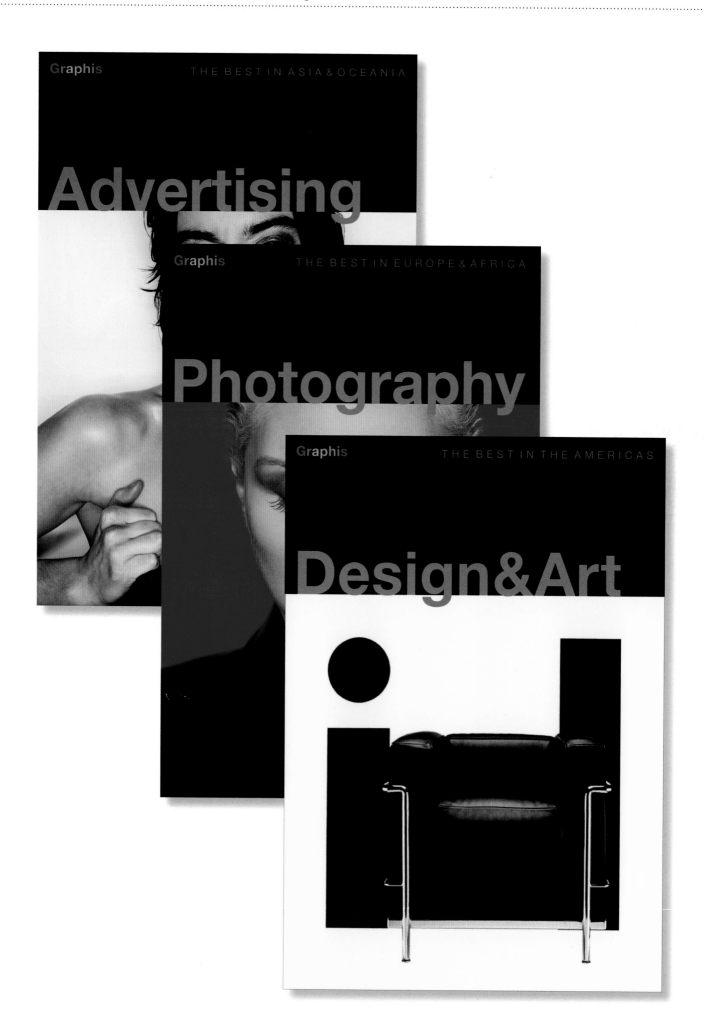